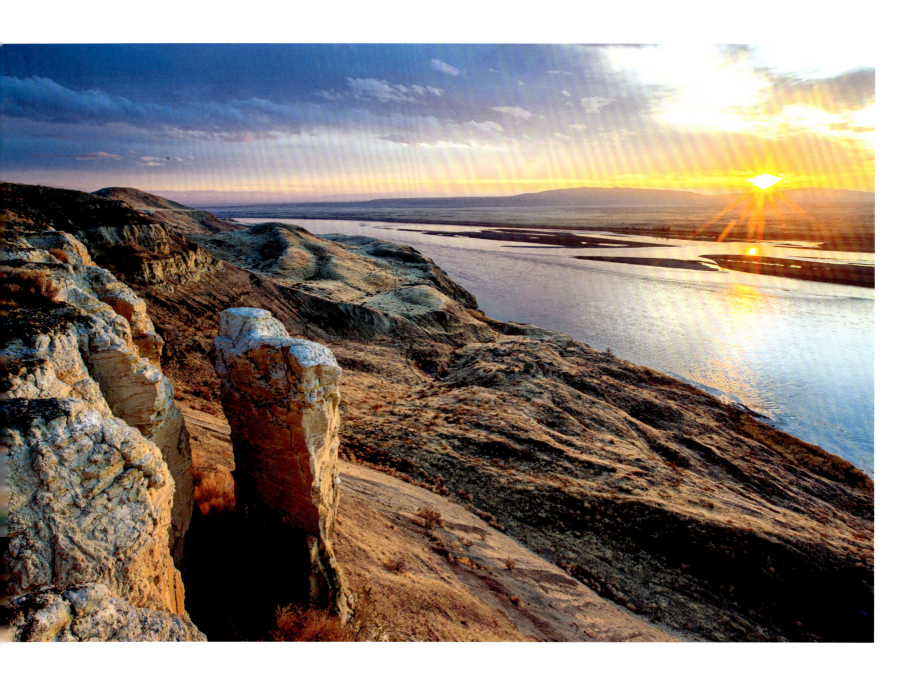

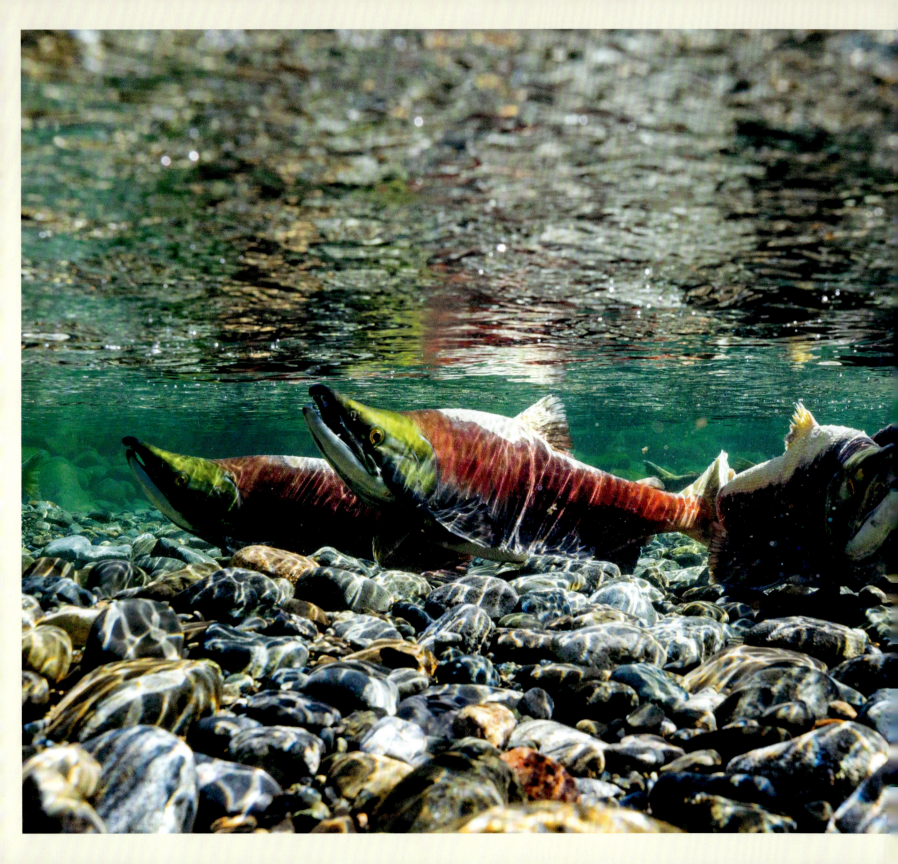

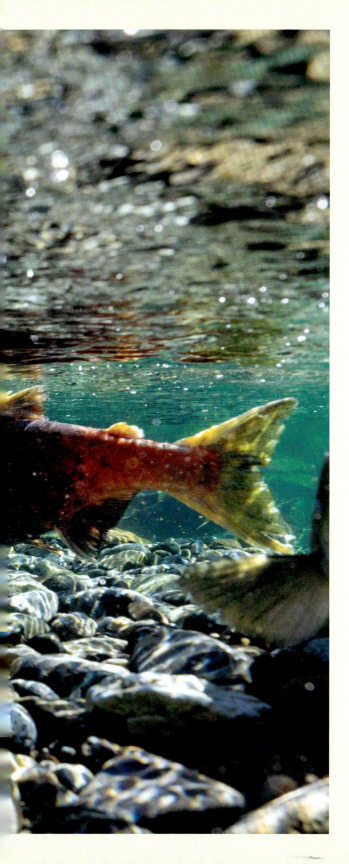

BIG RIVER

RESILIENCE AND RENEWAL
in the COLUMBIA BASIN

PHOTOGRAPHY AND INTRODUCTION
DAVID MOSKOWITZ

NARRATIVE
EILEEN DELEHANTY PEARKES

BRAIDED RIVER

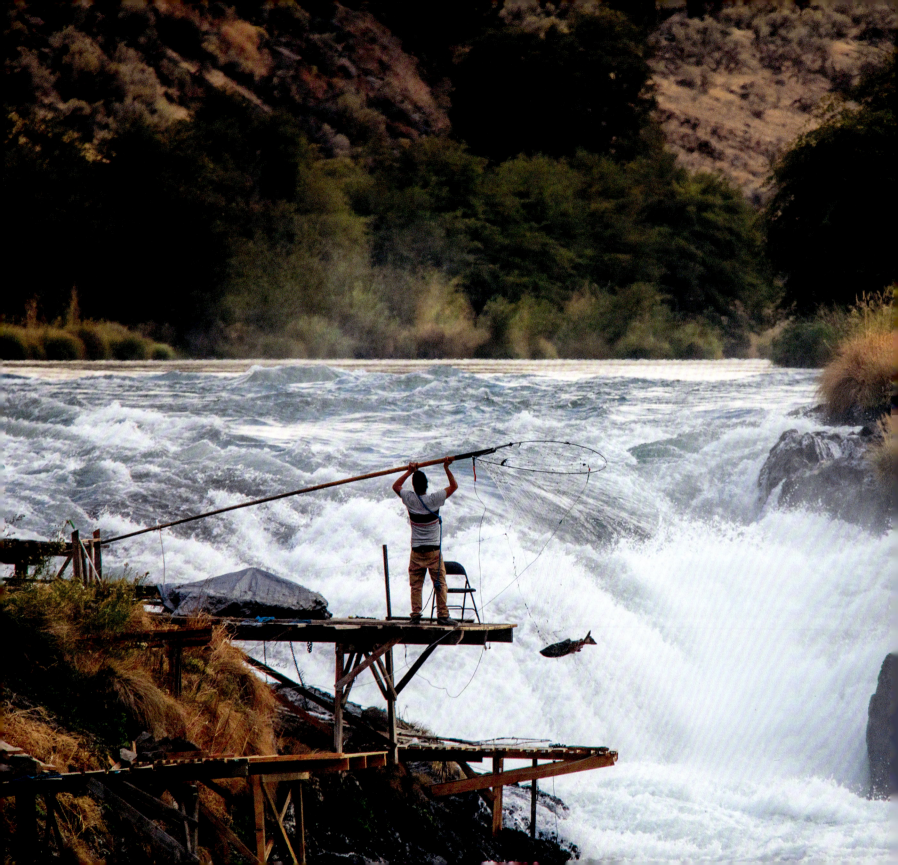

The publisher and contributors respectfully acknowledge our intent for this book to honor the lands, waters, and ways of Indigenous Peoples who have resided in and cared for this place since time immemorial. We recognize and honor their rights, and we are grateful for both their ancestral and current stewardship of the Big River.

A member of the Confederated Tribes of the Warm Springs dip-netting for salmon on the Deschutes River in Oregon

PAGE 1 Sunset over the Hanford Reach of the Columbia River and Rattlesnake Mountain from the White Bluffs, Hanford Reach National Monument

PREVIOUS PAGE Sockeye salmon in the Cle Elum River, Washington Cascades

Grizzly bear along a tributary of the Kootenay River

NEXT PAGE A herd of elk crosses the Gros Ventre River, a tributary of the Snake River in Wyoming, in early spring.

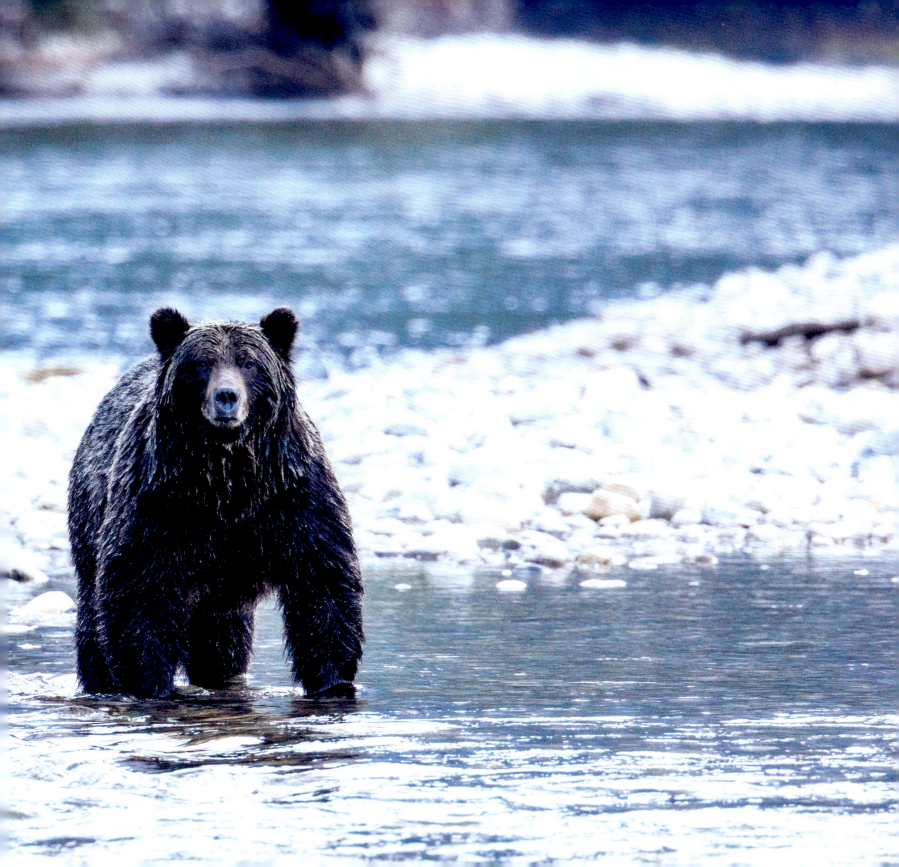

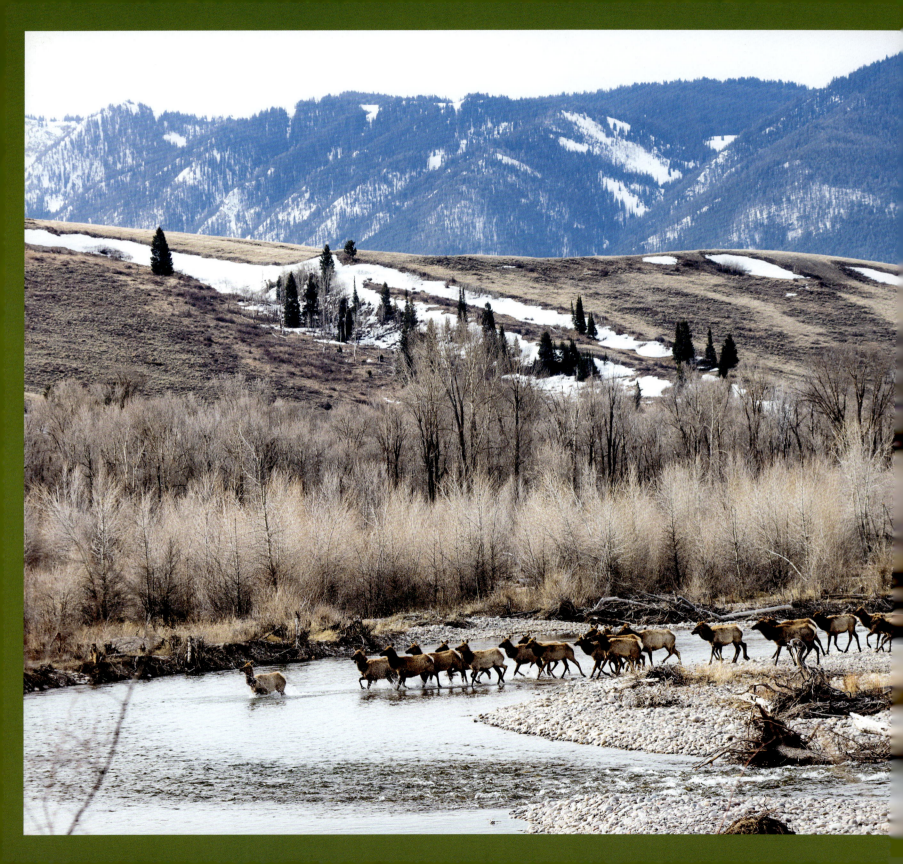

CONTENTS

Map of Columbia River Watershed 10
Language and Landscape Eileen Delehanty Pearkes 11
Map of Columbia River Tribal Language Groups 12

Introduction: Bringing the Big River into Focus 15
David Moskowitz

The Grace of Water 33
Eileen Delehanty Pearkes

Origins 37 / The Rooted Ones 44 / The Wandering Ones 48 /
Flood and Flow 52 / The 1964 Columbia River Treaty 59 /
Livelihood 60 / Reciprocity 73 / Toward a Confluence of Values 83

A Photographer's Journey Through the Big River Basin 86
David Moskowitz

Columbia River Headwaters 88 / Columbia River Plateau 110 /
Snake River 144 / Lower Columbia River Basin 178

One River, A Thousand Voices Claudia Castro Luna 213
Acknowledgments 215
A Note about the Photography 217
Notes 218
Resources 219
Learn More and Get Involved 220
In Appreciation 221

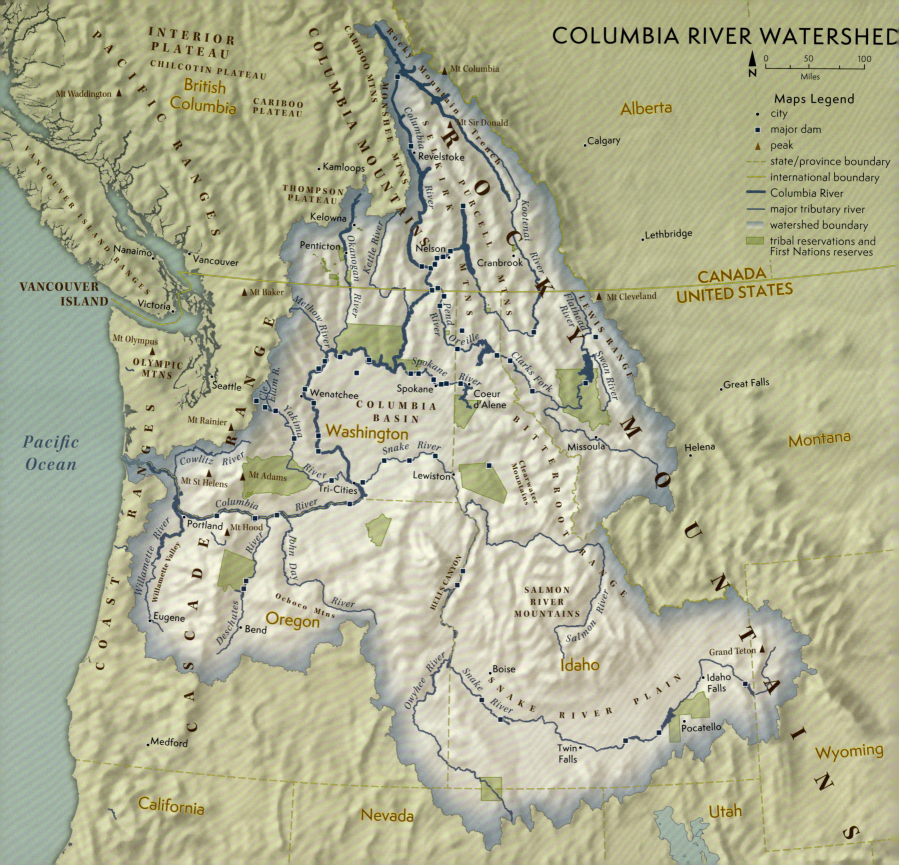

LANGUAGE AND LANDSCAPE

Eileen Delehanty Pearkes

The Indigenous Columbia River Basin, in all its startling geographic variety, expresses a polychrome of language and cultural identities. The broad language groups identified here are Chinookan/Chinook Wawa, Interior Salish, Kalupuyan/Molala, Ktunaxa/Kutenai, Sahaptian/Ichishkín, and Shoshone/Uto-Aztecan.

Within these broad and inclusive categories exist multiple dialects and distinct cultures, whose vitality and sense of self have been shaped by landscape, resources, kin-consciousness, and, more recently, by colonial structures.

After European contact, the United States and Canadian governments drew lines and asserted their will on tribes, determining who would be called what, where they would live, and even who would exist as "recognized" people. Colonial governments often banished tribal people to places that were not familiar to them or requested them to form confederations with people who spoke different languages. Over the past two centuries, some tribes have lost official status or struggled to regain it. Some still have no official recognition or rights. The international boundary continues to present challenges.

All are equal here. Language and identity weave in and out of each other as the tribal world strives to balance unity with diversity. Salmon and water provide constancy across a dynamic, Indigenous basin.

With respect and admiration:

Chinookan/Chinook Wawa
- Chinook Indian Nation
- Confederated Tribes of the Grand Ronde: Wasco
- Confederated Tribes of Warm Springs: Wasco (Dalles and Dog River Bands)
- Wishram

Kalupuyan/Molala
- Confederated Tribes of the Grand Ronde: Attalfi, Chafan, Chelamela, Chemapho, Chepenefa, Klalu, Mohawk (distinct from Eastern Mohawk peoples), Luckiamute, Santiam, Tsankupi, Umpqua, Winefelly, Yamhill

Shoshone/Uto-Aztecan
- Confederated Tribes of Warm Springs: Burns Paiute, Northern Paiute
- Shoshone-Bannock Tribes
- Shoshone-Paiute Tribes of the Duck Valley Reservation

Sahaptian/Ichishkín
- Cayuse
- Colville Confederated Tribes: Chief Joseph Band of the Nimiipuu (Nez Perce), Palus
- Confederated Tribes and Bands of the Yakama Nation: Kah-milt-pah, Kinquit, Klickitat, Kow-was-say-ee, Li-ay-was, Oche-chotes, Palouse, Se-ap-cat, Syiks, Skinpa, Yakama
- Confederated Tribes of the Umatilla Reservation: Umatilla, Walla Walla
- Confederated Tribes of Warm Springs: Dalles Tenino, Dock-Spu, Tygh, Wyam
- Nimiipuu (Nez Perce Tribe)
- Wanapum

Interior Salish
- Colville Confederated Tribes: Chelan, Entiat, Methow, Moses-Columbia, Nespelem, Okanogan ("Okanagan" in Canada), San Poil, Skoyelpi (also known as Colville), Sinixt/Lakes (also in Canada), Wenatchi
- Confederated Salish and Kootenay Tribes of the Flathead Nation: Bitteroot Salish (Flathead), Upper Pend d'Oreille
- Confederated Tribes and Bands of the Yakama Nation: Pisquose, Wenatshapam
- Kalispel Tribe
- Okanagan Nation Alliance (Canada): Lower and Upper Smilkameen Indian Bands, Okanagan Indian Band, Osoyoos Indian Band, Penticton Indian Band, Westbank First Nation
- Schitsu'umsh (also known as Coeur d'Alene Tribe)
- Secwepemc (also known as Shuswap; Canada)
- Spokane Tribe

Ktunaxa/Kutenai
- Confederated Salish and Kootenai Tribes of the Flathead Nation: Kootenai
- Kootenay Tribe of Idaho
- Ktunaxa Nation (Canada): Akisqnuk, Aqam (St. Mary's Band), Tobacco Plains Indian Band, Yaqan Nukiy (Lower Kootenay Indian Band)

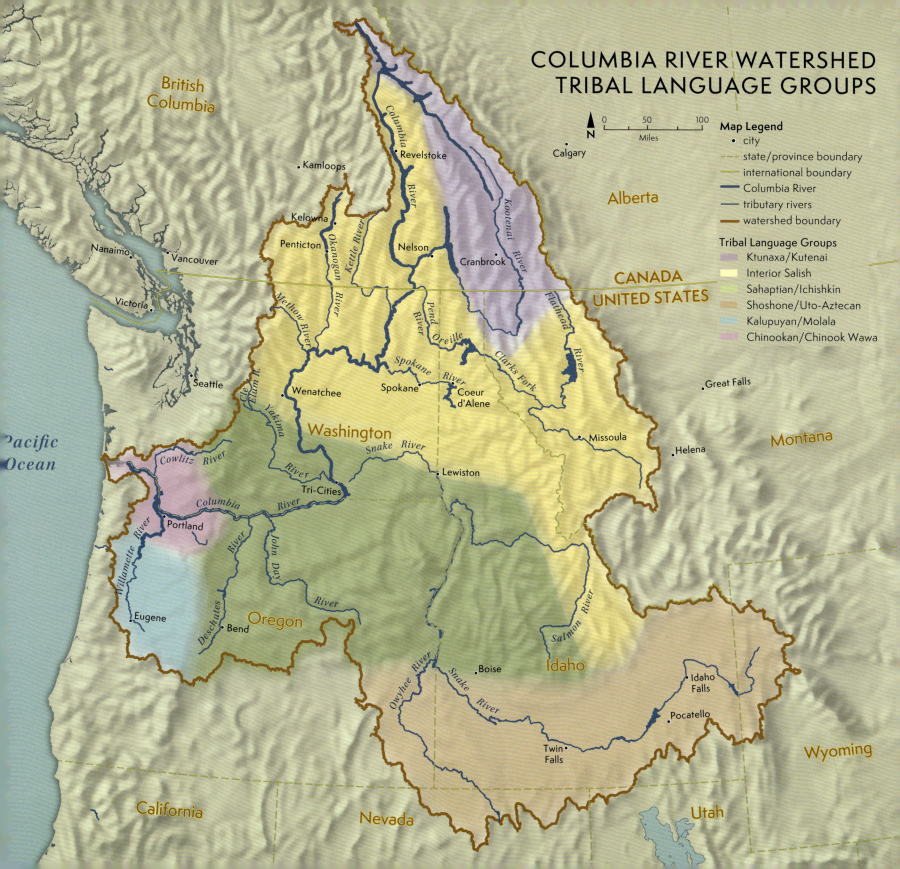

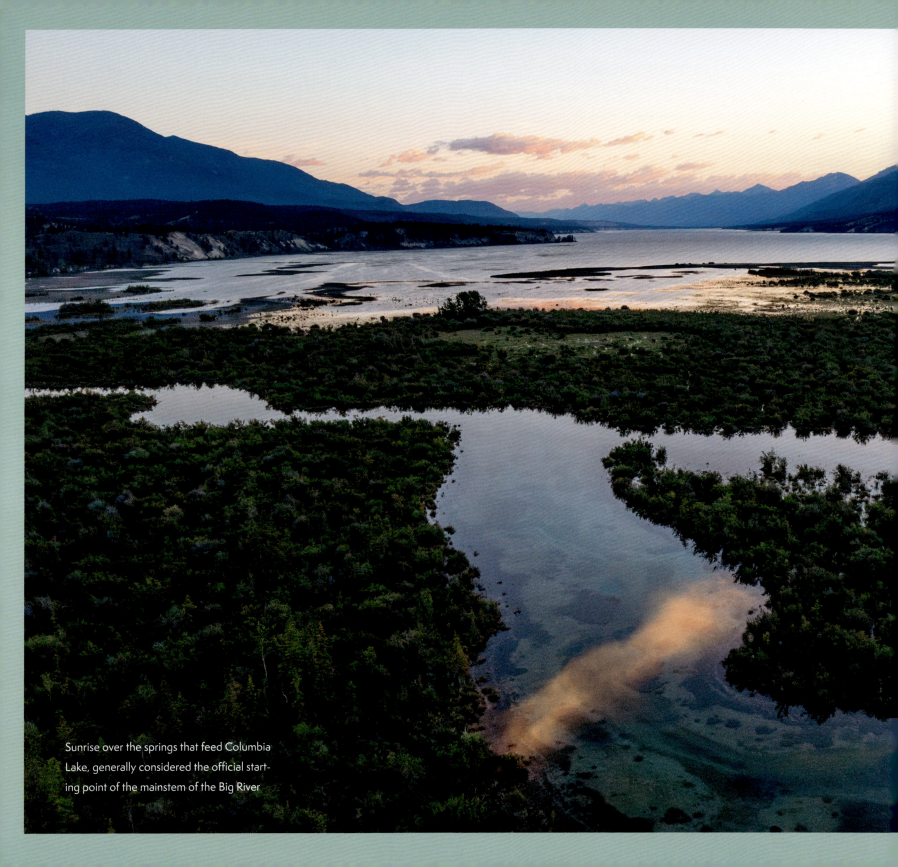

Sunrise over the springs that feed Columbia Lake, generally considered the official starting point of the mainstem of the Big River.

INTRODUCTION
BRINGING THE BIG RIVER INTO FOCUS

David Moskowitz

Day and night, the Big River—also known as the Columbia River—shoots an enormous volume of water out of the west coast of the North American continent, a freshwater arrow running headlong into the swelling Pacific Ocean. There, it is swept up and carried back inland to begin again as rain and snow, setting the stage on which the plants, wildlife, and humans build their lives in this watershed. Where precisely does the story of this magical river begin?

In reality, the start of any river, especially one as sprawling and complex as the Big River, can be defined in numerous ways. Wherever moisture falls upon the land is a starting point, each with its own unique contribution to one of the most ecologically diverse regions of North America. No matter where you begin, it's an awesome journey. The river touches the lives of millions of people, both within and far beyond the boundaries of the watershed, sometimes in ways we know and love and at other times are completely oblivious to.

This vast richness and diversity has defined my own journey to explore and document the watershed. Over the course of capturing photographs for this book, I have found myself taking pictures of desert wildlife one day, dam operators navigating huge barges down the Snake River the next, and people fishing for salmon on a rainforest-shrouded tributary the next. Two days after eating lunch on the banks of a river that begins in the arid mountains of central Idaho, I was trekking across ancient ice atop some of the highest peaks of Canada. Driven by logistics, my schedule for this project was exhausting at times but in retrospect also reflected perfectly the task at hand—how to create, in a collection of images, a snapshot of a place of infinite complexity at a finite and singular moment in time.

The idea of a river may conjure an image of a fairly predictable linear flow of water down an existing course. A river's watershed, however, is another thing entirely. It encompasses myriad hydrological, ecological, geological, and cultural processes, activities, and characters, all going about their business simultaneously in frenetic spasms of interaction. The ecological, cultural, and economic value of the Big River's watershed is immense. The wrangling over who benefits from, controls, or gets access to this value has been going on for centuries. In our generation, however, we are reaching a new inflection point as the dominant settler-colonial culture comes to terms with the existing unsustainable nature of their relationship with the watershed while Indigenous nations rebound and renew their efforts to steward their territories.

Over time, this river has been graced with many names. Indeed, given that dozens of Indigenous languages and dialects are spoken within the boundaries of the river's watershed, this should not be surprising. Many of the Indigenous names for parts of the river reflect the character of a specific section of the river included within the territory of a particular group. The Sinixt speak *nslxcin*, or "people's speech," an Interior Salish language of several distinct tribes who traditionally inhabited the Columbia, Okanagan, SanPoil, Pend d'Oreille, and Methow River basins. They refer to an important place on the river where they gathered to fish as *Sx̌ʷnitkʷ*, which translates to "roaring or noisy waters," a place known colonially as Kettle Falls. Probably the most ubiquitous name used by Indigenous people in reference to the entire river translates to "Big River." Interacting with Indigenous people fishing along the river today, you often hear the river referred to as either just "the River" or "the Big River." In my own quest to understand this river, it was the name "Big River" that captured the magnitude and importance of this river system and all contained within it.

One of the dozens of waterfalls on tributaries that flow out of the Oregon Cascades into the Big River in the Columbia Gorge

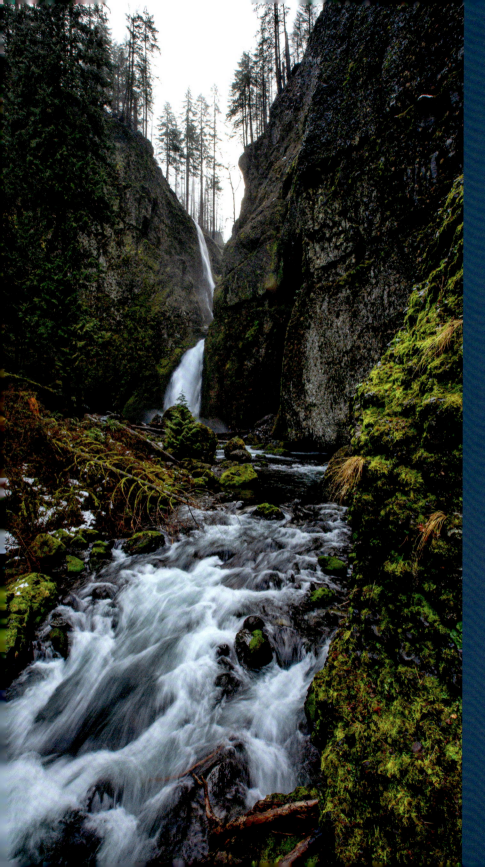

NAMING THE RIVER

Eileen Delehanty Pearkes

A hydrologist once explained to me that rivers always have two flow patterns: one on the surface—evident and visible—and another beneath the surface—less noticeable but no less important.

In 1792, American fur trader Robert Cook named the Columbia in honor of the ship that had carried him to the west coast of the continent: *Columbia Redivia*. Exploring 36 miles (58 kilometers) upstream, he claimed the water as "American," per maritime convention. Since then, the Columbia Basin has been shaped around names related to American and Canadian colonial adventure and the settlement period that followed.

What do the Indigenous people of the basin call this river? The answer defies easy categories or answers and often lies beneath the surface of how we understand the river.

For the Chinook people at the river's mouth, *Wimahl*, "big river." For the Yakama and Nez Perce people mid-watershed, *Nch'i-Wàna*, "big water." For the Sinixt and other Salish tribes in the upper watershed, *Sx̌ʷnitkʷ*, "water that makes noise." Another Salish word for a particular place on the river is "miraculous." This is where Chinook salmon could be speared easily from the shore in a back eddy.

Indigenous names for the river are numerous and rise out of cultures that have always been proximate to the water's own world.

INTRODUCTION / 17

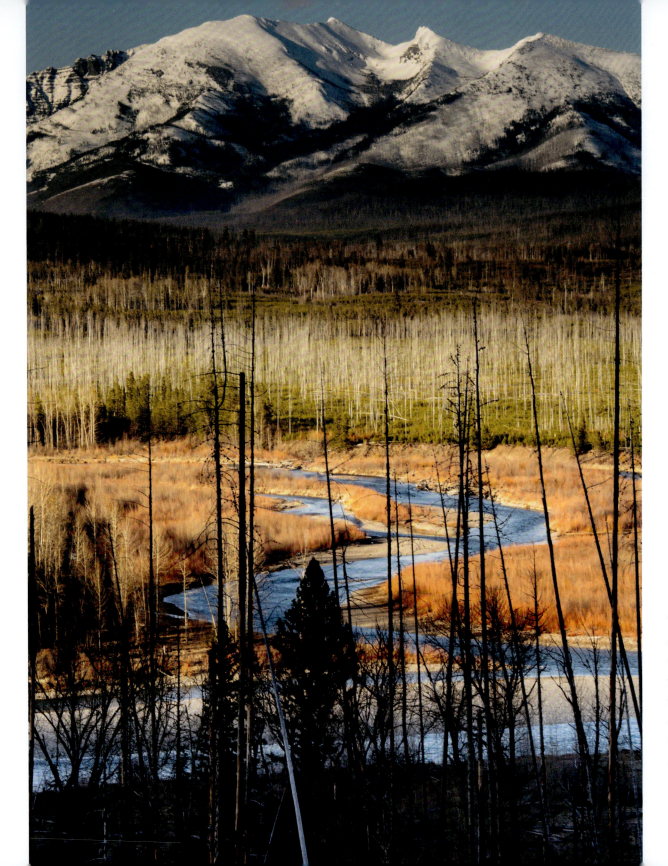

This photo, the earliest one I took of the Columbia River watershed to appear in this book, features the North Fork of the Flathead River flowing out of the Rocky Mountains in Montana.

The name "Columbia River" deserves some attention here as well, of course. That this is the only name the majority of non-Indigenous peoples in the watershed—and almost all peoples from beyond the watershed's boundaries—will recognize today speaks to a central theme of the river's contemporary cultural story. This is the overwhelming impacts of settler-colonialism on both the watershed directly and our cultural perspective on the river. As with all things "Columbia" in North America, this name for the river traces back eventually to Christopher Columbus. Unlike Indigenous names for the river, this name reflects nothing about the actual river system. It harkens back to a colonial society's founding myths—the doctrine of discovery and manifest destiny among them—as racist and destructive today as they have been for centuries. The continued persecution of ecological and cultural diversity across the watershed speaks to the power these stories continue to wield. Each time we say the name of this river, we choose which stories we feed and which we starve.

THE CHILD OF A FAMILY of scientists, I have both a natural curiosity about the world around me and an ingrained skepticism about things that are told to me as "fact" when I have no personal experience with a subject myself. As with numerous past photography projects, I started this one to see for myself what this river most people know as the Columbia is today. Who are the living beings that call this place home, and what does the river and the world look like from their vantage points? How does the past—defined alternately in geological, ethereal, or pragmatically historical ways—shape these perspectives? What does what we see today tell us about what the future holds? These were some of the questions I carried with me as I traversed the watershed capturing images. Perhaps some answers might come to light in the images that follow—as will, certainly, more questions.

Much of what has been published previously about this river focuses on what it used to be like or how the river system is managed like a factory. But what I found is one of the most ecologically rich and varied river systems on the planet—deserts to rainforest to alpine tundra; an agricultural breadbasket for the world; Indigenous communities that have persisted through generations of persecution and in many cases are in the process of resurgence. A similar story is true for salmon and other native wildlife in the region. This is not to minimize all that has been lost and is at risk. It's to recognize how much beauty and diversity exist in this system today, to recognize how much is still at stake.

Rivers are constantly changing, but like many natural systems around the globe, this river system is in the process of profound evolution once again—driven by human culture. The climate is changing, the human population and how we use the watershed are changing, plants and wildlife are adapting to new conditions or disappearing. We humans have decisions to make; treaties to honor, others to renegotiate; and relationships with each other and with the nonhuman world to tend to.

The first photo I made that appears in this book is from 2013. In the decade of photographing the watershed since then, beautiful and touching moments

of connection stand out—some captured in images, others only in my memory. Watching the light fade on the wild, rushing Snake River after a long day's descent to the bottom of Hells Canyon, the deepest canyon in North America. The smell of coho salmon roasting over an open fire—a gift from Yakama fisherman Ira Yallop, who caught it by dipnet on the Klickitat River—sharing it with friends on the banks of the Methow River.

The enormous complexity of creating a cohesive portrait of the watershed seemed overwhelming at times. My visit to the headwaters of the Owyhee River was one such moment. After driving until midnight on dirt roads in northern Nevada toward a spot I had marked on the map, I crawled into the back of my truck to sleep for a few hours as a gentle snow began to fall. I woke up in the morning, taking in the vast silent and still landscape, a sea of sagebrush and barren desert mountains. How could this place be connected to rainforests and ice fields hundreds of miles away? And how could I stitch them together in one set of images? A similar sense of complexity struck me as I set camera traps for wolverines—an animal that requires deep winter snow to survive—in 6 feet (1.8 meters) of snow at tree line in the North Cascades and realized I was less than 50 miles (80 kilometers) from the desert where I had set camera traps for kangaroo rats, a species so well adapted to life without water that it never needs to drink.

As a wildlife biologist and tracker, capturing images of the many other animals that live in the watershed is of keen interest. Tracking down rare and elusive wildlife starts with trying to understand

20 / BIG RIVER

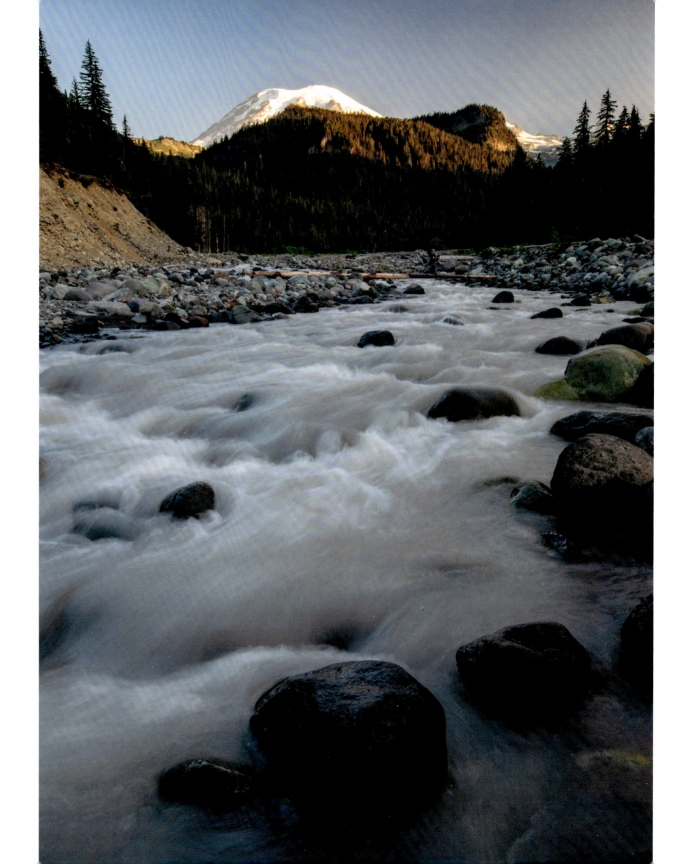

OPPOSITE Snow and glacial ice on the Columbia Icefield, Canadian Rockies

The Muddy Fork of the Cowlitz River carries glacier sediments off the ice-covered summit of Tahoma, Mount Rainier National Park, Washington.

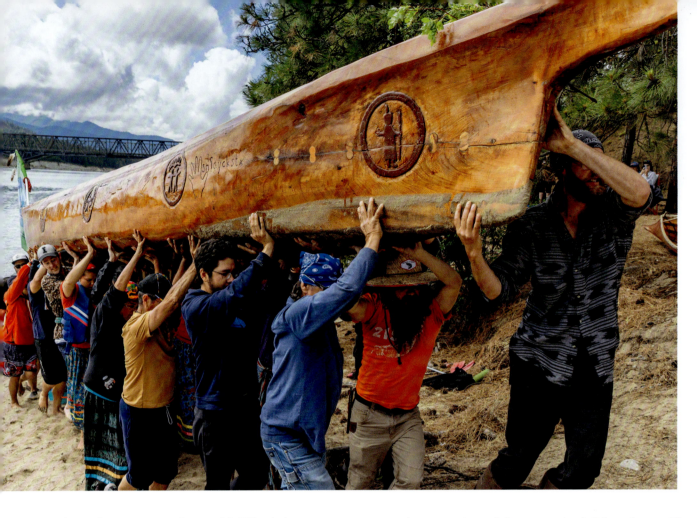

Out of respect, canoes are lifted and carried on shore rather than dragged. The Sinixt people are bringing this canoe ashore for a salmon-honoring ceremony at Sx̌ʷnitkʷ, which translates to "noisy fast water," a reference to the rapids here before the river was flooded by the construction of the Grand Coulee Dam. Carved into the canoe are representations of ancient rock art from various places in Sinixt traditional territory.

how they perceive the world. What's important to them? What makes them feel safe, and what scares them? What do they see as their "home"? I work hard to translate what I learn from my observations of them and the traces they leave behind on the landscape into the photos I make. In the same way, I work with humans from across the watershed and try to translate each one's perspective on the river into the portraits I create.

Creating immersive images requires me to become deeply engaged in the subject matter. To really understand and photograph the deep snowpack of the northern portion of the watershed, I found myself trekking across the Columbia Icefield in absolutely awful conditions, postholing up to my knees for miles in a whiteout across a rolling and endless sea of snow best described as "shmoo." Reaching the headwaters of the Snake River required a 63-mile (101-kilometer) round-trip continuous push along the southern boundary of Yellowstone National Park. My running partner, Anna Machowicz, and I weathered a massive lightning storm that soaked us to the bone as we stumbled out at twilight into the wet meadow at the river's source, shivering but elated to look upon a

landscape where many important stories begin. My time out with commercial gillnet fishermen Bryce Devine and Russ Ipock on Bryce's boat was another overnight marathon. This one I ultimately lost, falling asleep in the back of the boat around 2:00 a.m. while they continued to fish until dawn. The wolverine image featured in this book came out of four years of winter fieldwork on backcountry skis in the North Cascades with the Cascades Wolverine Project documenting the slowly recovering wolverine population in this part of the Big River's watershed.

Along this journey, I met Eileen Delehanty Pearkes, whose voice and perspective I first encountered in her book *A River Captured*. We eventually met in person, fittingly on the banks of the Big River at Kettle Falls, where tribes from the upper basin gather for an annual ceremony hosted by the Sinixt and Skoyelpi people and attended by many tribes in the region. Eileen's lyrical words in this book add vital depth, insight, and perspective built on a lifetime of research and personal experience with the people, landscape, and waters of the upper basin, in particular regarding the need for ecological healing and restoration in the wake of intensive hydropower development on both sides of the international boundary.

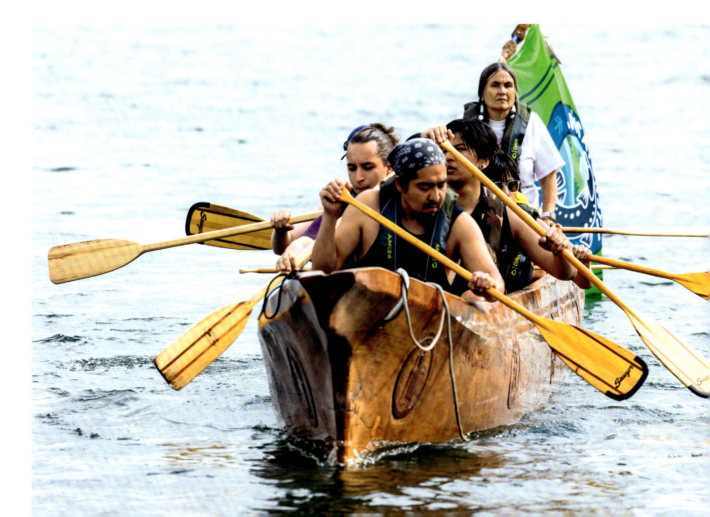

Steering from the stern of Sn̓k̓lip̓qn̓ (Coyote Head), the dugout canoe of the Sinixt people, cultural leader Shelly Boyd guides a journey on Upper Arrow Lake through her people's traditional territory.

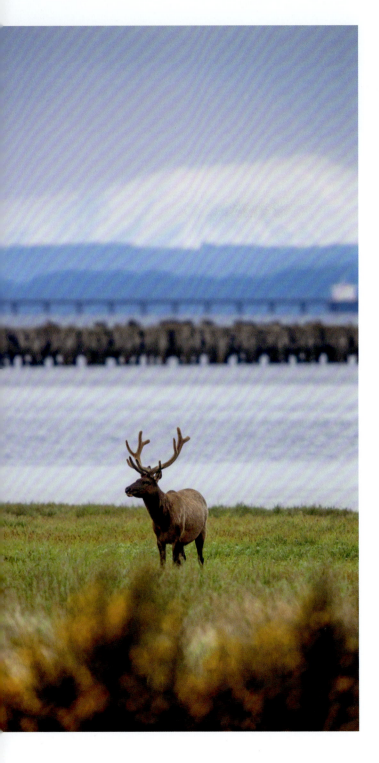

LOOKING OUT OVER THE SLACK water behind the Bonneville Dam, environmental and social justice activist Ubaldo Hernandez shared his first memories of rivers. He described how the rivers that ran into Mexico City were used as sewers, recalling how terrible it smelled when he was a child. Juxtaposing that vision with his life today on the Big River, he explains that "being able to run along this river, which is clean, makes a big difference."

Ubaldo's words drew me back to my own first memories of a river—the Hudson (another major North American river pinned with the name of a colonial explorer), just upstream from New York City. Adults warned us to stay out of the polluted water. For my two best friends, both named Mike, and me, such an admonishment only fueled the fire of our curiosity. Our wilderness was where the storm drains emptied into the river. Our wildlife encounters were with rats, and when we came home from tromping along the huge river's edge, we stank of sewage. My own journey to the Big River watershed has been long and varied, a bit like snow that falls high in the Canadian Rockies and then undergoes years of metamorphosis to turn into glacier ice. Then after decades of sliding slowly down the mountainside to the glacier's ablation zone, it is transformed once again—melting to join the flow of the river.

Three decades after arriving at this watershed, I look back on the many beginnings of my own relationship with this place. One of the earliest was my first perfectly ripe peach picked from a tree on a friend's orchard in the Yakima Valley and the feel of warm juice running down my fingers and chin. At 19, I was

A male Roosevelt elk near the mouth of the Big River with Loowit (Mount St. Helens) in the background

24 / BIG RIVER

UBALDO HERNANDEZ

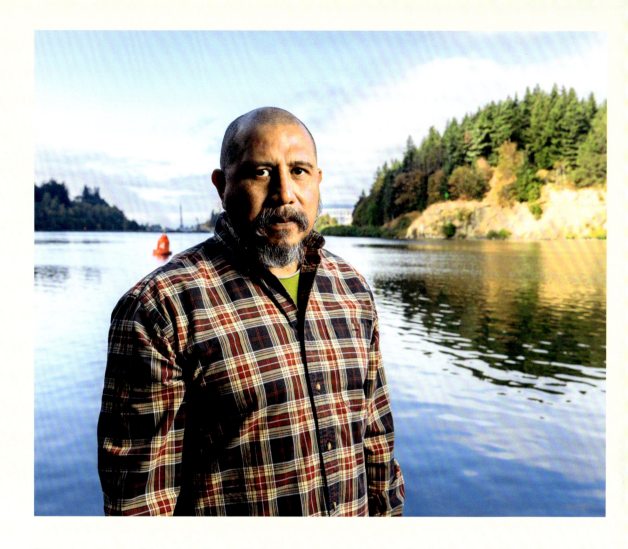

A resident of the Gorge since the mid-1990s, Ubaldo Hernandez is a community organizer for Columbia Riverkeeper and director of Communidades. Behind him are Bonneville Dam and Bradford Island, which was recently listed as a Superfund site, after persistent petitioning by conservation groups. The area became polluted from years of dumping by the federal government.

"Coming from a big city where all the rivers were dead or highly contaminated and playing in those rivers—and then coming here to the Gorge where the river is so accessible for drinking water and playing—it inspires me to fight to keep this river clean.

"Mexico City was built on a lake—the rivers that ran into it—they were turned into sewers. When I was a kid, it stank. Now being able to run along this river, which is clean, makes a big difference. I tried windsurfing, rafting, kayaking, fishing, all sorts of things in the water. I love to be on the river.... So many communities depend on the river. There are so many threats to those communities from corporate interests, etc."

INTRODUCTION / 25

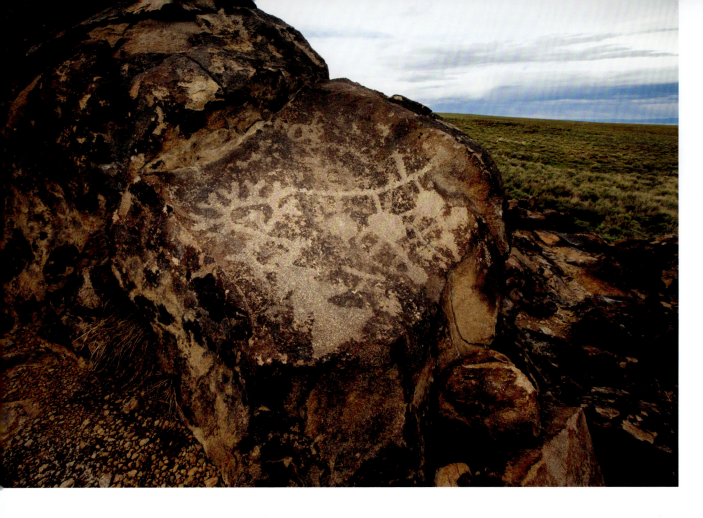

adrift in life after dropping out of school several years earlier. The people and landscape of this watershed nourished me and, in many ways, shaped the contours of the life that has followed.

I have seen again and again how many ways this river feeds us both physically and metaphorically. Wherever I went in the fall when the salmon were running, I found people, sometimes hundreds of them, fishing from the banks of the river or its tributaries. Far upstream, I watched a grizzly bear nicknamed Snorkel swimming head down, scanning a tributary of the Kootenay River for kokanee salmon. I watched my climbing partner Jeff Rose, in an almost religious act, lying on the glacial ice of the Columbia Icefield, sipping meltwater flowing over the glacier.

The inequity of access to this river's wealth is also plain to see. On my way to photograph people recreating in the parks along the waterfront in Portland, Oregon, I passed homeless folks sleeping in doorways of buildings along the Willamette River. While new mansions are built on the banks of the Big River, and hydropower produced by dams is sold to places hundreds of miles beyond the watershed's boundaries, some Indigenous peoples I met have turned a tiny

Ancient petroglyphs, such as these in the Owyhee River watershed in the traditional territory of the Northern Paiute and the Cayuse, Umatilla, and Walla Walla, speak to the long history of occupation of the watershed by Indigenous peoples.

26 / BIG RIVER

parcel of land next to the river with no running water or septic system—land set aside by the federal government for fishing access for them—into a permanent village of sorts out of old trailers and RVs. One resident, Lewis George, told me, "Our elders told us that the reason we live here right by the river is to take care of her. We have to stay here by the river to protect her. Someone always has to be here—right by the river." Despite the hardships and deprivations, living adjacent to affluence and power, they persist.

Looking back, the time and effort I put in to dig deep into this watershed brought me great joy, but I am also profoundly humbled by the task of sharing a story whose parts are known so much more intimately by so many others. One couple I met, Mark and Julie Mackenzie, from a ranching family in the Snake River watershed, are the fourth generation of their families on the land. The family of environmental activist and lawyer Brenna Bell, who I photographed for this story, goes back six generations, having come to the watershed on the Oregon Trail. Mark Miller, a descendant of the Methow tribe and a resident of the Methow River watershed—where I, too, reside—talks about 400 generations of his family in the watershed. Most Indigenous communities I interacted with say they have been here since "time immemorial." By comparison, I am the third generation of my family born on this continent. My twenty-seven years in the watershed to date, let alone the three years I have worked on this project in earnest, feel quite modest. But it's also a reminder that the story of this watershed is enriched by the diversity of lives within it—like the

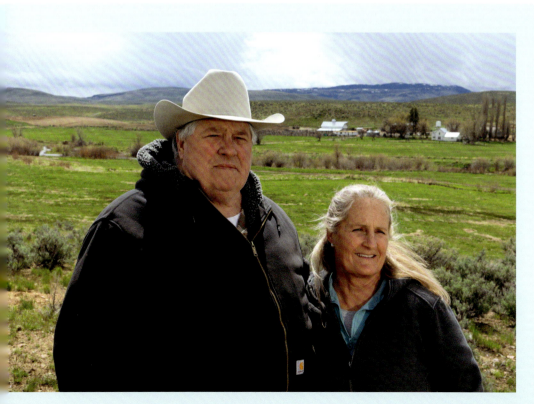

MARK AND JULIE MACKENZIE

"We own it in the English version, but Mother Nature says we are just caretakers. *We are just caretakers.* We must do our best to maintain and enhance what little water we have here in the desert."

Mark and Julie Mackenzie own a family cattle ranch on Succor Creek, a tributary of the Snake River.

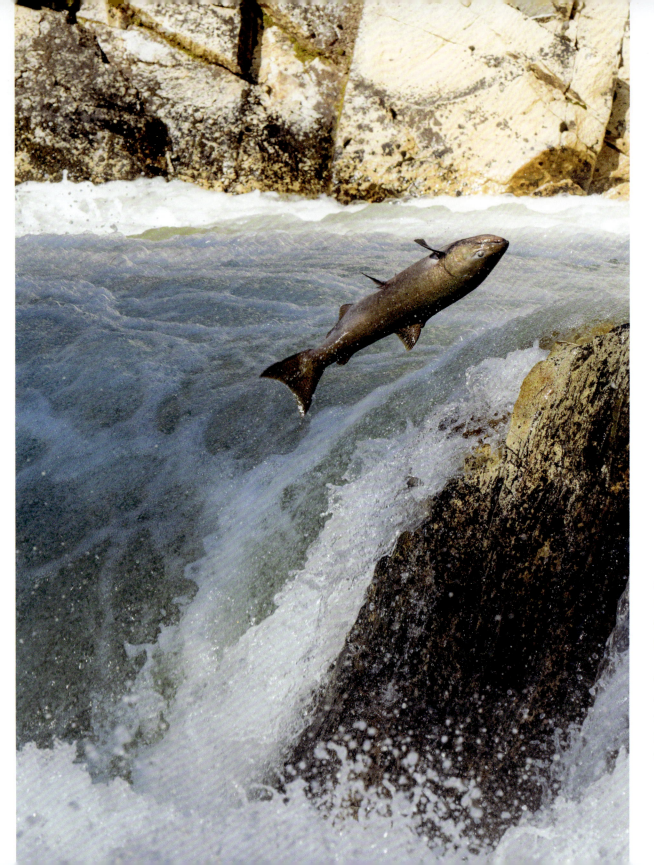

A Chinook salmon flings itself up Dagger Falls on the Middle Fork Salmon River, Idaho.

OPPOSITE Chum salmon spawn along the mainstem of the Big River upstream from Vancouver, Washington.

infinite drops of moisture that comprise the Big River, some of which fell thousands of years ago and are slowly making their way through glacial ice, while others are falling from the clouds as I write. All perspectives are part of this story.

Sitting on the banks of the Salmon River on a recent sunny July day, I listened to the roar of Dagger Falls on the edge of the largest remaining road-free landscape in the contiguous United States, over 700 river miles (about 1,100 kilometers) from the ocean. I was waiting for Chinook salmon to jump up the waterfalls. Day one yielded nothing. Where uncountable masses of salmon used to jump these falls, their numbers have dwindled, and now this run is threatened with extinction. Everywhere in the watershed, there used to be *more*—more salmon, more bears, more old-growth forests, bigger glaciers, more languages spoken. But on the second day, fish begin to arrive and leap as they have since the ice released these mountains at the end of the last ice age. Is what we're witnessing across the watershed a farewell on our journey toward annihilation or a moment of resurgence? You can interpret the signs either way, but momentum is not with us.

Although much has been taken from this watershed, much remains. For many other documentarians, telling the story of the Columbia River is a cataloging of what has been lost to

colonization and industrialization across the watershed. In this telling, the river is shrouded in a recent past with a shadow so deep and dark that much of the beauty that exists today is lost in it. Perhaps because of my own relatively short connection to the river, this is not the story I saw initially or chose to tell here. Rather, this is the story of a river, alive and well, although struggling, as many of us are today.

This river's many pasts are written into the folds of the landscape like the creases in the weathered face of an elder who has seen much. It is the face in its wholeness, that I celebrate in images of beautiful places, both untrammeled and deeply scarred by us humans. It's the resilience of salmon, bighorn sheep, wolverines,

and people—nations that have persisted through millennia of change, often in the face of transformative forces and unbelievable hardships, ranging from lava flows to unfettered capitalism. Here, in this place on Earth, infusing every aspect of life, the Big River continues to flow, connecting disparate stories through summer thunderstorms and winter snowfalls, underground aquifers, and the magic and power of water seeking its way across our blue planet. These images are my attempt to share some of this magic with you.

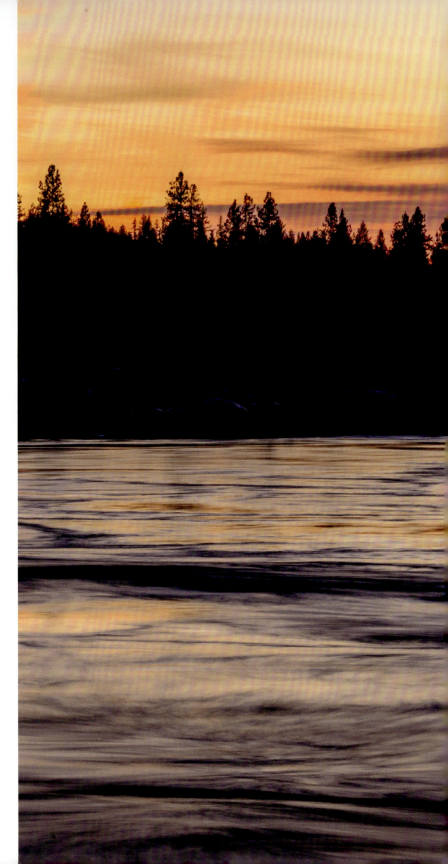

Sunset over the flowing water of the Big River near the international boundary. This free-flowing section is part of a 30-mile stretch from the Hugh Keenleyside Dam tailrace to the international boundary, where the river meets slack water from Lake Roosevelt Reservoir behind Grand Coulee Dam.

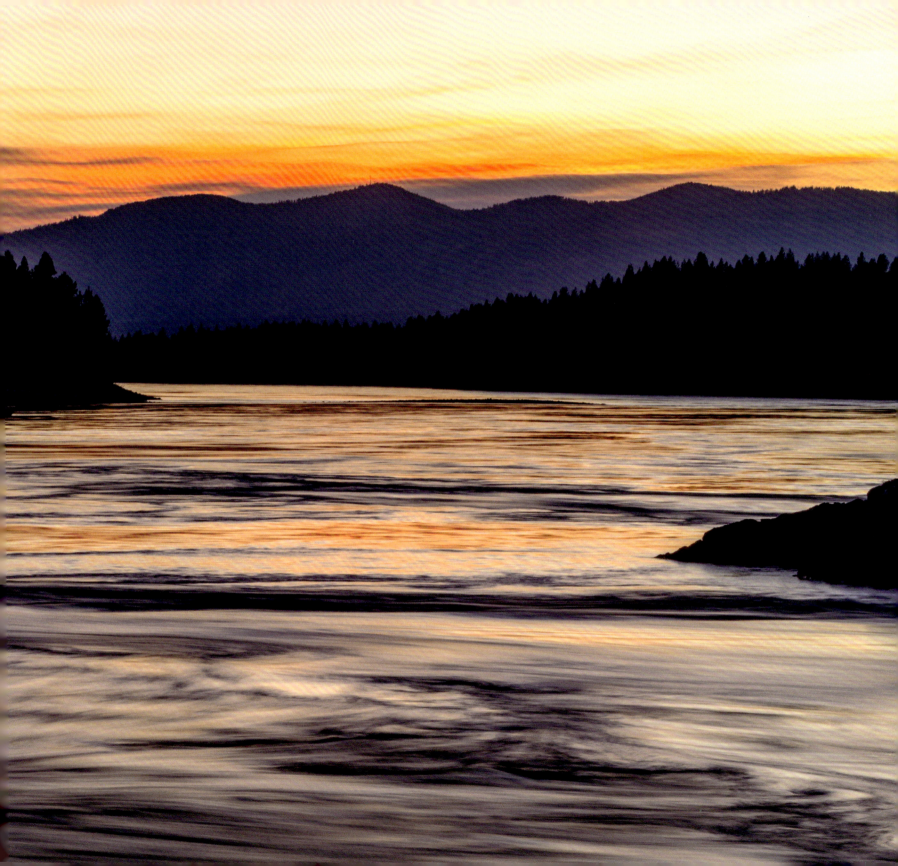

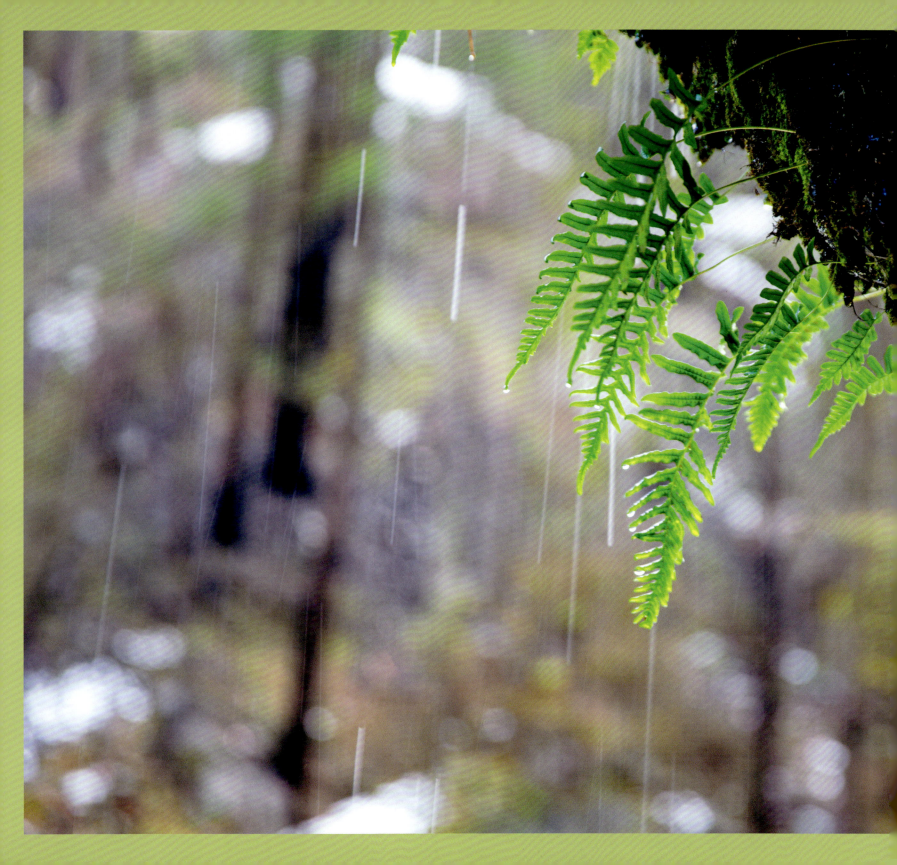

Licorice ferns cling to an overhanging cliff during a rainstorm in the Columbia River Gorge.

THE GRACE OF WATER

Eileen Delehanty Pearkes

Rivers rush and pool, flow and swirl, move and travel. Constantly on the move, they are agents of change.

The Columbia River, fourth-largest waterway by volume in North America, nests within an earthen basin of 260,000 square miles (nearly 420,000 square kilometers), spreading across an area the size of France. This watershed hosts three major tributary rivers, those that contribute the bulk of spring snowmelt and water volume to the Columbia—the Snake, Kootenai, and Pend Oreille (spelled Pend d'Oreille in Canada)—and a fourth, the Willamette, whose primary contributions are from winter rains that historically accumulated in an intricately braided, ecologically rich floodplain close to the mainstem channel. The watershed also hosts many less voluminous tributaries, including the Clearwater, Deschutes, Flathead, Incomappleux, Okanogan (spelled Okanagan in Canada), Salmon, Slocan, Spokane, Walla Walla, and Yakima. Together, the tributaries large and small all join the Columbia as they drain snowmelt from

the rocky spine of the continent into the Pacific Ocean. Three of the basin's largest—the Columbia, Kootenai, and Pend Oreille—cross the international boundary between the United States and Canada, braiding together the two countries, seeking a common purpose. That ruler-straight border—and the 14 dams on the Columbia's mainstem—all serve to cleave water's fluid ability to transform itself and adapt freely to a landscape of remarkable variety.

Once upon a time, only natural geography formed any constraint to this water. Rivers flowed noisily and industriously, but also graciously and generously, as the basin drained into the sea. Indigenous peoples shaped their lives around the recurring salmon resources, seasonally tracing worn paths up into the mountains to hunt or to visit expansive root-digging fields and drier plains where grazing animals gathered in the shadow of both active volcanoes and ancient ones, stilled and worn down by time. In the bodies of all the rivers that pulsed large and small across the basin, many other aquatic species once thrived: lamprey, sturgeon, bull trout, rainbow trout, and pikeminnow, to name a few.

Today, the city of Portland, Oregon, prospers on a historic floodplain protected by tightly controlled spring flows; Lewiston, Idaho, boasts status as the largest human-constructed inland port on the continent; and Spokane, Washington, sits beside falls absent of salmon yet still expressive of beauty and whitewater power. Far in the northern and eastern part of the watershed, the population of people thins out, even as the number of snowflakes and trees increases exponentially. Rural communities—Libby, Montana; Coeur d'Alene, Idaho; Colville, Washington; Castlegar, Nelson, and Revelstoke, British Columbia—nestle into scenic, forested valleys. The latter small Canadian cities sit beside nascent rivers; brimming, deeply blue lakes; and multiple storage reservoirs.

Abundance takes many forms in this basin and echoes what has long been true—water fosters life in manifold and even unimaginable ways. I have long marveled at the way in which the shape of the land quietly unites and embraces two countries across such diverse ecosystems: the fuzz of moss and dense rainforest trees through the Columbia Gorge; the more arid landscape of scattered pines near The Dalles; a low sagebrush forest carpeting the hills around John Day Dam; and finally, those steep, crowded mountains in British Columbia, Canada, the northerly womb of a great river that derives so much of its power from snowmelt. In the end, variety demonstrates that the work of the river and its landscape can defy differences and modern borders. The water's task is at once enduring, uncomplicated, and unifying: to empty the land of its annual burden of snow and rain by swelling up like the belly of a whale each spring and summer, offering terrestrial nutrients to the great expanse of salt sea where fish swim free. And then, to invite marine nutrients to return, carried on the backs of the salmon, in a great exchange that provides an example for us all. One could say that wherever any being lives in the great Columbia Basin—whether human, four-legged, winged, or swimmer—our lives here tilt toward the ocean, that great mother to us all.

If diversity rather than divisiveness can govern the future of this great river basin, a healthier watershed

A bald eagle follows the path of a tributary of the Kootenay River in British Columbia on a misty fall day.

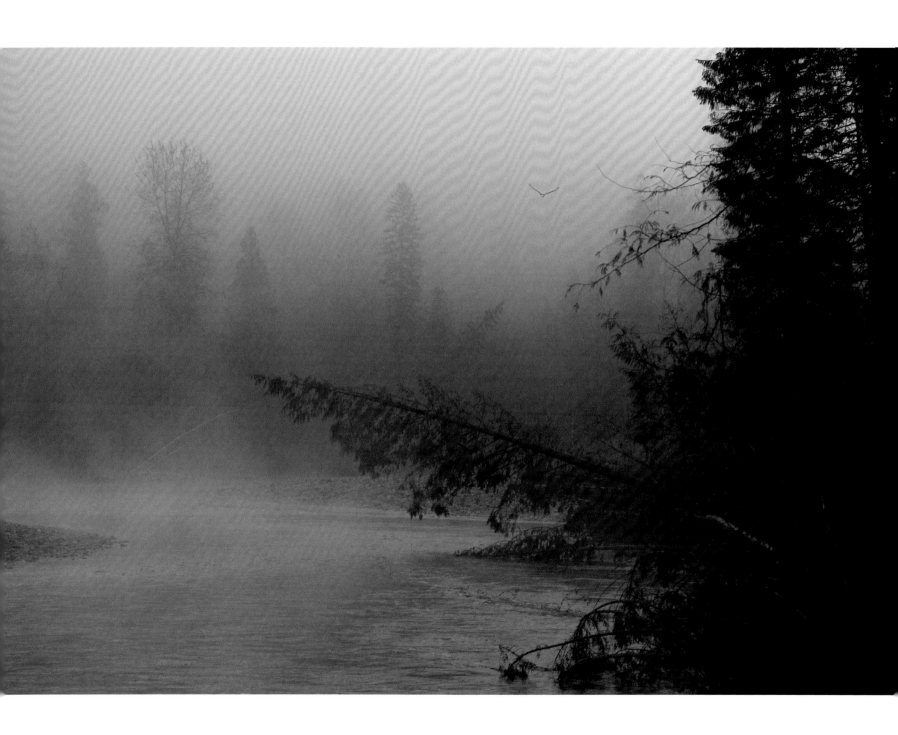

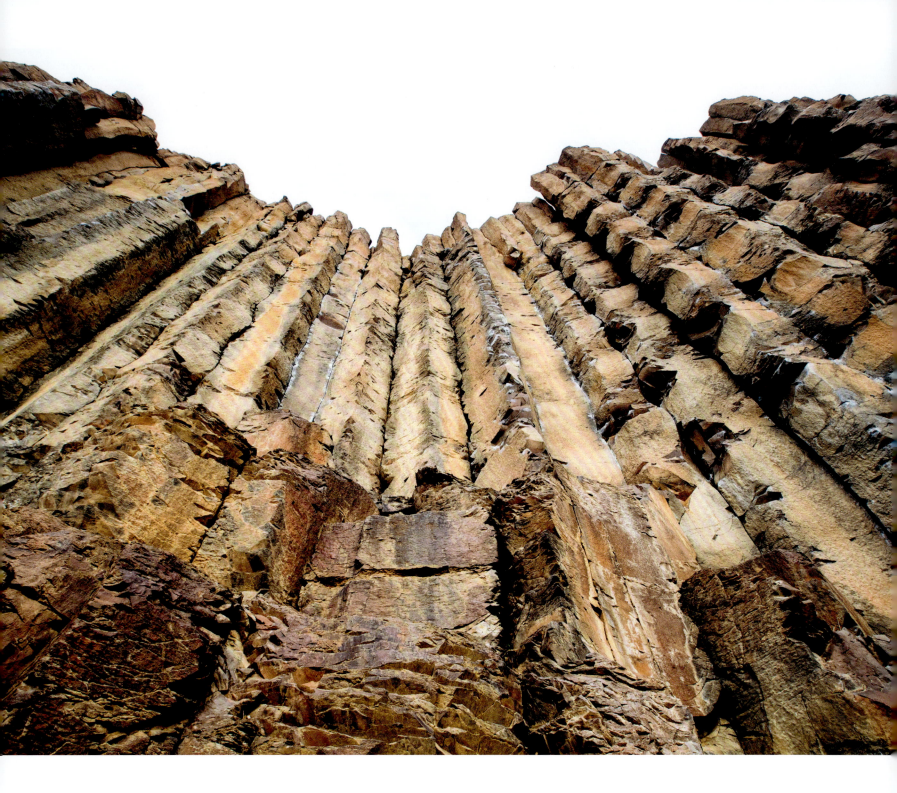

could emerge: more fluid, more gracious, and more alive with possibility than anything we have yet seen in our lifetimes. It's an enticing possibility, one as old as time, one that keeps me thinking and writing about the magic of water.

It's important to know what the river has been, so that we can be part of what it may become.

ORIGINS

When traced on a map, the quirky, uneven boundary of this watershed expresses a diversity that cradles the fourth-largest river basin by volume in North America. "Basin" comes from the French word *bassin*—a vessel or a bowl. The flow of snowmelt tumbles down from all points of the watershed's sometimes smooth, sometimes jagged rim, draining into the Columbia's mainstem, into the base of the bowl. Water gathers its amplitude in high mountain streams and creeks, then flows into minor rivers, and from there into major tributaries, and, finally, into the Columbia itself. The volume of water grows until it reaches the limits of its own grandeur and empties into the Pacific Ocean.

A landscape hosting such hydrological power and effusive generosity of purpose could only emerge out of creative chaos, drama, and cataclysm. The Columbia Basin's complex geography formed from great seismic rending, molten sheets of rock, and thick, obtrusive glaciers. Eruption, magma, fire, and then ice—turmoil leading to the eccentric nature of this landscape that hosts so much water.

While the North American continent had been constantly evolving since the days of one global continent, Pangea, the basin really took shape between 20 and 50 million years ago, when continental tectonic shifts compressed and thrust upward the Rocky Mountains. This spine marks the east and north rim of the Columbia's great bowl, tilting ever so slightly west toward the sea. On the west side, the Cascade Range holds the Columbia back from tumbling freely into the Pacific. To the north, a dense array of peaks known as the Columbia Mountains feeds the river's headwaters as it gains power, passing through that northerly region's unique inland rainforest. Near its mouth, the river threads west through the Cascade mountains and Coast Range, receiving water from the surrounding peaks before arriving at the Pacific.

In the wake of upstart mountain ranges came a period known as the Mid-Miocene Climatic Optimum. Scientists consider this warm and relatively wet period between 17 and 14.75 million years ago to be one of Earth's most recent and prolonged periods of global warming, with atmospheric CO_2 levels similar to those we are experiencing today. During the mid-Miocene, rivers caterwauled across the Pacific coastal region. Lava surged up through multiple earthen fissures. Some scientists theorize that in that era, a giant meteorite caused the earth's crust to open and expose its heated insides. However it happened, magma surged from deep below the surface and traveled hundreds of miles across Oregon, Idaho, and parts of Washington. In some places, sheet flows of lava measure over two miles (3.2 kilometers) thick and spread across 81,000 square miles (nearly 210,000 square kilometers). One, the Pomona flow, from west-central Idaho to the Pacific Ocean, is the longest

Basalt flows covered much of the Columbia Plateau in layers thousands of feet thick in places.

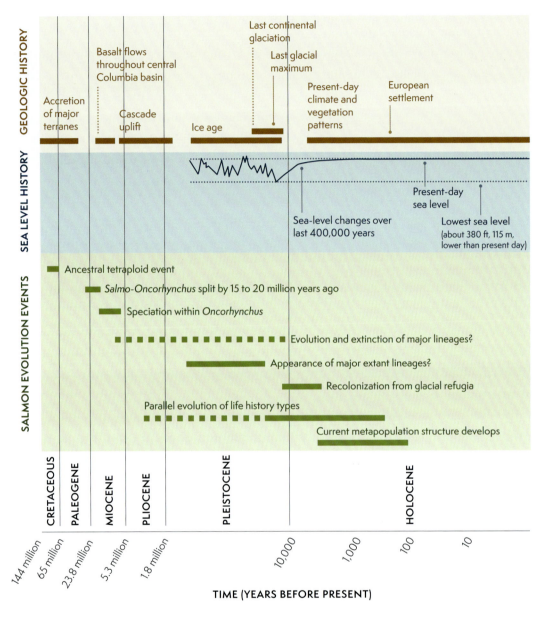

cementing the southern and eastern shape of today's watershed, laying the groundwork for the great Columbia Plateau, a giant platter of volcanic rock that spreads through the heart of the basin, across parts of Washington, Oregon, and Idaho. It also pushed the Columbia River's channel west, toward its current path through central Washington.

Beneath the arid surface of today's plateau spread complex catacombs of water, pooling and gushing amid the folds of long-cooled basalt. These discrete aquifers are of varying depth and originate from a mysterious source. They link directly to the watery, turbulent, and carbon-rich Miocene. Some are highly pressurized and come to the surface as springs. Others are shallow and persist only through recharge from rainwater or melted snow. Still others form underground lakes or disconnected deposits. These come to the surface only after deep drilling, followed by powerful wells to draw the water up. The great bulk of aquifers in the Columbia River basin do not recharge easily through these byzantine folds of adamantine basalt.

continuous lava flow on earth. Today, it forms bedrock under the Snake River Plain.

Eventually, things settled down. The flow of lava eased, even as rivers continued to gush around and through the fire, mixing with ocean tides. Layer after layer of lava cooled into basalt bedrock,

Could the mid-Miocene be an analogue for the contemporary Earth's ecosystem and climate? Since none of us was there, it's hard to be definitive, but some scientists posit that it is the closest historical version. Certainly, that era's level of geological turmoil echoes our

OPPOSITE Timeline of evolution of Pacific salmon. Source: Waples et al., "Evolutionary History of Pacific Salmon in Dynamic Environments" in *Evolutionary Applications*.

Glacier ice flowing off the Columbia Icefield in the Canadian Rockies

own mental condition as we bend our minds around the Anthropocene and struggle to find a way to change.

Shifts in the climate have been happening for a very long time. Nothing is static in geology. Chaos is a creative force that sets the stage for something else to emerge. Yet another analogue for our time? As the Miocene's climate shifted into the Pliocene, and then the Pleistocene, the Columbia River basin settled more and more firmly into position, but the transformation continued. Having been outlined by seismic force and flowing magma, the landscape and rivers would now feel the weight of ice.

The most recent glaciers to shape the Columbia Basin formed during the Quaternary glaciation, a cold period that began 2.5 million years ago. Despite its fixity, ice can unleash intense creative forces. Glaciers erode land, transport and deposit geological material, reshape river systems, form lakes, and influence sea levels, to name a few of their generative abilities. Enter the Cordilleran ice sheet of that Quaternary period, a frozen slab formed over the course of a million years that covered all of North America at one point, in some places miles deep. When this, the latest global ice age, finally waned, the ice shrank—and shrank

THE GRACE OF WATER / 39

THE CHANGEMAKERS

*Eileen Delehanty Pearkes
with assistance from biologist James Baxter*

Born in fresh water, young salmon migrate to the nutrient-rich ocean to mature. Within two to eight years, depending on the species, they return to fresh water as adults to spawn and die. All salmon are anadromous, or "up running," a term that refers to their migration.

Seven species of Pacific salmon and trout are native to the Columbia River watershed. Five always die after spawning: Chinook, chum, coho, pink, and sockeye. Sea-run cutthroat and steelhead trout can survive after spawning. Steelhead living exclusively in freshwater are known as rainbow trout.

The entire endocrine systems of these remarkable fish must adapt when they return to fresh water as adults. Before spawning, anadromous salmon undergo dramatic changes to their body color and shape to attract mates and deter competitors (illustrated here in males).

For the purposes of this book, "salmon" refers to the species native to the Big River.

MARINE

Chinook salmon, or king
Oncorhynchus tshawytscha

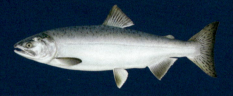

Pink salmon, or humpy
Oncorhynchus gorbuscha

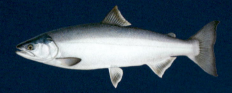

Sockeye salmon, or red
Oncorhynchus nerka

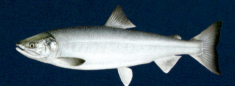

Chum salmon, or dog
Oncorhynchus keta

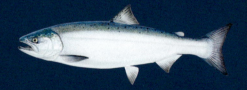

Coho salmon, or silver
Oncorhynchus kisutch

Sea-run cutthroat trout
Oncorhynchus clarkii clarkii

Steelhead, or rainbow trout
Oncorhynchus mykiss

SPAWNING

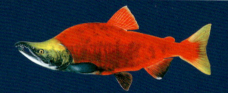
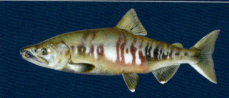
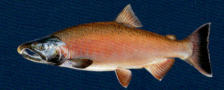
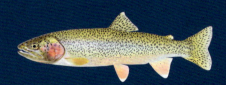
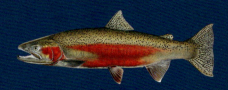

again. Its last period of melt began about 115,000 years ago; by about 11,700 years ago, the landscape was freeing up.

This most recent glaciation inspired another remarkable series of events that formed and shaped the basin's array of natural capital: its fertile soil, fast-charging salmon rivers, springs, coniferous forests, and continued annual snowmelt, all connected smartly to the sea.

The anadromous salmon species—those that travel from the land where they are born to the sea for adulthood and back to the land to spawn—arrived on the scene about four to five million years ago, a few million years before the most recent Quaternary glaciation began, according to Western science. Their patterned journey emerged out of the tailings of Miocene turmoil to rest deep within the layers of Columbia Basin geologic time. How did these anadromous salmon and trout manage to maneuver around and through the thick sheets of ice? What is most remarkable, and even less possible to imagine, is how the anadromous salmon and trout local to the Columbia Basin today developed the ability to transform their endocrine systems from being freshwater fish (when they emerge from river gravel), to salt water (where they spend most of their adult lives), and then back to fresh water again (when they spawn and die in their natal streams). Their resilience underpins both their survival and their ability to thrive. They hew tightly to the early creative forces that made this basin what it is.

As the Cordilleran ice sheet continued to shrink and shift in response to a warming world, it carved and smoothed granite peaks around the Columbia's headwaters and throughout the Rockies. It shaped river gravels and cobbles and left behind dense piles of sandy silt. Everywhere, ice was melting and transforming into water, breaking up, reforming and rearranging itself, and repeatedly, capriciously blocking rivers. At times, in the 100,000 years of gradual glacial diminishment, the movements of ice stranded some ocean species far inland. In the northern and western reaches of the basin, some of the anadromous sockeye and the steelhead trout became kokanee and Gerrard rainbow, landlocked fish who ceased any of the anadromous rhythms of their relatives and instead adapted to be entirely freshwater beings. River mussels are another freshwater echo, one of marine bivalves, though they likely

THE GRACE OF WATER / 41

emerged as a species hundreds of millions of years ago, not during this most recent glaciation. Extremely important water purifiers who birth millions of tiny babies to provide microscopic nourishment to young fish, the unassuming riverbed shellfish links marine and riverine systems with another ancient story of adaptation.

During deglaciation, expansive and changeable meltwater lakes also appeared. They filled Oregon's Willamette Valley and Washington's Tri-Cities area (Kennewick, Pasco, and Richland) at the confluence of the Snake, Yakima, and Columbia Rivers. Yet, these large meltwater lakes pale in comparison to an immense one that formed behind an ice dam near present-day Sandpoint, Idaho. Geologists have named it Glacial Lake Missoula. This freshwater sea once covered 3,000 square miles (nearly 7,800 square kilometers), in places up to 950 feet (290 meters) deep, seeping up the sides of some mountains around present-day Missoula, Montana. Water on this grand scale staged itself at the eastern edge of the basin, ready to participate in the next wave of chaos and change.

And then it happened. About 15,000 years ago, water breached the lake's half-mile-high (0.8-kilometer high) ice dam, unleashing intense creative forces of movement and change. Up to 100 successive flood events followed, as the ice dam eventually collapsed completely and drained Glacial Lake Missoula. Over thousands of years, these floods shaped the visible surface of the watershed's gently tilted, concave inland surface. Gushing currents carved basalt columns and marked out fresh channels and canyons through cooled lava. New meltwater lakes formed behind geological bottlenecks such as Wallula Gap in southeastern Washington and Red Rock Pass in southeastern Idaho. So much water. Geologists theorize that one of these flood events alone could discharge 350 million cubic feet (10 million cubic meters) of water per second—over a thousand times the daily discharge of the contemporary Columbia River. Landmarks from these commanding floods remain visible today across the arid Columbia Plateau. They include the Grand Coulee, Drumheller Channels, Dry Falls, and Palouse Falls in central Washington, as well as many box-shaped valleys and basalt boulders, carried like pebbles by the sheer force of water.

But the collapse of Glacial Lake Missoula was not just about water. Whenever a dam breaks down, obstructed silt that might have been transported to a new place by a free-running river releases with the water. After Glacial Lake Missoula's surface water overflowed, the ice dam's serial disintegration sent masses of accumulated silt cascading across the Columbia River basin. The silt traveled west from the rim of the Rockies, oozing as lava once had. Rippling humps settled into the rolling hills and plains south of Flathead Lake, in western Montana. There, it formed the foundation of future grasslands for herds of bison and fields of camas, a blue-flowering root food beloved by most, if not all, Columbia Basin tribes. More silt flowed west and south, where it settled in copious earthen mounds, smoothing somewhat the Snake River's basalt foundation and providing purchase for coniferous forests. Smack in the middle of the basin, glacial silt rippled into the remarkable, undulating surface of the Palouse in central Washington and

Flowering paintbrush blooms amid sagebrush with flowering antelope bitterbrush and native bunchgrasses beyond in an arid grassland in the Snake River watershed.

42 / BIG RIVER

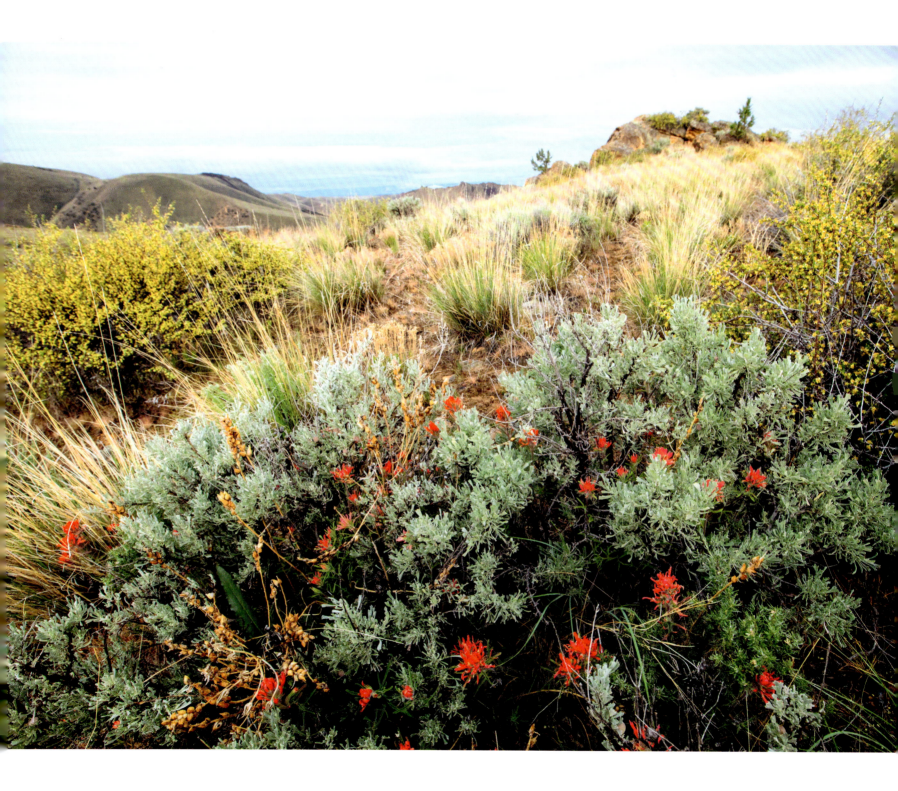

THE GRACE OF WATER / 43

southern Idaho. Dense with nutrients, teeming with promise, these soils softened the bedrock and began to host plant communities: sage, hemp, white camas, and rabbit bush, among others.

It was time for people.

THE ROOTED ONES

Ahead of me on the highway that tracks the edge of the Clearwater River, a tributary of the Snake River in central Idaho, I see the pickup I am following turn and pull into the Nez Perce tribal gas station. It parks off to the side of the busy pumps. Janet BlackEagle, a Nez Perce elder and knowledge keeper, steps from the driver's side door. I pull in and climb out to stand beside her in the bright spring air.

"I thought you'd like to see something," Janet says softly.

I had been introduced to Janet that morning and had been spending the day with her, listening to her stories of the land, including those of the Animal People who preceded human beings. One of them, Coyote, holds a prominent position in Columbia Basin stories of origins and moral guidance. The capricious dog offers a potent mix of pathos, humor, and fallibility as he lies, steals, offers miraculous gifts, and magically transforms.

Janet's long, thick braid hangs to her heels and sways gently as she turns, pointing to a grassy slope immediately behind the gas station.

"See that over there?"

I notice an innocuous hunk of basalt, one that I would have missed entirely if she hadn't pointed it out.

44 / BIG RIVER

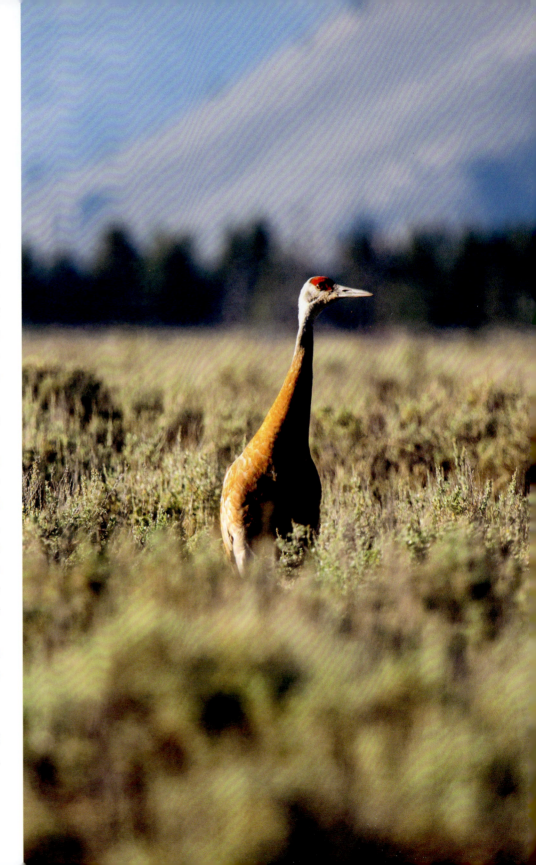

spring up from the very land itself. There is even one story of the first woman of a tribe emerging right out of the ground, growing up like a root, a plant, or even a tree. A human being, grounding and seeking a sunlit sky at the same time.

In the intersection of tribal rootedness and Western culture, with its tradition of science and inquiry, sits the story of Kennewick Man. The tribes of this basin call him the Ancient One.

Accidentally discovered in 1996 on the fringes of a Columbia River reservoir near Kennewick, Washington, at the confluence of the Snake and Columbia Rivers, the 9,000-year-old skeleton almost immediately unleashed a furious legal battle between various government agencies and scientists for possession and study of the remains. Indigenous tribes of the basin asserted ancestral lineage and urged immediate reburial. When scientists accessed and studied the bones, they pieced together the story of a 40-year-old man, five foot seven (1.7 meters) and likely weighing about 160 pounds (72.5 kilograms) when he died. His position when exposed in the river embankment indicated he had been buried respectfully, by people who cared about him. Chemical analysis indicated that he had subsisted on marine fish and mammals and had consumed plenty of glacial meltwater. The bones also indicated that he had been right-handed, with a heavily developed right arm and shoulder, likely from throwing a spear. One spear point had lodged in his pelvis and was still there when the reservoir unearthed him, the foreign object having found a lifelong home.

Based on these details, and the use of the now-refuted practice of skull-shape analysis, scientists and historians developed a sequence of incorrect theories about the man's origins: this hunter-fisher must have come by sea, down the coast from present-day Alaska, where there are still plenty of glaciers today. Echoing the Bering Sea land bridge theory, others suggested that he must have been an ancestor of the Ainu of Japan, given the shape of the skull. Or, perhaps, an ancient Polynesian who traveled here by sea.

No one, except the tribes of the basin, believed that the Ancient One could be from the place where he was found.

For years, the exact biological origin of Kennewick Man remained theoretical, as he remained above ground. Then, in 2015, more precise DNA analysis linked him directly to contemporary members of the Colville Confederated Tribes, the only Columbia Basin tribe that had agreed to supply DNA sampling. DNA analysis is a controversial process that many Indigenous people resist, but in the case of the Ancient One, it proved to be a good decision. Western science met Indigenous knowledge. The bones spoke the truth. The meltwater the Ancient One drank and the marine mammals and fish he consumed had come from his own homeland, the still deglaciating Columbia Basin.

A reburial of the Ancient One in 2017 was attended by tribes from across the heart of the river basin: the Confederated Tribes of the Colville Reservation, the Confederated Tribes and Bands of the Yakama Nation (spelled differently from the river and city of Yakima), the Nez Perce Tribe, the Confederated Tribes of the Umatilla Reservation, and the Wanapum Band of Priest Rapids. The oldest skeletal remains yet studied by archaeology in North America are at rest again, having affirmed that the Indigenous people have been here since the moment the landscape was habitable.

At the time of the Ancient One's death, ice turning to water still held sway over some portions of the landscape, especially the mountainous areas. Even in southerly areas where the land was open to sunlight, water still carried great quantities of mineral-rich silt out of the easterly mountains to the westerly ocean, enriching salmon habitat. The anadromous life cycle the fish follow today still traces this mythic shape across the land. Salmon return from the wide ocean, funneling inland as in the story of Coyote leading them upstream, homing precisely to their natal stream, or sometimes, seeking new places. They spawn the next generation in a

"That's Frog Rock. You see, Frog was a woman at one time. She was very pretty. She was vain. She was also envious. A jealous type of a person. She wanted to be the queen. Coyote got her good. She's stuck there now. That beautiful woman. Forever."

Janet smiled and turned a half circle to point to a hill on the other side of the Clearwater River and the highway. The hill was dusted with bright green grass from the wet spring. A dark crust of basalt marked the ridge.

"See up there? Those people there? Dancing and celebrating in a line? It's our people's way. These people, well, they didn't know how to stop. They danced and danced and danced. Coyote said that's enough, we got to rest. But they wouldn't quit. They turned their backs to Coyote and kept going. So he turned them into rocks, to make them stop. That's what can happen. If we get addicted. If we're not living in balance. If we stop listening. We get stopped, one way or another."

EARTH'S CURVE SHAPED THE PROGRESS of glacial melt, with snow and ice withdrawing first in the southern part of the Columbia Basin around 10,000 to 12,000 years ago. In the basin's northern climes, ice maintained a firm clutch, especially in the great river's source mountains in southeastern British Columbia, for at least another few thousand years. When did human beings arrive in the basin? For some time, archaeologists theorized that human culture arrived from northeast Asia about 13,000 years ago, traveling across a Bering Sea land bridge, then following a widening ice-free corridor south to populate the basin and spread out across the west. But for many decades, other researchers have pushed back against this theory. A large amount of new evidence gathered in the past 10 to 20 years, including 23,000-year-old footprints, 26,000-year-old tools, and groundbreaking genetic analysis, is rewriting the story, combining more physical clues with DNA analysis, to challenge how science explains origins. The depth of time human beings populated landscapes is still an unfolding story, one that continues to test the non-Indigenous perspectives on time and landscape. The Columbia Basin tribes, for their part, have long echoed each other when they say *we have always been here*.

Use of salmon by human culture in the basin shows up in the known archaeological record around 12,000 years ago, materially linking the people and the fish in a symbiotic relationship that may have begun in this basin at the end of Earth's most recent glaciation. The interchange between endings and beginnings informs plenty of spiritual and cultural clues of deep time inhabitation, offered up from the people themselves. Multiple tribes speak of Coyote leading the salmon up the Columbia from the ocean, coaxing the fish home against the current. Some speak of whales swimming up the mainstem from the ocean, a story disbelieved by non-Indigenous researchers until the skeleton of a whale was unearthed in an archaeological dig. Both of these stories resonate with the gradual withdrawal of ice, a process that just as gradually marked the fluid boundaries between land and sea. Janet BlackEagle's stories, animating the exposed basalt of the Snake River watershed, demonstrate how a culture can

Sandhill cranes migrate into the southern portion of the Big River watershed to breed in wetlands and grasslands, including this area in central Idaho.

nooks and crannies of the watershed in the first place. They pushed and probed across thousands of years and river miles, until they reached the end of the line in several places: high in the upper Snake River watershed, up into the forested foothills of the Cascades and northward, to the headwaters of the Columbia River, where, when it was finally freed from ice, the water's own mysterious origins bubble up from the ground to form Columbia Lake. Here, the salmon reached the end of upstream possibility, even as the water began its 1,200-mile (1,930-kilometer) journey downstream to the ocean. In a trick of geography, the nascent, south-flowing Kootenay River travels past Columbia Lake, with less than a mile separating the two waterways. Recent research by a retired hydrologist has revealed how the two rivers connect through an aquifer that carries some water from the Kootenay west to Columbia Lake. In this way, the Kootenay offers Columbia Lake more than half of the lake's volume, thus forming a potent reminder of the collaborative nature of origins.

In every way, symbiotic exchanges link the development of Indigenous culture in the basin to salmon and moving water. The Chinookan peoples at the Columbia's mouth know how to make and pilot broad canoes of seafaring strength from cedar logs, canoes that have practical and deeply spiritual importance for them. The dugout canoes of the Umatilla, Yakama, and others in the mid-river, in use more or less from upstream of the Columbia Gorge to the terrain of Yakama, broaden out until they are nearly flat, providing transport to crisscross the broad water between rapids and waterfalls, and to transit goods. In the upper Columbia, the narrowing river system upstream of the mouth of the Okanagan River, several tribes employ a sturgeon-nosed canoe shaped somewhat like a kayak, light enough to portage, stable enough to handle stormy lake waves and to link human communities, as today's highways connect cities and towns. All these canoes are containers and carriers—holding and moving people and salmon, roots, tule mats, and other goods, dried and carefully preserved, back to winter home grounds. They are agents of connection.

Today's contemporary system of tribal names and governance structures only hints at the variety and vitality of the place-based cultures that once dominated the river basin. Multiple languages, distinct spiritual practices, clothing, adornment, baskets, housing, and other local adaptations created a web of relations united by water, furthered by the recurring gifts of salmon. The salmon's committed understanding of home, combined with its quest for new opportunities, forms a powerful analogue for the Indigenous human beings rooted thousands of years deep in the basin, ever expanding their sense of relatedness to each other and to the beings in the natural ecology, the descendants of the Animal People.

But cultural change was on the wind.

THE WANDERING ONES

In 1836, a baby girl was born at the headwaters of the Columbia River, near the shores of Lake Windermere, in what is now British Columbia. To the child's east loomed the grandeur of the Rocky Mountains. To her west rose the sharp pinnacles of the Purcell Range.

In spring through early summer in big snow years, the entire Rocky Mountain Trench between the Rocky Mountains and the Purcell Mountains can flood, turning the free-flowing Columbia into a massive wetland that stretches dozens of miles down the valley.

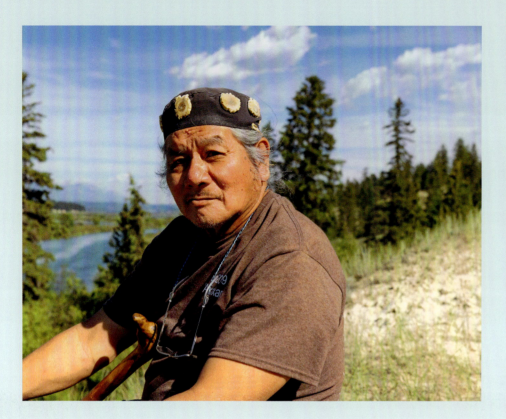

ALFRED JOSEPH

"I always decide on whether the water is good or not by whether or not you can drink it. That's my standard. So, when we talk about the Columbia or the Kootenay River, I gauge the health by how far down river can you safely drink the water."

Alfred Joseph, a custodian of Ktunaxa traditions, near his home along the upper reaches of the Big River

gesture of sacrifice before their death. Birth, death, renewal. And in the process, a gift of food for survival, an offering to the people.

Western science does not know for certain how the salmon understand when and where to go, but there is no question that they do. Their mysteriously honed biology inspires awe in its focused strength of purpose. That is how, from the first moments of the landscape's liberation from ice, human culture found the salmon already coming home, mile by mile. Human populations grew and developed around the reliability and rootedness of the salmon, a species with memories of tracking through and under sheets of ice. As the land reemerged from ice, wherever it could feel that stroke of sunlight, habitats for many other beings began to welcome bears and eagles, badgers and foxes, bison and pronghorns. These latter, together with elk, mountain caribou, and deer, ranged across wider and wider distances, through the expanding grasslands and scattered forests. They attracted the predators: cougar, coyote, wolf, and wolverine. The four-legged grazers required people to follow them for collective harvest. But salmon—salmon came to people. The fish sorted themselves into communities, returning again and again to the same place to spawn, echoing the people's return to villages after harvesting plant foods and making the most of a herd's migration patterns. A few salmon always strayed beyond, searching for and spreading into new places to spawn, new streams, new beds of gravel that suited their needs.

Their adventurous spirit is, after all, how the salmon managed to make their way from the open ocean deep into the mountainous

THE GRACE OF WATER / 47

Here, in an open valley marked by a swirling, slow-moving Columbia in its infancy, Sophie Morigeau began a long and vital life.

Several decades before her birth, Captain Robert Gray had come by ocean in 1792 to find the mouth of a great western river—one that eventually took the name of his ship, the *Columbia Rediviva* (or, the Dove Restored to Life). In 1806, American explorers Meriwether Lewis and William Clark crested the Rockies on their westward search and descended to find the great river. After that came the traders Simon Fraser and Alexander Mackenzie, from the north, and around 1810, the British cartographer David Thompson. The Columbia Basin had been "discovered." Not long after, fur traders imported a different form of commerce and set the first global market value for the basin's rich resources.

In almost every sense of the word, Sophie's soul was hybrid. The trade world into which she was born had many stories like hers: parents who came and went; Indigenous women with French or British husbands who reversed course, crossed the Atlantic and thus abandoned their "country wives" and often, children. These complexities course through the currents of Sophie's personal history, mapping the distance between her Indigenous origins and

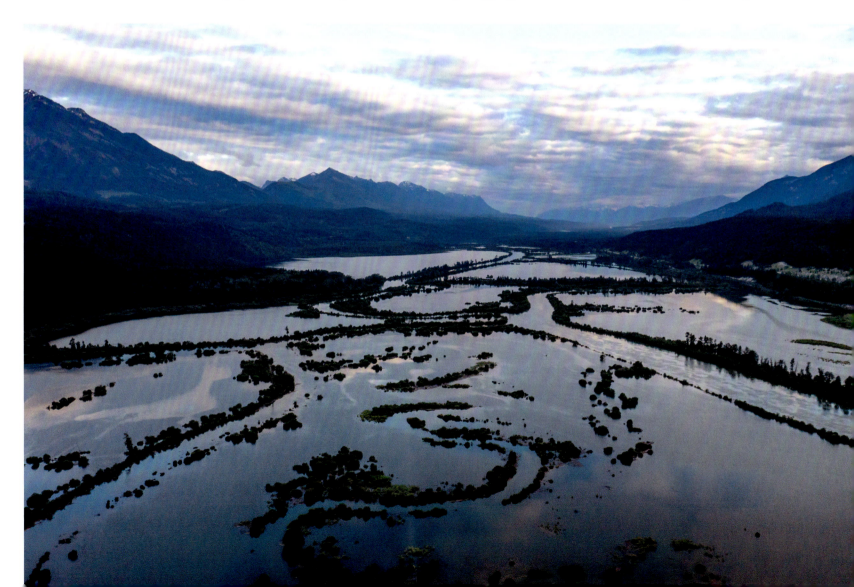

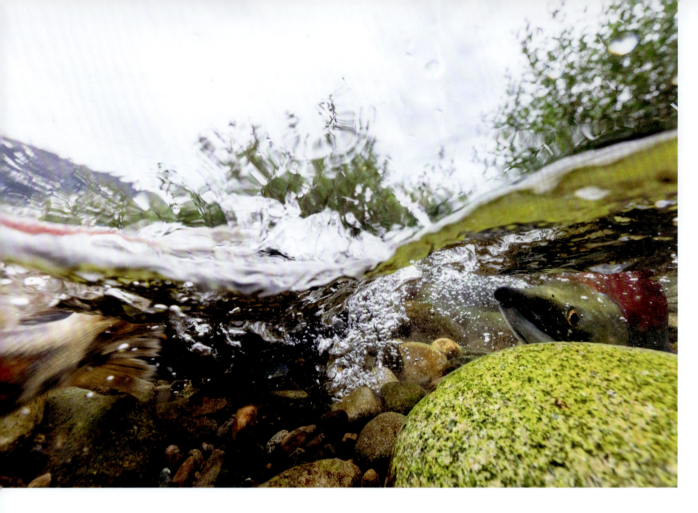

the rapidly settling western landscape. The little girl's familial headwaters were as complex in language and culture as the flow pattern of the nascent Columbia River, twisting and turning like a serpent through the broad, silted valley known today as the Rocky Mountain Trench.

Though Sophie carried the surname Morigeau, her baptismal and marriage records point to a biological father named Patrick "Pichina" Finley, the son of the legendary British fur trader Jacko Finlay. The Finlay/Finley name persists today in several Indigenous tribes in the upper Columbia Basin, a testimony to this one man's web of connections. By contrast, Sophie's mother, Isabella/Lisette/Elizabeth Taylor, had been born at faraway Red River settlement, in present-day Manitoba, Canada, at the mouth of the Assiniboine River.

In autumn 1845, the Catholic missionary Pierre DeSmet supped with Sophie's household at Lake Windemere. In his journals, he praised both the family's Catholic practices and the wilderness menu: soup made from the well-boiled muzzle of a moose. That same year, the family relocated downstream, south and west, to the dwindling Hudson's Bay Company at

Sockeye salmon make their way up the Cle Elum River, a mid-Columbia tributary.

Fort Colvile (spelled differently from the river and city of Colville), and the St. Paul's (Catholic) Mission, both established beside the upper Columbia Basin's great Indigenous fishing falls, *Sx̌ʷnitkʷ* (Sounding Water). Today, the falls lie silent beneath the Lake Roosevelt Reservoir, though a settler community known as Kettle Falls, Washington, remains. The following year, the United States and Britain signed the Treaty of Oregon, splicing the Columbia Basin in two at the 49th parallel. Sophie married a francophone trader, a union that did not last long. Her homing instincts drew her back to the headwaters and into the work of a roving entrepreneur. For years, she transported goods across the boundary for the region's big rush of gold miners in the 1860s—from Walla Walla to Fort Colvile and Missoula (via the Jocko River, where she had relatives)—then on to Wild Horse Creek and Fort Steele in Canada, just south of her birthplace. Eventually, she established a 320-acre homestead there and another one farther south, in Eureka, Montana.

A river as grand as the Columbia needs space to play itself out, from the slow-moving, silted headwaters, through confined, steep-sided mountain canyons, downstream to many small or large back-eddy floodplains, past basalt cliffs and grassland plateaus—all places Sophie had traveled in her own restless years. In 1894, Eureka's first schoolteacher, Mary Harshman, visited Sophie in Montana, where Sophie served a bowl of fresh strawberries, cake, and whipping cream, at a table covered by a white cloth. Her feral life had embraced moose-muzzle soup and white table linen, linking missionaries, rugged pack trains, and docile homesteads. Her biography threads together the Indigenous world and that of the new arrivals, those wandering ones in search of a home.

FROM FURS TO GOLD TO FARMS, the settlement period of the Columbia Basin was, paradoxically, deeply unsettling. The explorations of Lewis and Clark, informed by the US policy known as manifest destiny, had opened up the Pacific Northwest to wagon trains. Pioneers arrived at a steadily increasing pace, in search of land and home. In 1844, 500 settlers followed that trail. By 1855, 3,000 were arriving each year. The discovery of gold from California to British Columbia between 1848 and 1864 sent a gushing river of men ranging across the basin, seeking quick fortune. The pack trains Sophie led during that time supported this fervent economy of extraction, one in which the international boundary could still be crossed relatively freely. Hydraulic mining techniques destroyed tribal fisheries. Defensive miners shot Indigenous men who arrived unawares at a traditional place to fish or hunt seasonally in their territory. Settlers mapped out farms, registered land titles, and plowed up root grounds that had once been so expansive with blue-flowering camas as to be mistaken for lakes by arriving settlers. Trees dropped quickly from the saw to feed new logging mills. Farmers and foresters burned berry-picking grounds beyond recovery, and fences went up. Government promises were made, then broken, as the tribes struggled to restore a semblance of their sovereign lifestyles in this period of profound human change.

There was so much natural capital to make use of. The stunning resources of the basin contained manifold opportunities that the tribal people, in the eyes of the settlers, seemed not to have fully recognized. In reality, two value systems had collided. The energy and excitement of settlement involved a lot of hard work, as settlers pressed for entitlement to more land. In 1854, the Grand Ronde tribes signed a treaty with the US government that resulted in their removal from vast territories across Oregon. In 1855, after a series of wars, strife, and conflict, Washington's new territorial governor gathered more tribes together to sign another treaty east of the Cascades that he hoped would apply to the rest of the basin, up to the international boundary. Those tribes who attended and signed one of those treaties became "treaty Indians." They forfeited formal title to much of their territory but reserved the right to fish, hunt, and gather in "usual and accustomed places." Those who either did not attend the

1855 meeting or did not sign what was offered did not forfeit any of their rights to land or its use, but also today have no US government protection to rights named in the treaties.

Above the international boundary, in Canada, the province of British Columbia formed in 1867, but an Indian reserve system was still decades away. To this day, the BC government has not yet signed treaties with any Columbia Basin tribes living above the 49th parallel. One of those tribes, the Sinixt, were caught in border dynamics. With 80 percent of their traditional territory north of the 49th parallel and 20 percent below it, their seasonal cycles gave the BC government increasing opportunities to bar them from free use of their own lands, a policy that led the Canadian government to declare the Sinixt extinct a century later. That 1956 proclamation was recently overturned in 2021 by the Supreme Court of Canada, affirming the tribe's right to access their entire Aboriginal territory.

In the United States, between the 1850s and 1870s, the federal government, with the help of the state of Washington, mapped out and signed into law areas of the basin that they called "reservations," for both treaty Indians (the Grand Ronde tribes, the Yakama and associated allies, the Nez Perce, and the Umatilla) and non-treaty Indians (the Chinook and most of the 12 Colville Confederated Tribes). As settlement pressure and resource development increased, the US government revoked title to most of the lands they had promised the tribes, shrinking back the reservations by as much as 90 percent in order to facilitate further agricultural settlement and increase extractive, commercial activities. What did not get revoked, however, was the central right of the 1855 treaty: to gather resources, fish, and hunt in their usual and accustomed places.

This tendril of legal continuity persisted throughout the fast-paced era of extraction and agricultural settlement in the late 19th and early 20th centuries. Loggers felled old-growth forests to open areas to farming and to construct towns and cities. Domestic cattle and sheep supplanted bison, pronghorn, and caribou; and workers, the majority of whom were Asian, toiled to pack prolific salmon runs into cans. The first cannery opened in the United States on the Columbia River in 1867. By 1889, one company alone operated 39 canneries on the lower Columbia River. The canneries churned through salmon species, exhausting first the Chinook, then the sockeye, coho, and chum, and finally the steelhead, all in the course of a few decades.

By 1940, confined to reservations, often located far from their traditional salmon-fishing locations or blocked from their homelands across an international boundary, most of the tribes of the Columbia Basin began to experience physical hunger. They suffered other forms of malnourishment too: loss of languages, lack of freedom to practice cyclical harvest of traditional foods; and the condemnation of spiritual practices that had long been interwoven tightly with the natural world. These incalculable losses were all gains for an adventuring, recently arrived culture. As the basin's natural ecological richness transformed into the new arrivals' own economic prosperity, the tribal world struggled. Yet, how could anyone arriving freshly to the beautiful and resource-rich Columbia Basin do anything but celebrate and take advantage of all that the river and its varied ecosystem had to offer?

The river, for its part, provided no obvious response to that question at the time. Its turn to give all it had was next to come.

FLOOD AND FLOW

The tumult and drama of the basin's founding geology had created a landscape of stunning variety through which the Columbia River and its many tributaries flowed. Water traveled and danced, pushed and pooled, roared and rippled. Water made a lot of noise, possessed strong currents, and carried itself capriciously downhill

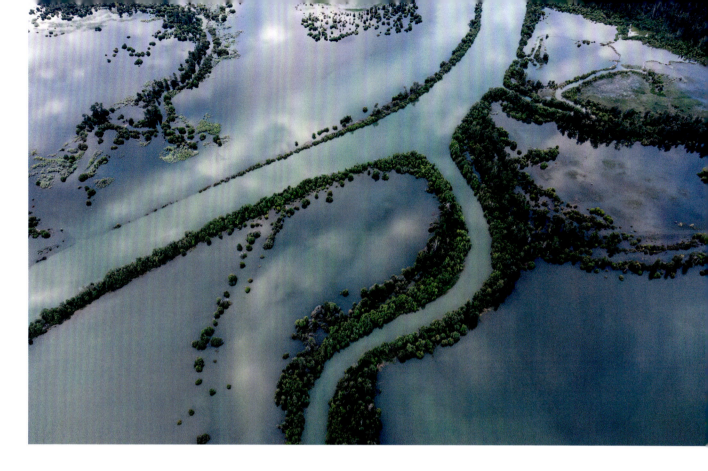

The braided channel of the upper Columbia River during flood stage

toward the sea. A count of major historic rapids and waterfalls of the Columbia River mainstem soon reaches 61—an average of one every 20 miles (32 kilometers), from source to sea. This estimate leaves out many more waterfalls and rapids located along all the tributary rivers of the basin. The largest falls on the Columbia's mainstem—at Celilo and Kettle Falls—had developed into major tribal salmon fisheries of great cultural importance. Some tributary waterfalls were traditional fisheries that limited salmon passage—in the United States at Cascade Falls (on the Kettle River), Spokane Falls (on the Spokane), and Shoshone Falls (on the Snake River), and in Canada at Slocan/Bonnington Falls (on the lower Kootenay River). Celilo and Kettle Falls were rare gateways on the mainstem that offered both concentrated, reliable fishing and successful upstream passage to the Columbia's headwaters.

The roar and rugged rush of water provided habitat for many fish species but did not facilitate easy human travel. From its earliest discovery by fur traders in the early 19th century, the Columbia's natural hydrology frustrated the hope for a wide, flat river of easy transport. The river and its landscape possessed a youthful and powerful energy, shaped by dramatic seismology, lava, and glaciers. Natural seasonal water dynamics answered to spring snowmelt surges, followed by declining summer flows that were steadied by remaining high-mountain glaciers; low autumn

THE GRACE OF WATER / 53

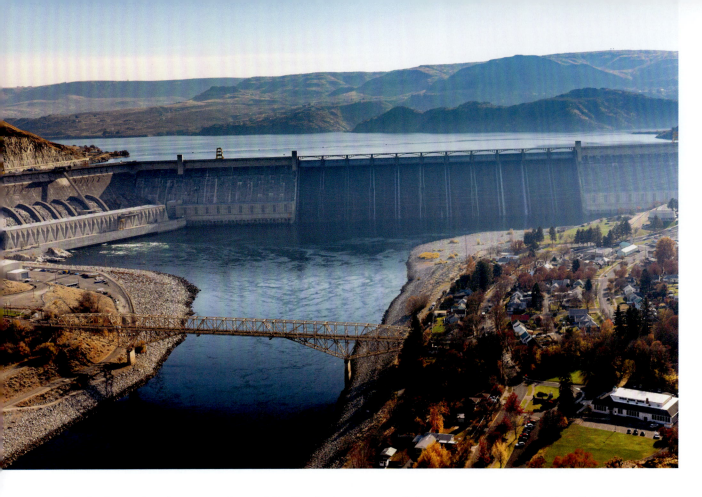

levels charged up by some rain; and finally, the inert winter water, as portions of the Columbia River often froze into ice. In this natural system, snow in high mountains had always served as an annual reservoir, holding the life-giving energy of water in dormancy until it could unleash itself in warm weather—rushing through, soaking, and renewing the entire landscape. Longtime Indigenous residents understood the elegant shape and design of water's natural behavior. The bedrock basalt and its narrow canyons might magnify the rise of water in high-flow periods, but it also provided ideal conditions that favored the rapid downstream transport of juvenile salmon to the sea.

Salmon, steelhead, and other fish evolved over millions of years to thrive in this flood and flow of water. Mature spawners, living sometimes for years in the open ocean, journeyed upstream just after the highest surge of floodwaters began to recede. Various species came one after the other, throughout the late spring and summer, and into early autumn. The largest—what came to be known at Kettle Falls as the "June hogs" (weighing up to 100 pounds each)— were mature spring Chinook salmon, fish who had evolved enough power and strength to push against the still-powerful, late-spring currents. Burbot and bull trout also thrived in the upper river region, in

The 550-foot-tall (168-meter) Grand Coulee Dam in Washington State is a mile (1.6 kilometers) wide and backs up the river for 152 miles (245 kilometers). In 1942, it extirpated anadromous salmon from hundreds of miles of spawning habitat in the upper Columbia River watershed.

54 / BIG RIVER

a landscape of steep mountains and deep lakes where water was coldest. Young sturgeon sought camouflage throughout the system, sheltering in cloudy spring meltwater that was rich with nutrients and had a curtain of turbidity, to protect them at the right time from predators. The ancient lamprey, a type of eel, had long known their own niche, as climbers of waterfalls and riffles who could attach their strange, circular mouths to boulders as they inched their way up. Their tight, muscular bodies managed the powerful waterfalls with grace and strength, providing rich fats and nutrients to the marine mammals and people who harvested them.

The sounding roar and energetic movement of water was commonplace throughout the basin, especially, but not only, in spring. After thousands of years of watching, listening, and shaping their lives around the movement of water, Indigenous residents well understood how the spring floods worked and the good that their annual chaos bestowed. The late Martin Louie, a Sinixt-Skoyelpi spiritual leader and elder from the upper watershed, a "salmon chief" responsible for the health of the fishery, once described his tribe's attitude toward the water's natural cycle:

The north changes the world. . . . In the winter snow comes, covers the land. When it breaks up in the spring, the mountains and the hills will gather all deteriorated stuff and bring it down the Columbia, the main channel, and take it away . . . and we have a brand-new world in the spring. The high waters take everything out, wash everything down.

SETTLERS, BY CONTRAST, FOUND THAT multiple river rapids grew worse or better at certain times of the year, challenging navigation because of high water flows or because reduced flows exposed rocky sections. Ice sometimes obstructed passage; boats upturned easily and people drowned. Spring floods were higher some years than others, complicating the planned certainty of where to construct riverside towns and cities. And then, there was the river's way of passing right through the dry plateau in central Washington, flowing in a deep channel strangely positioned below the heaps of fertile soil once deposited by the glacial floods. Settlers had come in great numbers to this plateau during some wet years but soon grew frustrated when cyclical drought turned against their efforts. The river's natural geography seemed completely illogical to the farmers, a problem to be solved. Water, meanwhile, kept flowing, flowing, flowing on past, out of reach of the plow.

As the 20th century arrived, the mutability and vitality of this snow-melted web of water became an impediment to further growth, but the new basin culture gradually woke up to the latent, gravitational power of the water, realizing that its downhill speed could be captured and turned into electricity. A Scottish entrepreneur constructed major hydropower dams on the Kootenay River in Canada in 1897. Three more on that same rapid stretch of river went up in 1907, 1928, and 1932. Three of these generated hydropower for a metal smelter and a fourth lit up the growing city of Nelson, a new capital of mining commerce.

The first major dams on the international Columbia rose up in the United States during the Great Depression: Bonneville on the lower Columbia (1937) and Grand Coulee on the mid-Columbia (1942). Bonneville facilitated navigation by inundating riffles and waterfalls, offered flood control, and generated electricity. Grand Coulee addressed the region's desire for irrigation, with generators originally designed to create only enough power to operate a pumping station that would move river water above the Columbia's main channel. From there, water would travel by gravity canal to dry farming areas in the plateau, as electricity yoked itself tightly to irrigation for the first time. But then, the advent of World War II increased the need for aluminum to make

war planes. That process needed more electricity. The dam rose higher, the number of generators increased, and Grand Coulee Dam became not only an irrigation project but a hydropower producer in its own right.

Bonneville Lock and Dam, constructed by the Army Corps of Engineers, included passage for salmon, in line with the 1920 Federal Power Act and the 1934 Fish and Wildlife Coordination Act, both of which required dams on public waterways to have either fish passage or hatcheries in compensation. Grand Coulee blocked fish from going upstream to access a 1,400-mile (2,250-kilometer) stretch of fertile, cold-water spawning habitat in Canada. With Canada's major industrial salmon harvest on the West Coast at the mouth of the Fraser River, Canada told the United States when asked that it was not interested in the Columbia's headwater-salmon. A delegation from the Colville Confederated Tribes most certainly was interested, traveling to Washington, DC, to speak up for this important inland salmon run. They received no Canadian support, and before long, the United States was free to construct the dam without fish passage. Biologists at the time rationalized that a seven-mile-long (11-kilometer-long) passage system might tire the fish too much.

The tribes of the upper Columbia Basin gathered at Kettle Falls to hold a Ceremony of Tears in June 1942. There, they said goodbye to the anadromous salmon and steelhead trout that had been a central part of their lives for thousands of years.

The numbers of salmon returning to the Columbia watershed to spawn had peaked in the 1880s. After a brief revival in the 1920s, populations continued their steady decline, even as human population in the basin began its increase. By the time government agencies had completed the Bonneville and Grand Coulee Dams, the fish were already engaged in a mighty struggle, one that increased due to continued overfishing and the mortality of downstream-migrating juveniles who were caught in hydropower turbines and died. Glacial ice from the Quaternary period was proving to have been a far more manageable obstruction than engineered walls of concrete in possession of whirring generators.

And then came the 1948 flood. That year, significant accumulations of snow, combined with heavy rains falling just as that late-season snow began its melt, created so much water for the basin to discharge all at once that it soon transformed into a Big Water year. The record-breaking spring flood overflowed into areas that had been developed in recent decades: for agriculture, industry, cities, and housing. Hastily constructed on the natural floodplain adjacent to the two nearby cities of Portland, Oregon, and Vancouver, Washington, Vanport, Oregon, housed many workers for the Kaiser Aluminum plant, which had recently expanded to answer the wartime call for more planes. When inadequate dikes protecting Vanport failed, and evacuation orders were botched by being announced early, then rescinded, people died. The built community was completely destroyed. Other parts of the recently settled basin were also ill-prepared for the natural event, from Portland on upstream into Canada. After all, it had been half a century since the last Big Water year of 1894, several important decades in the changing relationship between the river and human culture.

The Columbia took the blame for the 1948 flood, and today the historic destruction of Vanport remains a rallying cry against the universal danger of flooding—a continuing, powerful justification for complete control over seasonal water fluctuations.

The Columbia Basin is not actually prone to great floods, as is the Mississippi. Hydrologists describe its flow as erratic, with a degree of variability, but not one of extreme and constant, catastrophic overflow. Prior to settlers arriving, the landscape and Indigenous people had evolved their own resilience around the river's way. People had settled permanently in places that remained consistently dry. They had learned to tend root-digging grounds of camas and other foods after the floodwaters receded, and to burn annually in

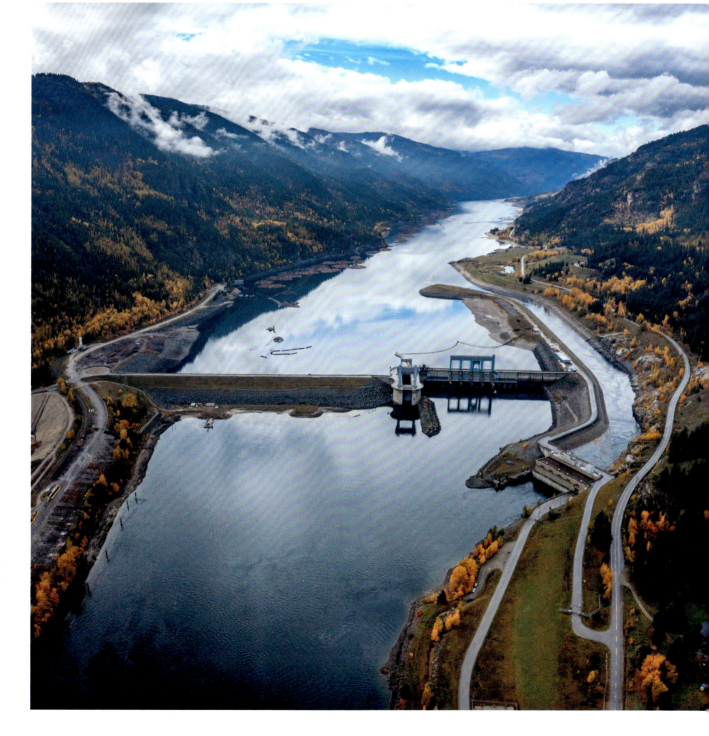

Fall colors grace the mountains around Keenleyside Dam along the Big River in British Columbia. This Columbia River Treaty dam flooded the entire Arrow Lakes valley in 1968, converting two lakes and two free-flowing stretches of river into one 230-kilometer-long reservoir.

THE GRACE OF WATER / 57

early spring for good grazing in areas that regularly flooded in spring and then dried out to flourish with rich nutrients from floodwaters left behind. What had looked like inviting, empty land to a new arrival trying to settle year-round to farm was actually a natural floodplain that received seasonal overflow and buffered the high-water events. Whenever water charged up into these riparian areas, nutrient levels rose. Fish recently released from their graveled birth found temporarily flooded back eddies and shallow areas filled with micronutrients. After the water receded, it took many of these nutrient benefits stirred by the floods back into the aquatic habitat. Some nutrients had been carried down from high mountain peaks by the water. Water's lush mutability has always given many gifts to ecosystems. Floods in today's culture are unfortunately and nearly always presented as chaotic and rarely, if ever, welcomed, due to settled areas not having adequate protection or because people chose to construct homes or cities on known floodplains.

The entire Columbia River basin dried out as the 1948 Big Water year drew to a close, but military leaders who had recently returned from war had a new civil works mission: taming the Columbia. Newspaper accounts at the time, from Kimberly, British Columbia, to Portland had characterized the floodwaters as angry, or as a dangerous "torrent," signaling clearly how the settler culture had begun to feel about the river basin's natural spring flows. The Army Corps of Engineers went to work, as did a Canadian general, Andrew McNaughton, a trained electrical engineer and former minister of national defense during World War II, who became one of the important political leaders in the Columbia River Treaty discussions.

It was time to get serious.

Over the next decade, engineers on both sides of the international boundary studied the Columbia River basin, as corporate and industrial interest in generating more electricity converged with a public need for more flood protection. It was becoming clear that the mountains of the upper watershed—in British Columbia, but also northern Idaho and Montana—contributed a great volume of the snowmelt. Damming

An Idaho Fish and Game employee removes the eggs from a female Chinook salmon at the Sawtooth Hatchery on the Salmon River.

58 / BIG RIVER

and controlling that snowmelt became the central purpose of water management. With a sense of urgency inspired by the recent flood, both countries began to plan for many water storage projects. By 1956, the Canadian government had finished its survey maps of the entire mountainous basin above the boundary. The United States had identified where it wanted dams to be placed too. Detailed conversations between the United States and Canada had begun.

THE 1964 COLUMBIA RIVER TREATY

Today's international river border is not an entirely unfriendly one, thanks in part to the unique treaty that governs the operation of the Columbia's transboundary hydropower systems and flood control. Signed in 1961, adjusted and ultimately ratified by both countries in 1964, the Columbia River Treaty required the construction of three storage dams on the upper river in British Columbia, Canada. The Canadian government did not consult its citizens about where these dams would be built or how and when land would be flooded. The treaty also granted the United States permission to construct a fourth if it wished: Libby Dam in Montana. The three Canadian treaty dams—Mica, Keenleyside, and Duncan—permanently flooded dryland farms, ranches, and grasslands, as well as riverine fish habitat and wetlands for waterfowl or grazing animals.

In exchange for these services, the United States paid Canada a one-time fee of US$64 million (CA$84.3 million) (around US$500 million [CA$658.5 million] today) for 60 years of fixed flood-control benefits and also agreed to equitable distribution of the electricity that Canadian storage made possible. This fifty-fifty split is a principle of fairness built into the life of the treaty unless both countries agree differently. In 1964, the two countries agreed that the United States would pay a 30-year lump sum of this annual obligation to British Columbia, which chose to use these funds to offset the cost of constructing the treaty dams and reservoirs. By 1972, British Columbia had completed all three treaty dams. The following year, the United States completed Libby, flooding more Canadian dryland farming communities and some in the United States. The complex flow pattern of the transboundary Kootenay/Kootenai River system meant that both countries found themselves downstream of each other, and experiencing the negative effects of each other's dams.

More dams preceded or followed the completion of the treaty dams over the next few decades, until 14 blocked the flow of the Columbia mainstem, 13 obstructed the Snake, its largest tributary, and 7 controlled the Kootenay/Kootenai. All told, tributaries on the US side of the basin hosted 58 midsize dams for electricity and another 78 for energy, irrigation, or flood control. More than 2,000 smaller dams also went up in Oregon, Washington, and Idaho, many of which were in the Columbia Basin.

A primary goal for the treaty dams in the upper basin was flood control. Positioned in the upper system, near the high mountains where snow accumulation is greatest, the megaprojects would keep floodwaters from flowing to the sea and therefore protect human communities. Across the US portion of the basin, the Army Corps of Engineers and the Bureau of Reclamation also channeled smaller streams, to make areas drain more efficiently and safely. Every project, from the macro to the micro, altered the natural pattern and impulses of rivers, streams, and lakes.

By 1980, a basin once noisy with flowing water had gone eerily quiet. But the built economy was humming with prosperity, and everyone was safe from floods. The remarkable gift of abundant, clean energy had also arrived—energy that, like the salmon, could be renewed each year, with the right weather and another captured spring flood. Within a few decades, engineers had transformed a gushing ecosystem into one of reliable water supply, abundant electricity, and controlled floods, with water gathered behind high cement or earthen dams that would not melt or burst into places it wasn't wanted. They had reversed the natural hydrological cycle.

Spring water was held back for use later to heat homes in winter, with some of it drained out in summer to power air conditioners or to slake thirsty croplands and maintain recreational opportunities. Producing power in winter drained reservoirs completely, exposing in earliest spring a riparian shoreline that would have no time to naturally restore wetlands or cottonwood trees before being once again covered by the constrained waters of the next spring flood.

The treaty and the government policy that informed it originally predicted that the generation of nuclear power would at some point surpass hydropower, to devalue the latter. But then, the 1979 Three-Mile Island disaster in Pennsylvania resulted in the partial meltdown of a nuclear reactor and the release of radioactive material into the atmosphere, shifting public attitudes toward this form of thermal electricity. The value of hydropower continued to rise rather than fall. In 1994, at the end of the 30-year payment agreement, the United States began to deliver the Canadian share of treaty-generated electricity north of the border along transmission lines. Some years, the Canadian share sold for a high value on the open energy markets—often, ironically, back to the United States. The revenues varied between US$75.9 million (CA$100 million) and US$227.8 million (CA$300 million), money that directly benefited the government of British Columbia. Having to buy back electricity frustrated US hydropower producers, now forced by the treaty to share half of the electricity that had been made possible by upstream water storage.

As economic pressure on US producers mounted, each drop was stringently accounted for by agencies on both sides of the border in a complex balance of US industrial farming irrigation, snow accumulations in the Cascades and the BC mountains, and daily discharges that generated as much electricity (and therefore, money) for each country as possible. Hydropower companies in both countries installed more generators, increasing output. The predictability of the basin's hydrology fostered unimaginable growth, crop productivity, and extensive urban development, especially on the Portland floodplain. It was an ideal world of managed flood and flow: 39.7 million acre-feet (48.9 cubic meters) of flood storage across the international basin; a 465-mile (750-kilometer) navigation system on the Snake, and friendly enough interagency cooperation between the United States and Canada over the Columbia River Treaty.

Until, that is, the Endangered Species Act of 1973 reared its head, and US federal courts handed down the Boldt Decision in 1974. Signs of a shifting climate also began to emerge. The river and its landscape were changing again.

LIVELIHOOD

In 2013, the fifteen modern Columbia River basin tribes and confederations sponsored a conference at a hotel in Oregon. Changes to the Columbia River Treaty were on the horizon, renewing interest in the agreement. Tribes gathered to discuss salmon and water management—the floods and flows, the presence of anadromous species, and the dams and reservoirs. I watched and learned as the tribes counseled with one another. Over catered meals and coffee and muffins, they shared their views, seeking common ground and affirming fundamental values, rooted deep in basin origins. Even though the tribes don't always get along, they keep talking to one another.

"I'm an old-time Indian woman," Charlotte Rodrique said at the start of one plenary presentation. The room, filled mostly with tribal men and the noisy clinking of cutlery, immediately went quiet. A chairperson and elder of the Burns Paiute tribe of central Oregon, Rodrique had been asked to speak about the value of water. She began slowly. "It was never our people's way for the women to speak out. That was for the men. When the men spoke, the grandmothers were always there, but they were standing behind them. They were reminding the men of who they were."

60 / BIG RIVER

Arrowleaf balsamroot in bloom on the east slope of the Washington Cascades

She picked up speed, telling a story of traveling as a child with her grandmother to gather plant medicine high in the mountains above the Snake River. When her grandmother asked her to get water, she explained to Rodrique how to carefully part the lichen and moss gathered around springs that emerged from the ground. Water is precious, Rodrique's grandmother told her. Be very careful with it. Don't harm it.

"I am watching all of you," she concluded as she addressed the still-silent room. "Water is precious. Remember. This is your work."

As I traveled back to Canada, the clarity of Rodrique's words crowded into my thoughts, pushing aside details of the international water treaty, the competition between various water users across the entire basin, and even my still-developing knowledge of the intricate life cycle of the various salmon species. In Rodrique, I had heard humble gratitude, empathy, and ethics. Where, I asked myself as I flew over the Palouse farmland toward the BC source mountains, was my own heart? It's tricky to listen to that seat of emotion when you are still learning the difference between the roles played by the Bonneville Power Administration (the US entity that sells electricity produced by federal dams) and Powerex (a wholly owned subsidiary of the Canadian corporation BC Hydro) in marketing the system's hydropower; between consumptive use and annual discharge rates; between the often conflicting needs of irrigation and commercial fishing. While the issues around various industrial and agricultural users of the Columbia River's water date back only a century, the tribal commitment to ethical responsibility to water has always been there. In the past decade, that sense of responsibility has reached more and more ears, spreading across the mainstream of thought.

Fundamental to all prosperity on Earth for all creatures, including the human ones, is water. No one can survive without it. The tribes of the basin demonstrate their understanding of this basic principle of survival, but as Rodrique had so eloquently expressed, they also travel the terrain of the heart. Her approach echoes around the tribal world. "Fishing is an art and a spiritual practice," says James Kiona, a Yakama Nation elder. Mike Finley, a Sinixt descendant and member of the Colville Confederated Tribes, uses a unique fishhook developed by his family's ancestors and takes such pride in it that his voice swells with emotion as he describes it. Fishing connects these men not only to their work but to something far greater. From the heart rises an urge to take loving care of the water and all the beloved creatures who inhabit it.

Tommy Thompson, salmon chief at Celilo Falls, also exemplified Indigenous spiritual commitment during his long life. A member of the Celilo Wy'am tribe, he assumed the responsibility for the salmon fishery in about 1900. Located just 200 miles (320 kilometers) upstream of the Columbia's outlet, where a basalt canyon narrows the river, the falls had been a place of salmon fishing for 10,000 years, encompassing the life of the Ancient One. The Wy'am, who had not signed the 1855 treaty, steadfastly declined the request to move to a reservation. Like the Chinook people living where the Pacific embraces the Columbia, the Wy'am have never achieved lasting federal recognition or compensation for any of their losses. For Thompson, official status required a trade-off that he could not accept. His life work was to oversee the tumbling water and the fishing. He couldn't do that if he left. And so, he stayed.

Thompson was salmon chief throughout the turbulent first half of the 20th century, as the continued decline of Columbia River salmon species threatened the health and survival of many tribes. This decline also clipped the economic success of the cannery industry and upended commercial ocean fishing. Dam after dam brought a different prosperity in trade, one that might end up submerging the Indigenous economic activity built on a reliable return of healthy populations of salmon. Through it all, Thompson never wavered in his commitment to the water and the fish. He refused to cooperate with federal government plans to build the Dalles Dam. He shifted

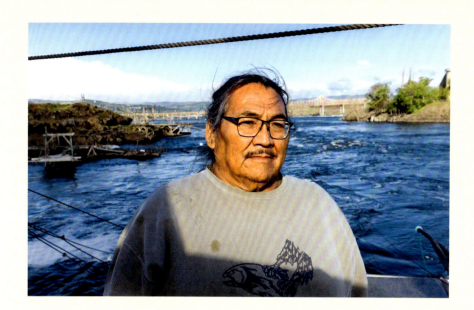

LEWIS GEORGE

"Our elders told us that the reason we live here right by the river is to take care of her. We have to stay here by the river to protect her. Someone always has to be here—right by the river."

Lewis George, Yakama fisherman photographed on one of his fishing platforms near The Dalles, Oregon

the Celilo fish scaffolds over and over again—out of the way of the BNSF railroad, then a canal, then Highway 84. Around him, the increasing controversy over Columbia River salmon rights, inflamed by a dwindling supply of fish, eventually sent the matter of fishing for livelihood and spirit to court.

Meanwhile, the mid-Columbia tribes hired lawyers and fought the state of Washington's closure of their traditional fisheries that had been assured in the 1855 treaty. They also persisted in fishing. The issue drew national attention, and in 1966, some high-profile entertainers who had decided to fish defiantly alongside Indigenous people were hauled off to jail. That finally got everyone's attention. A conservative judge named George Boldt, appointed by Richard Nixon to the US District Court, ultimately decided the issue. The 1974 Boldt Decision confirmed that the government and the tribes had equal rights. They were comanagers of the salmon fishery. The response to that judicial clarion was, initially, an increase in cross-cultural turmoil. Law enforcement made uninformed arrests of tribal fishermen. Some were clubbed. Some went to jail. Commercial fishermen resisted cooperation. The Nez Perce alone went to court 32 more times. Each time any tribe took the matter to court, treaty rights stood the test. Tensions between tribal fishermen and some settler residents of the watershed still exist today.

Before the mid-20th century era of salmon wars ended, Thompson had, unfortunately, lost the battle against the Dalles Dam. In 1957, the falls disappeared under rising water. Thompson, at close to 100 years old, died in a nursing home two years later. Yet, tribal fishing rights had been affirmed, and the Boldt Decision had planted a seed for future changes to come. As comanagers, tribes could eventually assert a different value system.

DECADES PRIOR TO THE COLUMBIA River Treaty, a conceptual map of Columbia Basin growth and prosperity circled around where to find water for agriculture, who owned it, and how to ensure more when supply waned. Settlers had moved into the region in large numbers during a series of wet years. By the 1930s, another cyclical drought had taken hold, threatening agricultural livelihoods. About that time, the big idea of Grand Coulee Dam and the Columbia Basin Project for water diversion

THE GRACE OF WATER / 63

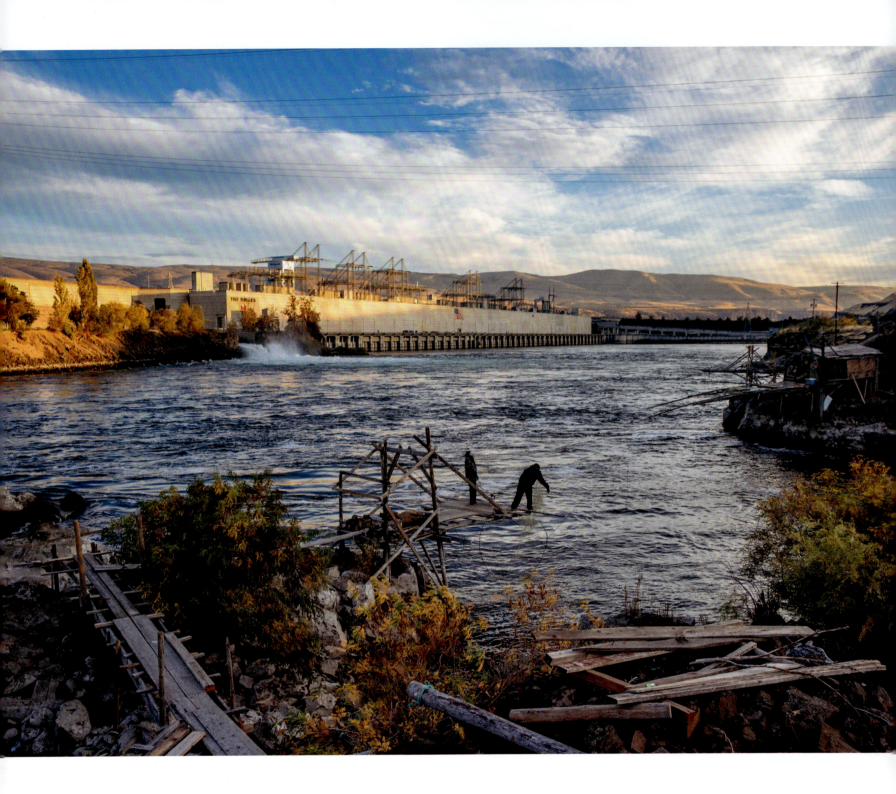

caught the attention of the recently formed Bureau of Reclamation, a US federal agency tasked with supporting western water projects that might "reclaim" the arid West. The resounding success of the Columbia Basin Project, assuring delivery of water to rich soils, led to more reclamation projects.

Today, the Columbia Basin Project irrigates 670,000 acres of land, much of it for high-value alfalfa and for potatoes destined to become frozen french fries. Across the rest of the basin, more hard-working farmers raise and harvest wheat, corn, hops, peas, apples, and grapes, most of it irrigated from various surface sources. Some is watered by Columbia River runoff—6 percent of the total, diverted to 7.8 million acres (3.1 million hectares). Some water siphons from tributaries. For example, in the Snake River drainage, the Minidoka Project waters 1.1 million acres (about 445,000 hectares) of agricultural land, from six storage and two diversion dams, along thousands of miles of canals. Beyond these sources, basin agriculture also draws water deep from within the folds of basalt, the massive Odessa Aquifer beneath the central Columbia Plateau.

Water as transportation plays another important role in basin livelihood. Snake River barges transport 50 million tons (about 445,000 hectares) of cargo—among it, a lot of agricultural products. The 359-mile (578-kilometer) segment that connects the unique inland port of Lewiston, Idaho, to Vancouver, Washington, must maintain a consistent channel depth of 14 feet (4.2 meters). To do so means that water being managed to maintain reservoir elevations competes with water needed for electricity

OPPOSITE Jordan Yazzie from Goldendale, Washington, and Sonnie Altaha from Arizona, are two of the young people who help Lewis George on his fishing platforms across the river from the Dalles Dam. As George says, "My survival is based on my grandchildren's survival."

TOP Fishing camp for a member of one of the Columbia Basin tribes with treaty-protected fishing rights near the Dalles Dam

BOTTOM Duane Miller III fishes from Lewis George's platform by the Dalles Dam.

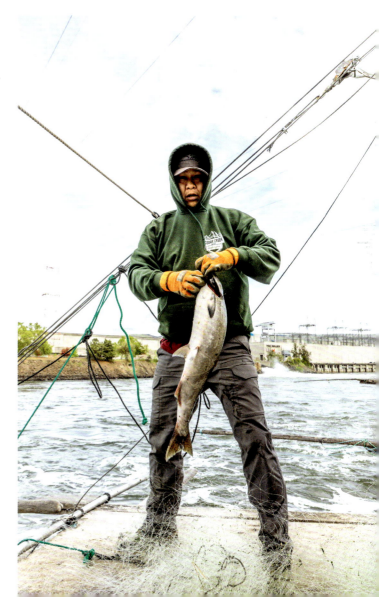

generation and for fish flow. In addition, the Snake River streambed must be consistently dredged. Years ago, a guide in the interpretive center at Grand Coulee Dam described the tension between the Snake River dams and salmon livelihoods as a choice between fish or bread. Potato growers and municipal governments within the Columbia Basin Project speak of wells that have been drained to the point that they draw up only saline water or sand. They want more water from the Columbia. Always more. Tribes urge hydropower companies and managers to liberate some of the Columbia's stored water for fish, not just for the treaty. In the complex game of policy hierarchy of needs, only one thing is clear: the era of limitless supply has ended. This constraint situation turns the biblical story of loaves and fishes on its head.

Settler approaches to water supply have presented a stark contrast to the Indigenous worldview of the Columbia and its tributaries ever since the Bureau of Reclamation water projects changed the flow and flood dynamic. The aspiration to move water from where it naturally found itself to where little had been since the end of the glacial period brought with it a disruption of the hydrological cycle. The settlers' approach developed naturally out of the Judeo-Christian culture they brought with them. Many

Aldolfo Martinez, from Santa Cruz, Mexico, is one of thousands of temporary workers who come to the Columbia River watershed every year to harvest agricultural products.

66 / BIG RIVER

biblical stories shape broad settler cultural thinking about water: the story of Moses striking a rock to bring forth water (Exodus 17:6) and God transforming "a desert into pools of water and a dry land into flowing springs" (Psalm 107:35–6), to name two. The quest for limitless supply forms a spiritual metaphor, too, as from Revelation 22:17: "let the one who is thirsty come; let the one who wishes take the water of life without cost."

These spiritual teachings also often express human dominion over resources. The word *dominion*, plucked right from Genesis, does not appear in all translations of the Bible from the original Hebrew. It is, however, the translation used in the influential King James version and has cast a long shadow across Western cultural ideas about water. The concept of dominion places human beings in charge, either at the center or on the top, in a controlling worldview of striking contrast to that of Indigenous tribes. Tommy Thompson's dedication to his work at Celilo Falls has its own spiritual roots—informing human care and protection of what is, not what could be. If anything rests at the center of Indigenous thinking, it is persistent respect and gratitude for the return of the fish.

Dramatic reshaping of a landscape's resources to support farming repeats itself in many parts of North America's West. Global human cultural history across time is also filled with examples of water diversion, canals, and irrigation—all to facilitate food supply and prosperity. Some archaeologists theorize that more than one North American, precontact civilization may have collapsed or relocated because of drought. The connection between water and survival is real, and universal. To that end, the floods and flows of the Columbia Basin today sustain industrial food production, hatchery-raised fish, and plentiful renewable electricity for urban areas. Only north of the international boundary, in Canada, has the Columbia Basin's water management resulted in *less* productive agriculture. There, the permanent flooding of thousands of acres of prime agricultural land around the Kootenay and Columbia Rivers as a result of the Columbia River Treaty ironically protects farmland south of the border in Idaho and elsewhere from inundation. While the size of the thriving mid- and lower-basin agricultural economy dwarfs the loss of Canadian land, these places are nonetheless significant for food sovereignty and rural livelihood.

Dams and canals, reservoirs and diversions also protect the entire Columbia River basin region from flooding, bundling the two purposes of irrigation and safety. Most recently, in 1996 and 2012, catastrophic flooding of built communities was averted due to cooperative water management and dams in the basin. Yet, for all the impressive efficiencies, industrial water values remain antithetical to what salmon and other aquatic creatures need to thrive. The list of salmon species and specific genetic populations of fish at risk of extinction continues to increase. The land creatures and birds that depend on salmon for food also struggle, as do the second- and third-growth forests that depend on decaying salmon consumed by terrestrial mammals, such as bears. The effects of climate change are raising summer water temperatures in rivers and decreasing snowpack, especially in the Cascades and in the southeast basin. A broad, developing sense of scarcity further challenges the notion of endless supply that confidently built the system of dams and canals, increasing the tension between two value systems.

In the 21st century, however, these divergent attitudes toward water may be experiencing somewhat of a rapprochement, circling each other, swirling around the rim of the basin's craggy bowl. Though the river system itself appears to be completely locked down in a series of tightly controlled hydro and irrigation projects born out of societal values that favor agriculture, though only a few symbolic yet still functional fish scaffolds remain at Celilo, and though Kettle Falls is, at the moment, only a historic fishery, something about the river's wild grandeur remains. I feel that spirit sometimes when I travel the Columbia on its voyage from source to sea. The river brims with potential for transformation and change. Geology teaches that

heat and pressure can transform the shape and height of bedrock. It can create new types of rock, birthed from that intensity. One could say that the Columbia River Treaty and the warming climate of the basin also stand at the nexus of impending transformation and renewal.

An expression of how dense limitations can transform into possibility is the eventual cooperation between irrigators and the Yakama tribe in the bone-dry Yakima River basin, near the geographic heart of the Columbia's surrounding watershed. Its contemporary story demonstrates how asserting the force of justice through courts can reach a limit that human hearts can surmount. By the early 21st century, a nearly intractable face-off had developed—between the needs and desires of farmers with legally protected water rights and the equally legal treaty rights of the Yakama, who wanted to improve the health of salmon spawning streams on their land. Solutions finally began to emerge, but not through the courts. Personal conversations and relationship-building softened positions, supporting the development of kinship. Ten years ago, Urban Eberhart, the manager of the Kittitas Reclamation District, who grew up on a farm in the basin, well understood the imperative and the risks at hand: "We won't recognize this economy or this ecosystem if we don't act." Today, Joe Blodgett, a Yakama Nation fisheries project manager, calls the resulting compromise between two extremes "an amazing collaboration of all these different interests, coming together." Others refer to it as a process of shared sacrifice in which everyone gives up something, but everyone also gains. A decade after those early personal conversations, the Yakima Basin Integrated Plan is now spending tens of millions of dollars, both to increase irrigation efficiency and reservoir storage and to remove fish barriers. Underpinning this integrated plan is a hope for a reliable, resilient water supply for everyone.

Just after formal renegotiations of the 1964 Columbia River Treaty between the United States and Canada got under way in 2016, the Upper Columbia United Tribes (UCUT) published a report that also called for a form of rapprochement between the basin's divergent perspectives. *The Value of Natural Capital in the Columbia River Basin* reshapes traditional Western notions of economic prosperity and considers the true market value of a river that is healthier for all. The year after UCUT released the report, Canada's negotiating team surprised everyone when they invited three of the Canadian Indigenous nations of the Columbia Basin to sit with federal and provincial governments at the treaty table as equal partners. (The fourth, the Sinixt, were not invited to represent Canadian interests because, the Canadian government said, their interests were represented by the US Colville Confederated Tribes.) In light of the Supreme Court of Canada's restoration of Aboriginal Rights to the Sinixt in April 2021, this position could now be called into question. Nonetheless, the move by Canada to establish some if not all Indigenous representatives as coequal signals a potential collaboration that could have lasting impact across the entire international watershed.

"Natural capital" is new language for an old concept: the measurable economic value of land and water. Western economics defines capital as an asset with monetary value. Corporate interests have historically viewed conservation or care of land and water as a lost opportunity for wealth, not a gain. What might be the "market value" of a landscape that supports prosperity for all beings? The UCUT study integrates these two value systems that have historically been in strict opposition to each other. Valuing hydropower at US$3 billion (CA$3.9 billion), for example, the report suggests that a US$69 million (CA$91.3 million) decrease in hydropower output (by allowing some water to flow through dams for fish flows, rather than electricity) would result in an overall increase of 50 percent (US$1.5 billion [CA$1.9 billion]) in the basin's economic wealth. Contrary to the argument that water spilling over dams is "wasted," the report suggests economic gain when flows increase modestly

for natural habitat. Water flows help juvenile fish travel downstream to the ocean, oxygenate water, and cool the mainstem river as mature spawners return upstream in summer and autumn. Flows also work to transport nutrients, increasing food-web vitality at the most microscopic levels. Integrating ecosystem function into river operations could be a win-win in which everyone ultimately benefits.

To that end, the report's proposed ecosystem function aspires to (1) increase spring and early summer flows to restore some of the river's natural hydrography, especially in dry years; (2) restore historic fish passage blocked by dams; and (3) reconnect the mainstem and other rivers with their historic floodplains where possible, allowing for more flexible river operations during extreme weather events. The results would enhance the food web, especially in the Columbia's estuary; increase juvenile and adult fish survival; decrease the travel time for outgoing juvenile salmon to the ocean; and increase the populations of resident fish throughout the basin.

Quantifying natural capital includes measuring the number of people who earn a living from the river through tribal and commercial fishing and their engagement with conservation, parks and recreation, wilderness and fish guiding, salmon mitigation projects, and water management. Of course, shifting river operations in this direction has the potential to further strain existing economic structures. As renewable energy sources come on stream, hydropower companies struggle with the decreased value of electricity on open markets. For them, more than ever, every drop of water has become economically precious. They see ecosystem function as a further erosion of their prosperity. Add to that the rise of energy-hungry, high-tech industries in coastal cities; the use of Columbia River cold-water flows to cool giant cloud-computing servers; the growth of Boise and other cities in drier parts of the basin—all are factors that pressure the river and its tributaries to continue to give their riches within an accepted economic model of hydropower, flood control, and irrigation.

Another opportunity to rewrite the relationship between contemporary human populations and water, one central to the continued livelihood of so many international basin residents, is the shape of the Columbia River Treaty. The original intent of the treaty

A grizzly bear sow and cub fish for kokanee salmon on a tributary of the Kootenay River in fall.

THE GRACE OF WATER / 69

THE VALUE OF NATURE: THREE PERSPECTIVES

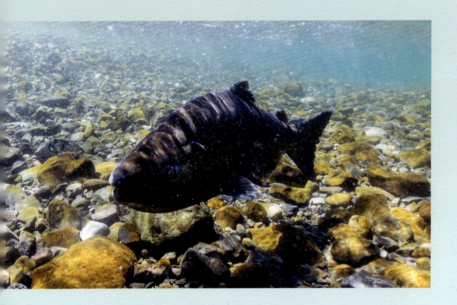

ECOSYSTEM SERVICES

Natural processes offer a life-sustaining benefit for human beings. This benefit is frequently overlooked or undervalued and can be valued monetarily. The basin offers many vital ecosystem services.

› Store, filter, and provide abundant clean water.
› Sustain sources of food and medicines: fish, wildlife, and plants.
› Provide clean air and fertile soil.
› Control erosion and regulate climate.
› Intercept rainfall and mitigate flooding.
› Sustain culture.
› Support healthy recreation.
› Provide jobs.

ECOSYSTEM-BASED FUNCTIONS

This worldview embraced by the Columbia River Basin Tribes accepts that human beings are an integral part of ecosystems. By virtue of existing, the natural world has a voice and value. The basin fulfills numerous ecosystem-based functions.

› Nurtures tribal subsistence and cultural traditions.
› Preserves tribal First Foods, including water, salmon and other fish, wildlife, berries, roots, and traditional medicinal plants.
› Restores tributaries and floodplains with an enhanced food web and salmon populations.
› Supports an increased and more natural rate of flow.
› Responds to environmental conditions, including climate change and greater demands as the human population increases.

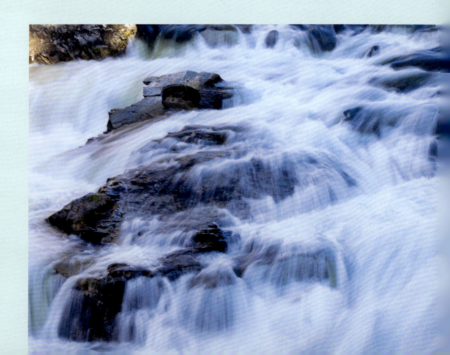

BUILT OR NATURAL CAPITAL

Human beings have altered the natural river in innumerable ways. The resulting stress of built capital on the river's ecosystem has led to a decline in the services the ecosystem naturally provides—also called natural capital. Increased value placed on one service (such as dams for hydropower) leads to the decrease in the availability of others (viable salmon populations). Human actions have altered the river.

› Construction and operation of dams for energy
› Agricultural systems and irrigation
› Building and situating cities and businesses close to economic and ecological services
› Navigation (including dredging and locks) for vessels that convey people and products

Economic exploitation of the river basin's natural resources has led to changes affecting not only the well-being of humans and other living species, but ultimately all economic enterprise. Human beings have changed ecosystems more rapidly and extensively over the past century than in any other comparable period in human history. As stressed ecosystems change at an alarming rate, studies indicate that businesses are most likely to prosper from developing strategies that benefit overall ecosystem health.

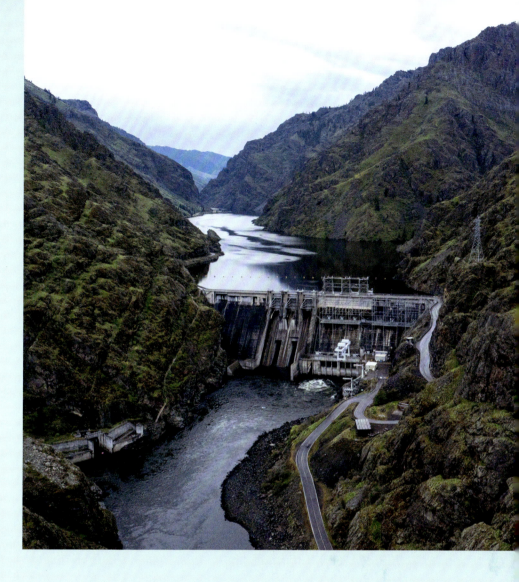

According to a recent comprehensive analysis, if the Columbia River watershed realized even a 10 percent increase in ecosystem-based function, it would likely increase natural capital by US$19 billion (CA$25.6 billion).

Source: Adapted from *The Value of Natural Capital in the Columbia River Basin*, by Lola Flores, Johnny Mojica, Angela Fletcher, et al., published by Earth Economics.

THE GRACE OF WATER / 71

was to protect human property and provide abundant, inexpensive electricity for industrial resource extraction and urban growth. The 2024 expiration of its flood control benefits and the renegotiation of the agreement and its aftermath are situated in a climatic scenario the treaty's authors could never have imagined. While the increasing number of dry years make Canadian flood control sometimes seem less significant, a few tremendously wet years (most recently, 1996 and 2012) are a reminder that more extreme conditions may soon be the norm in water management. How will river flows be managed in a climate-changing world? Another unimaginable cultural shift since the 1960s has been increased public awareness about the health and well-being of salmon, marine mammals, and other aquatic species. How can management of the Columbia and its tributaries better support the health of anadromous Pacific salmon, lamprey, steelhead, and sturgeon, and, in turn, other species on the land and in the air that depend on fish populations?

Since 2011, several international symposia have been organized to ask these exact questions. The symposia have been attended by a diverse collection of people: hydropower executives, Indigenous tribal members, academics, government resource managers, students, and others, from both sides of the international boundary. The possibility of changes to the treaty catalyzed a fresh look at water management. The evolving state of the river's ecosystem has propelled us all into much deeper and broader currents of thought, well beyond the written agreement: about Indigenous sovereignty, climate change, water supply in the west, and the fate of Pacific anadromous fish. Each year, American power producers must sacrifice some of their monetary profits and other management goals to fund fish mitigation efforts. In Canada, the 1942 extirpation of salmon due to the Grand Coulee Dam means no such river imperative exists. Yet, cold-water supply, stored in the upper watershed above the boundary, is important to anyone who knows what salmon need to survive. The system that provides that water storage in Canada caused enormous ecological damage to forestry, tourism, and the livelihood of Canadian farmers. What is the value of the "Canadian" storage, and who should benefit?

In a typical year, Canada's contribution to the Columbia's *entire* water volume hovers around 40 percent, despite its land area comprising only 15 percent of the watershed. In the increasingly frequent drought years, Canada's contribution to total water volume as measured at The Dalles, Oregon, can rise to 50 percent. This outsized contribution of top-end snowmelt carries greater weight in all transboundary discussions.

The basin's competing cultural value systems have, over the past few decades, intensified into a situation that can only foretell a transformation. Whether it's through discussions of dam breaching, or increased spring and late summer water passage, or how to define prosperity, or how to compensate for international water storage, these challenging discussions are worth the effort. In the crucible

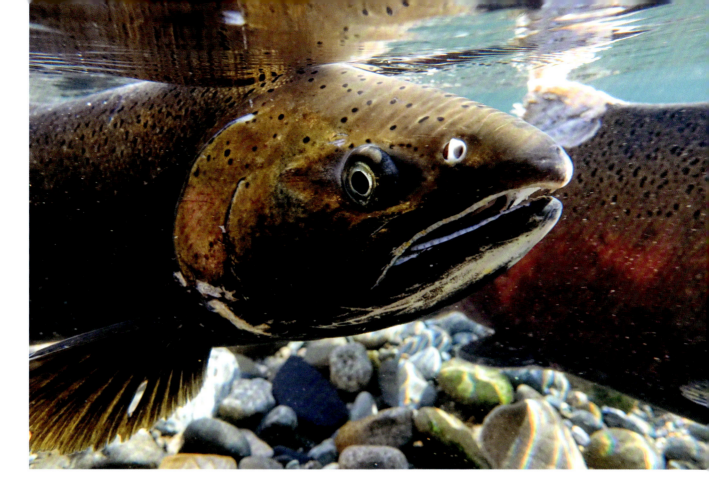

A female coho attended by a male at a redd in the Methow River watershed, Washington.

OPPOSITE Chinook salmon pack into the tributary of the Big River where they were born on their return journey to spawn on the Oregon side of the Columbia River Gorge.

rests the possibility of something glittering and precious to emerge: a healthier, more balanced river, one flowing for the benefit of all.

Standing together across differences, sharing perspectives and values, has never been more important.

RECIPROCITY

Reciprocity underpins all strong relationships—the more equal an exchange, the stronger and more resilient a connection can be. Natural systems of tremendous profusion and diversity have long evolved from this basic principle, as have healthy human families and societies. Animal and plant species exist together, seeking balance, with the needs of one answering the desires of another, thus strengthening the ties between them in what is often called a "web of life." Add appreciation, generosity, and love to this web of relationship, and something else happens. One offers what another might need or desire. Rather than *taking* what is offered, the other *receives* it. Intention and gratitude weave their way, and the web's tensile strength increases.

Dams are a remarkable invention. They have brought great prosperity to the Northwest. Yet nothing under the sun is either all good or all bad. In addition

THE GRACE OF WATER / 73

to their tendency to unnaturally inundate landscapes and control the free flow of water, dams have another significant downside, one that the hydrosystem's architects had little awareness of when they were designing it. Dams interrupt a gift exchange between water and land, one that had evolved over millions of years in the Columbia Basin—the salmon-to-ocean-to-land-and-back-again process. In doing so, they interrupt the often unseen movement of sediments from terrestrial sources, those that contribute vital structure and minerals to riverbeds and shorelines. This nutrient cycle, born from species and landscape interrelationship, had once been strong enough to find its way through shifting slabs of glacial ice but now meets an impenetrable barrier in imposing walls of concrete. The human culture built up around the dams may itself also have reached the point of taking more than giving. The scarcity being experienced in the entire hydrological system may signal that it's time for a different, more giving, expansive relationship with the river.

The opportunity for renewal that presents itself has been many decades in the making.

The 1973 Endangered Species Act set a framework of recognition in the broader culture about human impacts on the health and well-being of natural systems. Then, in 1980, in the further aftermath of the salmon wars, the US Congress passed the Northwest Power Act, requiring federal dams to mitigate, enhance, and protect salmon in the American portion of the Columbia River basin. Everyone knew that the exercise of tribal fishing rights depended on the existence of fish. By the mid- to late 1990s, a species review of the entire US basin, plus years of freshwater drought and unfavorable ocean conditions, led to numerous anadromous salmon and trout species showing up on the endangered list. Government agencies began to address the issue more urgently. Fish hatcheries, originally designed to restore stocks (in support of canneries), gained increasing prominence as a possible solution to the species crisis. This increase of hatchery output was controversial. Hatcheries provide an agricultural approach to fish, one that turns them into a crop to be harvested—a reciprocal, wild, and natural gift from the sea to the land and back to the sea again.

A scientifically well-documented consequence of emphasizing numbers of fish produced over connection to habitat and home has been the loss of genetic variation. Females and males, selected for health, size, and other determinants of viability for a species, are stripped of their eggs and milt to create engineered offspring. This process cannot replace the orgiastic spectacle of natural stream-spawning, one that includes salmon who stray from their natal stream. What results from the former are reliable but genetically limited populations. What results from the latter is priceless: genetically diverse, robust, and locally adapted fish. Some researchers even argue that hatcheries are completely antithetical to restoring salmon stocks because of the harm they do to the wild populations by removing that genetic diversity and robust outcome that comes from free adaptation. In terms of viability (and its twin, variability), hatcheries can compound species loss and diminish local adaptation, even as sheer numbers of salmon entering the system support the continuation of tribal and commercial fisheries. In addition, fish from hatcheries are often fed by human hands and learn to swim toward people, not away from them. They grow to maturity in the confinement of concrete raceways. Whether a mature fish originates from the wild or a hatchery can in fact be confirmed quickly by both the adipose fin, clipped by the hatcheries during rearing, and the dorsal fin, visibly battered from crowded conditions in the linear channels in which hatchery fish are born and raised.

But in an already tightly rationalized water system, where natural flows have been highly controlled, apportioned, concretized, and monetized, don't hatcheries make the most sense? After all, engineered solutions have succeeded many times in other parts

SHELLY BOYD

"The Sinixt are coming home and it's about time the salmon did too."

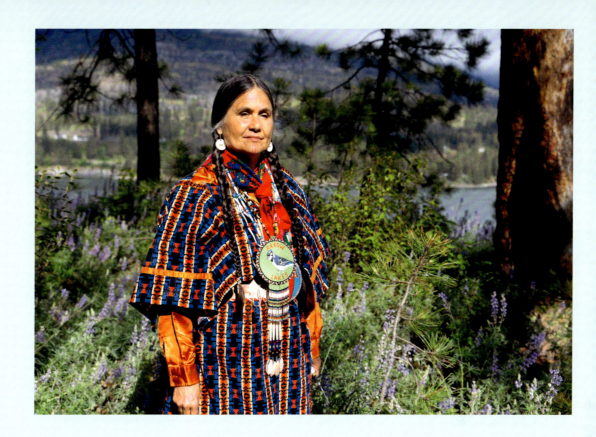

Shelly Boyd, former Sinixt/Arrow Lakes Territorial Land Advisor, is a passionate advocate for preserving the cultural heritage and traditions of her people. She was photographed near Sx̌ʷnitkʷ (The Kettle Falls), where her people once welcomed thousands of people for an annual salmon fishery. The falls are now flooded behind Grand Coulee Dam and the fish runs extirpated.

of the Columbia Basin over the previous decades—for agriculture, for flood control, for clean energy. Or have they?

In 1993, Thomas Kline, a research scientist at the Prince William Sound Science Center in Cordova, Alaska, stumbled on remarkable proof of the give-and-take between mountain streams and the sea. Using the same sort of isotope analysis that confirmed the Ancient One's consumption of glacial meltwater, Kline identified the microscopic presence of potent marine nitrogen in algae and aquatic insects thriving in water far inland from the sea. Up to 90 percent of the nitrogen in the algae, and 70 percent in the zooplankton, was a marine source that had penetrated the terrestrial ecosystem. That source? Salmon.

Several years later, biologist Jeff Cederholm took Kline's analysis one step further. He seeded streams devoid of wild salmon with spent hatchery fish and sat back to observe manifold creatures—from the largest grizzly bear to the smallest mouse and wren—gather in for the buffet. Researchers began to refer to salmon as a keystone species, one that made possible the survival of many others, including those invisible to the human eye. Even the trees and plants surrounding these streams have shown measurable health and well-being from marine nitrogen in a now well-documented symbiosis known as the Salmon Forest. Slowly, Western science was confirming what Indigenous science knows through millennia of observation: the reciprocal gifts of salmon.

From the tribal perspective, the salmon offer themselves as a gift. Human beings receive that gift, obliging them to give as well. At salmon ceremonies, tribal people perpetuate the generosity of the fish through offerings of food, beadwork, blankets, and other gifts.

Buffet tables groan with roasted salmon, salads, bowls of precious traditional plant foods (huckleberry, bitterroot, camas), and pots of venison stew. No one leaves hungry or without a gift in their hands. For thousands of years this generosity has been going on, and it remains far from commercial, though also largely out of mainstream public view. Today's tribes do sell some of their fish, as do settlers, yet they participate in only a limited way in a commercial system that they did not establish, a system that tried to overtake their own values. The culture of bigheartedness remains, as it must, for it is a central Indigenous cultural law in the Columbia Basin. Gratitude and respect for the returning salmon carry a sacred responsibility: to spread prayers and the spirit of the salmon, between each other, and back to the river.

While hydropower has often and quite rightly been saluted as "clean energy," the built infrastructure and management of water is not untainted in how it strains the basic principle of the basin's natural ecology and economy—balanced exchange. Gravity carries water downhill to the sea, but only fish can carry the ocean's goodness back up to benefit the landscape. The 1980 Power Act authorized the four Pacific Northwest states (Idaho, Montana, Oregon, and Washington) to create a new energy-planning agency, the Northwest Power and Conservation Council. The act directed the council to create a 20-year electrical

The clean rocks in a spot of sunlight is a Chinook salmon redd in a tributary of the Big River. Female salmon use their tails to build these redds, shallow depressions in river cobbles where they lay their eggs.

power plan for the Northwest and a companion Columbia River Basin Fish and Wildlife Program to mitigate the impact of hydropower dams on fish and wildlife. The act also directed the Bonneville Power Administration (the US entity tasked with selling electricity produced by federal dams on the open market) to pay for the work of the council. Fish and Wildlife investments under the program have grown from around US$50 million (CA$66.4 million) annually in the 1980s to around US$300 million (CA$39.5 million) in the 2020s.

In the "American" portion of the Columbia Basin, the council's program coordinates and funds a suite of efforts, including scientific research, stream habitat restoration, improved turbine design, bypass systems (ladders), screens on irrigation pipes (to prevent returning fish from traveling to farm fields), barges (to help juveniles bypass Snake River dams), and, of course, hatcheries. At times, to save spawners from mortality associated with warm late-summer water, salmon are even collected into refrigerated trucks on the Snake system and driven up to spawning areas. Salmon survival has become big business.

In Canada, where hundreds of miles of prime spawning habitat remain out of reach as a result of the 1942 Grand Coulee Dam, intensive hydroelectric development peaked at about the same time that the US Power Act was signed, largely due to public resistance and dwindling numbers of sites that could be dammed. BC Hydro, British Columbia's Crown corporation tasked with constructing and managing the treaty dams and others constructed subsequently in the upper basin, established their own Fish and Wildlife Compensation Program. Unsupported by any legislative muscle, absent of the need to address the extirpated anadromous salmon or to be guided by Indigenous rights in a treaty, the BC Hydro program has been modest, and for decades it remained entirely outside the influence of Canadian Indigenous nations. Yet, even the more robust American movement toward a reciprocal relationship with salmon was still largely without, if not completely absent of, any sense of the sacred.

Improvements focused on quantity, not quality, and leaned heavily on Western science. For the Bonneville Power Administration, the Bureau of Reclamation, and corporate entities, funding salmon mitigation was still a requirement, not an empathic offering.

Reciprocity functions best when freely tendered, with generous intention. The 1980 Power Act had invited justice to the table and also given some weight to the tribal perspective. Just as the Boldt Decision had confirmed the tribal right to fish, the act at that point gave tribes a say in repairing and possibly restoring the system. As mitigation efforts matured and gathered steam toward the end of the 20th century, tribes had more opportunities to express their values and attitudes. Their approach to natural resources has been neatly summed up by Keith Kutchins, a basin fish biologist employed by the Shoshone-Bannock and other tribes over three decades: "The tribes don't manage resources. They manage their use of resources." These three additional words—*their use of*—make a whale of a difference. Human beings have a lot of choices, choices that are always, absolutely, linked to a system and how it functions. Indigenous perspectives take into account the capacity for human harm, as well as the power of remedial action and loving intent.

SINCE 2016, I HAVE ATTENDED several salmon ceremonies upstream of Grand Coulee Dam, hosted by the Colville Confederated Tribes. In traditional times, these ceremonies celebrated the return of the salmon in the spring. Now, they pray for a blocked fish to find its way again. At the events, I have benefited from tribal generosity that honors the gifts of salmon. Food—offered freely by the tribal host to all who come. Blankets, T-shirts, cedar strips woven into rosebuds, and more—all are gifted. The drumming and spiritual songs contain so much emotion that it could only be true longing, or even love, floating across the air.

At one ceremony in 2019 to mark a cultural release of what the tribes call "hatchery extras" into the reservoir upstream of Grand

Coulee Dam, I felt that love physically. Standing in the shallow water, well away from the area where the salmon were being released, I felt before I saw one of them when it darted unexpectedly in my direction and grazed my calf, then disappeared into deeper water. A bolt of pure energy charged through me. Over the next few days, I dissolved into a weeping mess. When I called a tribal friend to help me understand what had happened, her words pulled at my heart in a way I had never before known. *"Eileen, there isn't any difference between the Salmon Spirit and the Holy Spirit. Hang on for the ride!"*

Today, more and more people across cultures in the international basin are feeling the pulse of fish. Public attention focuses on what can be done. More ladders? More barges and other methods to help young fish safely bypass the generators and move downstream? Out-and-out dam removal? Hatcheries and how they are managed—these options are rarely mentioned in public debates over what to do. Are the hatcheries a crutch that needs to be leaned on less often, part of an overly rational system that further rationalizes and threatens the fish? Or might hatcheries become a modern version of reciprocity?

The primary tool in basin-wide salmon mitigation today, hatcheries have been in the lower reaches of the Columbia since the 19th century. Developed originally in Europe in the 18th century to address overfishing and ensure food supply, they were used initially in the basin solely to increase salmon populations for canneries. As dams proliferated after the mid-20th century, more and more hatcheries poured more and more fish into the system, propping it up. Tribes continued to exercise their treaty rights, harvesting fish on the Columbia and its tributaries. Commercial boats continued to catch fish in the open ocean. Hatcheries were accomplishing a purpose—keeping the salmon from disappearing. A few experts question whether there would be any salmon at all in the Columbia today without the hatcheries and suggest that this solution may now be a permanent part of the basin's ecology.

The National Oceanic and Atmospheric Administration, the US federal agency that oversees today's commercial salmon fishery, directly links the number of fish produced and released at hatcheries to the annual allowable harvest in the Pacific: more hatchery fish, more offshore fishing. It sounds somewhat like reciprocity. But in doing so, the agency perpetuates what others claim is the nail in the coffin for wild fish: an open-ocean harvest where all salmon are created equal, irrespective of the length of their life cycles or of their homelands. Immature salmon, spawn-ready salmon, salmon bound for the upper Snake system, salmon headed up the Deschutes, salmon headed to the "Canadian" Fraser River, Alaska salmon, California salmon, wild salmon, and hatchery-reared salmon— all are caught and hauled in together. Some Chinook salmon are bycatch for pollock (breaded by fast food companies for fish sandwiches); some steelhead trout end up in mackerel nets. Wild fish advocate David A. Moskowitz describes the open Pacific as a sort of oceanic Serengeti, one that "we are now treating like a cornfield in Iowa." The mixed stock, nonselective ocean harvest disrupts any effort to balance wild and hatchery-raised fish in the river's mainstem, thus handing the wild ones only a slim chance at survival, let alone profusion.

It's difficult if not impossible to underestimate the complexity and controversy embedded in the operation of contemporary hatcheries, one that tilts quickly into a full-scale disagreement between their negative and their necessary qualities, rather than exploring whether careful use might foster harmonious give-and-take from the heart. Indeed, as the tribes insert themselves and their values more significantly into the system, hatcheries have started to change. In 2008, nearly 30 years after the passing of the Northwest Power Act, the Bonneville Power Administration, the Bureau of Reclamation, and the Army Corps of Engineers signed the 10-year Columbia Basin Fish Accord with several tribal organizations, who pledged to keep disputes out of court in exchange for more direct engagement

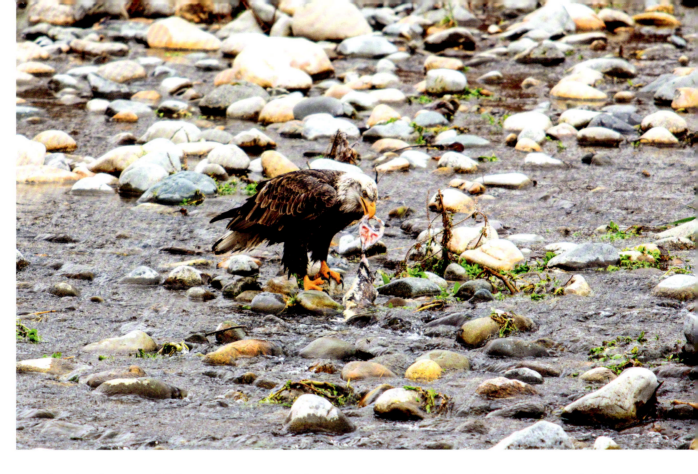

A bald eagle feeds on a spawned-out coho salmon on the Methow River.

regarding hatcheries and fish management. The fish accord is controversial. The Nez Perce refused to sign. Some non-Indigenous fish conservationists believe it keeps tribes from asserting treaty rights.

Yet, some of the tribes that did sign the accord do not have any treaty rights at all, such as the Colville Confederated Tribes. They are governed instead by US "executive order." Several years before signing the 2008 accord, the Colville Confederated Tribes had pressed the Army Corps of Engineers to complete a fourth compensation hatchery for Grand Coulee Dam, at Chief Joseph Dam, below Grand Coulee, the first to block upstream passage since 1979. Only three of the four hatcheries required as mitigation for Grand Coulee had been built—Leavenworth, Entiat, and Winthrop. Due to tribal advocacy, Chief Joseph Hatchery finally opened in 2013.

Regardless of accords and treaties, the tribes of the Columbia Basin have increasingly and ambitiously worked to localize hatchery processes in whatever way they can, bringing fish restoration efforts directly back to the land and water.

The emerging hybrid system—of hatcheries motivated or constructed by tribes—grows at once more opaque and strangely translucent as a spirit of true reciprocity emerges. Rearing channels in newly constructed hatcheries are widening, to give fish more room. They are being lined with gravel and filled

THE GRACE OF WATER / 79

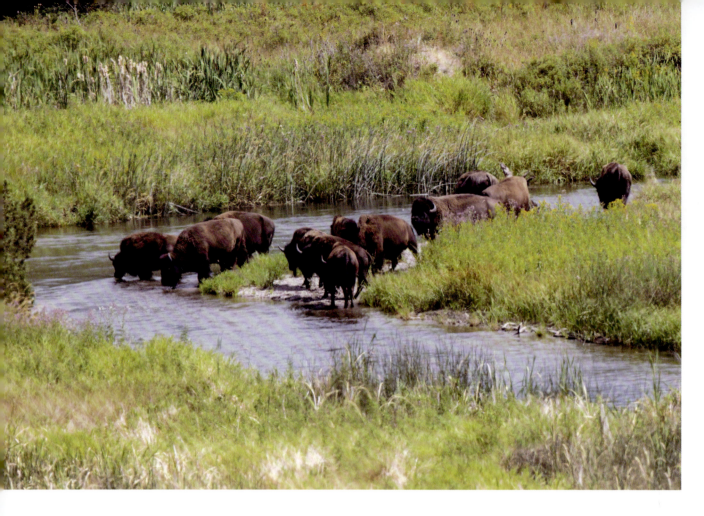

with the river's own water. The tribes are also transporting juvenile hatchery-raised fish to release them into tributary streams, to pattern these fish with the smell and feel of natal areas, in much the same way a wild fish would. Tribes continue to take over or influence hatcheries funded by the federal entities, with tribal values guiding their operation. A partial list: the Nez Perce Tribal Hatchery on the Clearwater River (2002); Kooskia National Fish Hatchery (Nez Perce, 2007); Yakama Nation Sturgeon Hatchery (2008); the Chief Joseph Fish Hatchery on the Columbia (Colville Confederated Tribes, 2013); a state-of-the-art facility for burbot and sturgeon at Twin Rivers (Kootenay Tribe of Idaho, 2019); the Melvin R. Sampson Coho Facility (Yakama Nation, 2020); Dworshak National Fish Hatchery (Nez Perce control of fish rearing, 2022); and finally, a brand-new facility in the Walla Walla River basin (Confederated Tribes of the Umatilla, 2022).

Renewed in 2018, the fish accord between the three federal entities and the tribes continues to encourage collaboration and support place-based fishery restoration.

Meanwhile, in British Columbia, the upper basin's Indigenous nations have long struggled against a

Bison on the Flathead River in the Confederated Salish and Kootenai Tribes' Bison Range

system that never offered them a treaty. The upper watershed's salmon got its first big break in the early 2000s, when, in a quest for sovereign relationship, the Colville Confederated Tribes partnered with the Okanagan Nation Alliance in a transboundary sockeye restoration. The mouth of the Okanogan River (spelled Okanagan in Canada), the access point for sockeye returning from the ocean up the Columbia mainstem, is in the United States. The important spawning and rearing water that the fish sought, Skaha Lake, is in Canada. The sockeye restoration has been phenomenally successful due to transboundary cooperation.

Before restoration, 25,000 to 35,000 fish returned in a highly variable run. In 2022, an astonishing 661,000 fish returned. The 10-year average now stands at 300,000 fish, a ten-fold increase from where the project started. Central to the process is the local nature of the restoration, the focus on removing or modifying passage barriers, and, to a lesser extent, a 2014 hatchery, funded through the Colville Confederated Tribes with US hydropower profits, constructed and operated in Canada by the Okanagan Nation Alliance in a manner sensitive to the fish. A side benefit not to be overlooked has been the return of a river-mouth recreational sockeye fishery near Brewster, Washington. This fishery is open to all people and has proven to be a significant boost to the tourism economy of surrounding communities.

It's not just the fish who are feeling the heart's influence. The watershed's bison, all but eliminated from their lands during a well-documented late 19th century slaughter by settlers, are making a comeback. Both the Shoshone-Bannock and the Flathead tribes now manage large herds in southeastern Idaho and northwestern Montana. They have set aside thousands of acres of federal and reservation lands—on Snake River floodplain soils and in the silted hillocks of the Glacial Lake Missoula floods—to nurture and protect the growth of these herds. In northern Idaho, the Kalispel tribe manages a small herd on the historic Pend Oreille River floodplain, for ceremonial and subsistence food. All these management programs combine a measure of human intervention while preserving the animal's spirit of freedom. The tribes, relating to the bison as kin and in a way consistent with their traditions, offer the animals room to graze and grow as they once did, and in doing so foster a reciprocal relationship that, like that of the salmon, forms a bedrock of generosity in the Columbia Basin Indigenous and ecological culture. Other tribal initiatives include the Yakama restoration of pronghorn to the central basin and the Colville Confederated Tribes' reintroduction of lynx to the inland forests near the international boundary.

The Columbia River basin's salmon got another big break in 2018, when Canada invited three of the upper basin's Indigenous nations to sit at the treaty negotiating table as coequal negotiators with the provincial and federal governments. While the US entities involved in negotiations have persistently resisted inviting tribes to the table, the presence of a coequal Indigenous perspective on at least one side of the border demonstrates a broader shift in values. The entire Columbia River, in this way, has the potential to dissolve the boundary. Indigenous people do not recognize the line separating the two countries but instead see one river, one watershed ecology.

Love of rivers is not limited to the tribal world. It expresses itself throughout the Columbia Basin through fishing, hiking, river rafting, kayaking, and myriad other ways people recreate in and along the waters of the watershed. Any heart's engagement with the natural world can foster human attachment. The trick is to expand that attachment into policy that fosters not just relationship but interrelationship. A stronger and more resilient balance between human-centric values and those that consider the habitats of fish, animals, plants, and water grows out of the cultural heart's capacity for empathy. Love is not an oppositional force. It does not see barriers, concrete or otherwise. It is an inclusive force that can build balanced relationship between hydropower profits, genetic diversity,

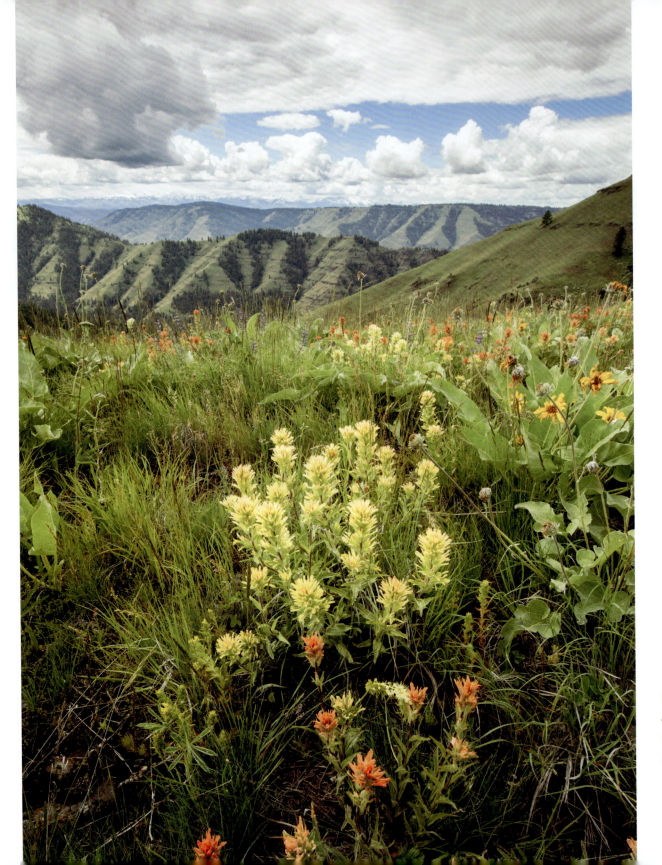

Paintbrush, balsamroot, and lupine in bloom on a ridgetop in Hells Canyon, Snake River watershed

the ideals of wild fish, and the development of marinas, golf courses, or shopping centers.

By stepping in to reform and manage hatcheries, the tribes demonstrate that hatcheries are part of the modern Columbia system. They continue to focus on close interrelationship and observational science. They are persistent. They recognize solutions more than barriers. They are idealistic but also practical.

This much I know: in a hoped-for age of reciprocity, anything human beings give back to the care-worn Columbia Basin, whether on water or land, with hatcheries, habitat restoration, or restored natural flows, will be gratefully received and returned many times over.

TOWARD A CONFLUENCE OF VALUES

As the day I spent with Nez Perce elder Janet BlackEagle unfolded, it took on a dreamlike quality. My notebook remained largely unopened on my lap as we drove along, absorbing the beauty of Idaho's Clearwater River basin, doubling back to Lewiston, then heading southeast and upstream, farther into the mountains, following the south fork of the Clearwater toward Kooskia, where Janet has spent most of her life. We turned off near Kamiah to park for a while so that I could feel the spiritual weight of the basalt mound her people call the Heart of the Monster. We walked the photo wall of the Nez Perce Spalding Cultural Interpretive Center, where Janet recognized many relatives and friends in the archival images, including the leader Black Eagle, two generations descended from Red Grizzly Bear, another leader who had met Lewis and Clark.

Most memorably, we enjoyed a lunch of takeout Chinese food beside the Snake River in Lewiston. This community at the eastern edge of the impressive Snake River canal system sits beside an important watershed confluence, where the Clearwater River meets the north-flowing Snake, as the latter turns west toward four dams that converted this portion of the river into a sort of canal.

Though a brisk wind was ruffling the water's surface, the river passing below our picnic table was starkly geometric and unvaried, a waterway made uniform and predictable for barges. Janet, on the other hand, was not at all predictable. She shared that day that she does not eat salmon. I had never met a Columbia Basin tribal person who didn't eat salmon. I listened as she described how a salmon's slippery skin upsets her when it's served at collective gatherings. She sees blood and death, rather than food. Astonished, I said nothing, at the same time wondering what I had missed. Only a few months later did I have the courage to call and ask her to explain.

Growing up, I was fine with salmon. We had a small well, but we always washed our hair and bathed in the river. I played in the river and swam in the water a lot. I sometimes asked myself as a child, "What would it be like to be a fish?" I had lots of dreams of them, growing up. One of a white salmon. Swimming up. Then the river turned red. I felt that connection. In the old days, at Selway Road, at the falls there, you could count 20, 30, 40 salmon, coming up in minutes. My mother's mother and my mother—they also fished at Celilo. My mother remembers walking across the train bridge as a child, to deliver fish. It was dangerous when a train came. But that was the only way to carry the fish across.

I was at the community supply salmon freezer locker one day. Back in 1987 or '88. Something like that. We keep salmon there for everyone to have. It's meant to be shared and is free for the taking. I took four, or maybe five, for my family. There were a few other families there, too, taking some for themselves. I loaded my share into the cooler and then I heard the other families bickering. They thought what they had wasn't enough. They were arguing. The greed I saw really troubled me. I went right down to the river and apologized to the salmon. I smudged. I thought that would be enough. Then I drove home and unloaded our share of the fish into my freezer. When I went to get that fish out a

month or so later, it was already freezer burned. That was when I realized that something was still wrong. I tried eating salmon after that, but it always made me sick.

Janet abides in an unseen terrain, a place where the heart and spirit travel. It's a landscape of interrelationship so tightly bound that there is no real separation between feelings and knowledge, people and fish, water and land. She speaks a Nez Perce language, Sahaptin, which defines her people not as Nez Perce but Nimiipuu (People That Are Coming Out of the Mountains). Janet epitomizes a word I've learned from the upriver Salish language: *sqilxʷ*. A friend, a Sinixt language speaker, once translated it for me by telling a story. It can go that way—a translation of one word takes 10 or 15 minutes, as the speaker tries to compress an entire worldview, to pull someone like me across the threshold of understanding. She received the knowledge from Tom Louie, a Sinixt-Skoyelpi salmon chief at the Kettle Falls fishery. He had stepped into that work early in the new millennium, following the death of the previous spiritual leader, his close relative Martin Louie.

When my friend asked Tom to explain what *skayluch* meant, he took a piece of paper towel and ripped part of it away. That piece, she explained to me, is a person who is not *skayluch*. "The word doesn't mean 'Indian,' as it's commonly translated." Her eyes grew strangely more intense and loving before she spoke again. "*Skayluch*—it means being joined to the land. You could be any color, any race. When you no longer remember that you come from the land, you are no longer *skayluch*. When you do remember that you come from the land, you are *skayluch*."

Crossing the threshold. Loosening the grip of a mind's patterned ways. Shifting away from human supremacy. Sinking into the unseen beneath one's feet. I have spent most of my adult lifetime feeling for a way to step onto that road. I've apologized a lot. For arrogance and selfishness. For taking more than giving. For ignorance and neglect. Once, I picked every flower in my garden and offered them all up to the river. I watched each bloom find its own place in the current. The flowers danced freely along until, eventually, the water received them.

84 / BIG RIVER

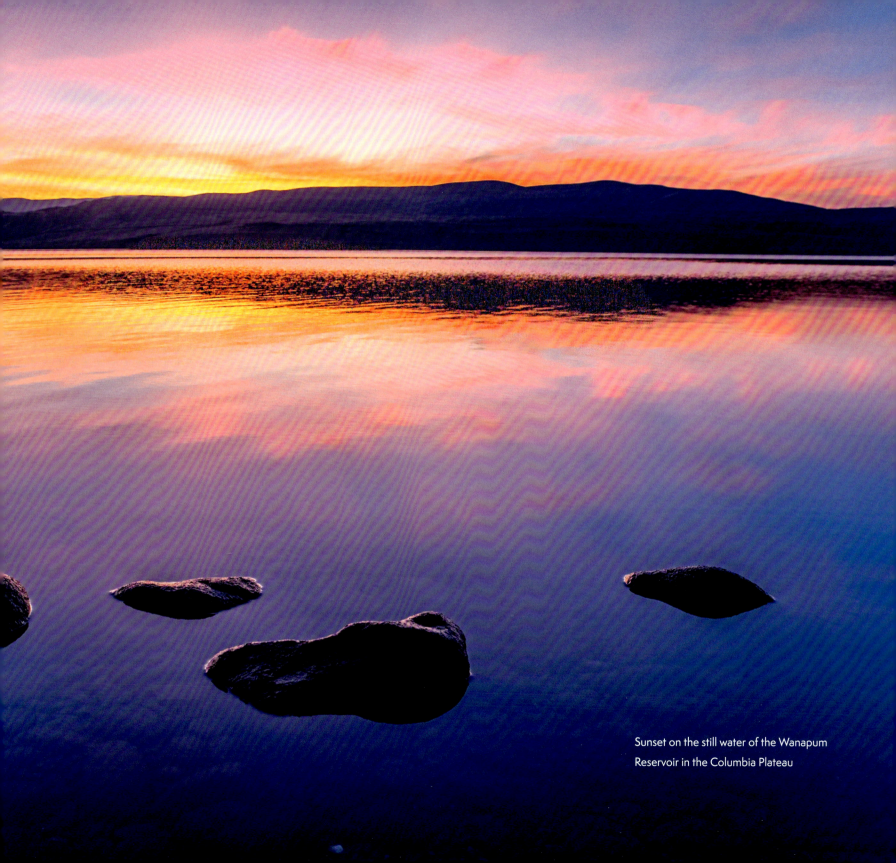
Sunset on the still water of the Wanapum Reservoir in the Columbia Plateau

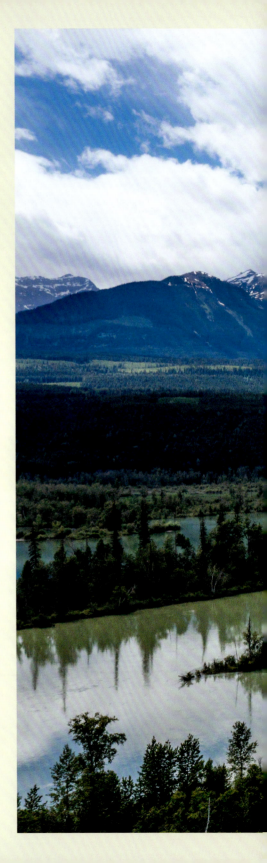

A PHOTOGRAPHER'S JOURNEY

Through the Big River Basin

David Moskowitz

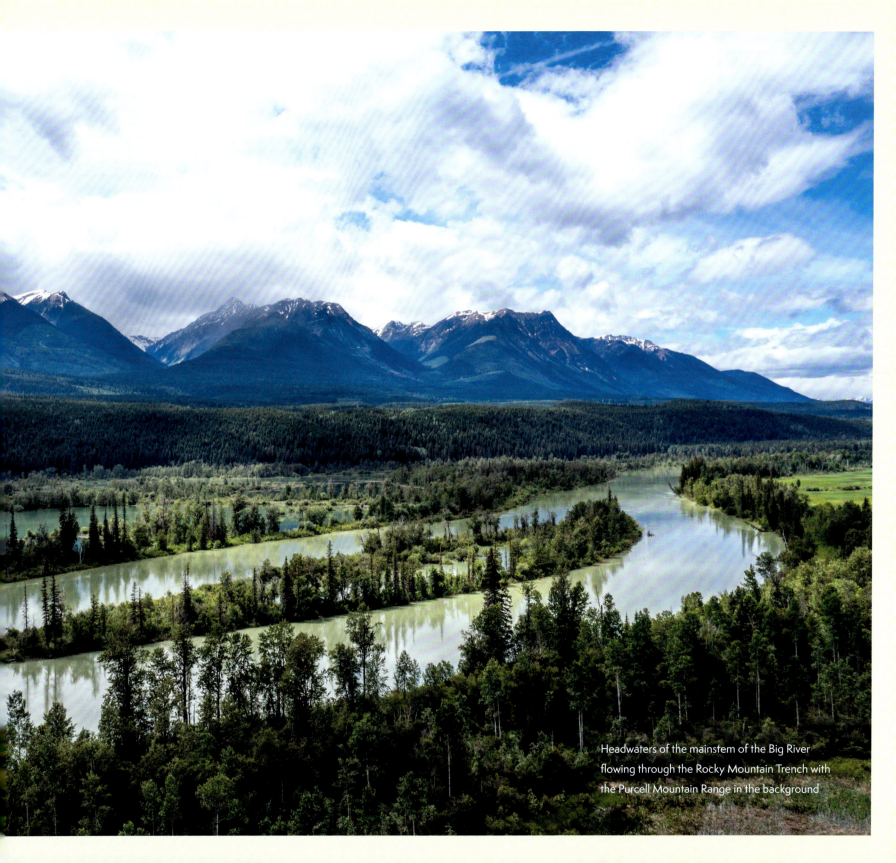
Headwaters of the mainstem of the Big River flowing through the Rocky Mountain Trench with the Purcell Mountain Range in the background

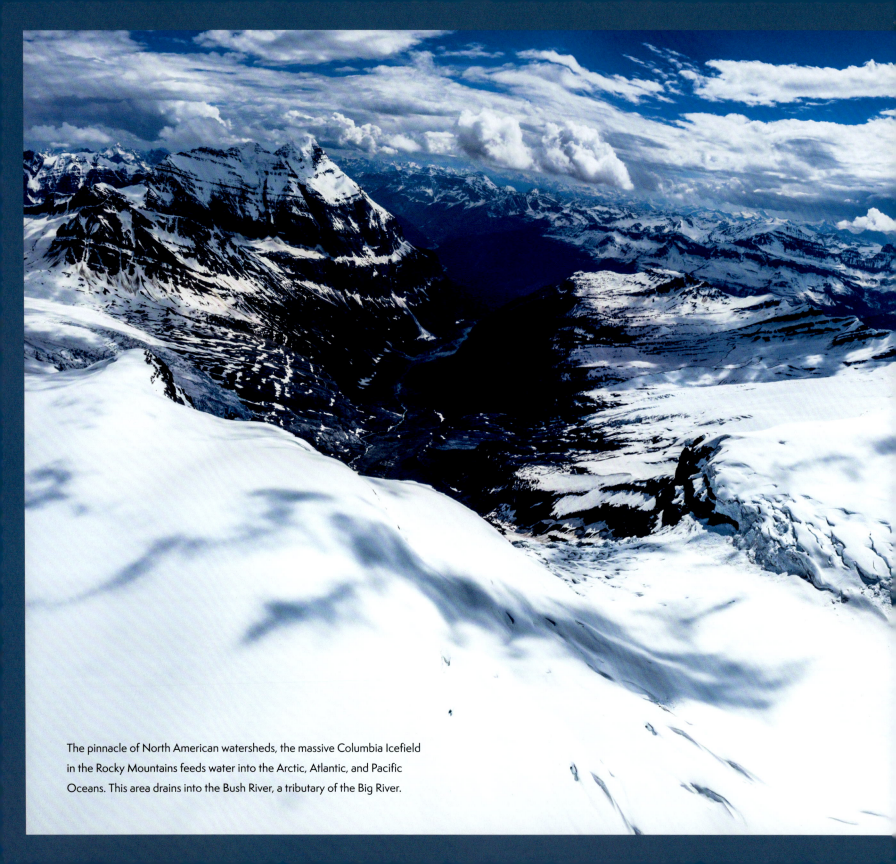

The pinnacle of North American watersheds, the massive Columbia Icefield in the Rocky Mountains feeds water into the Arctic, Atlantic, and Pacific Oceans. This area drains into the Bush River, a tributary of the Big River.

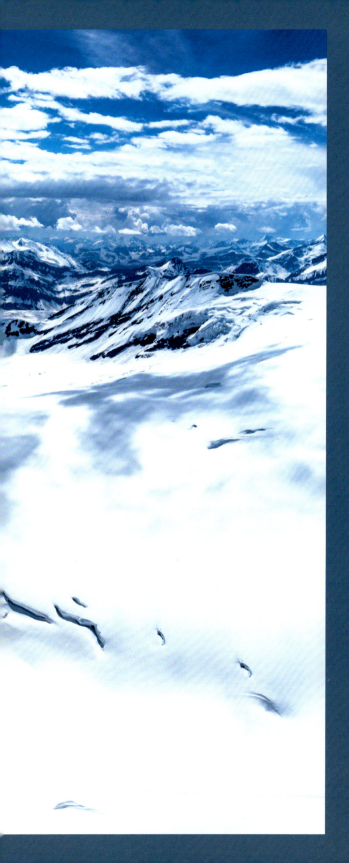
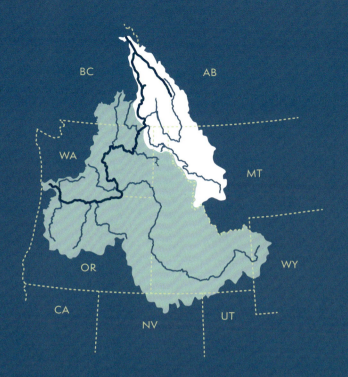

Part 1

COLUMBIA RIVER HEADWATERS

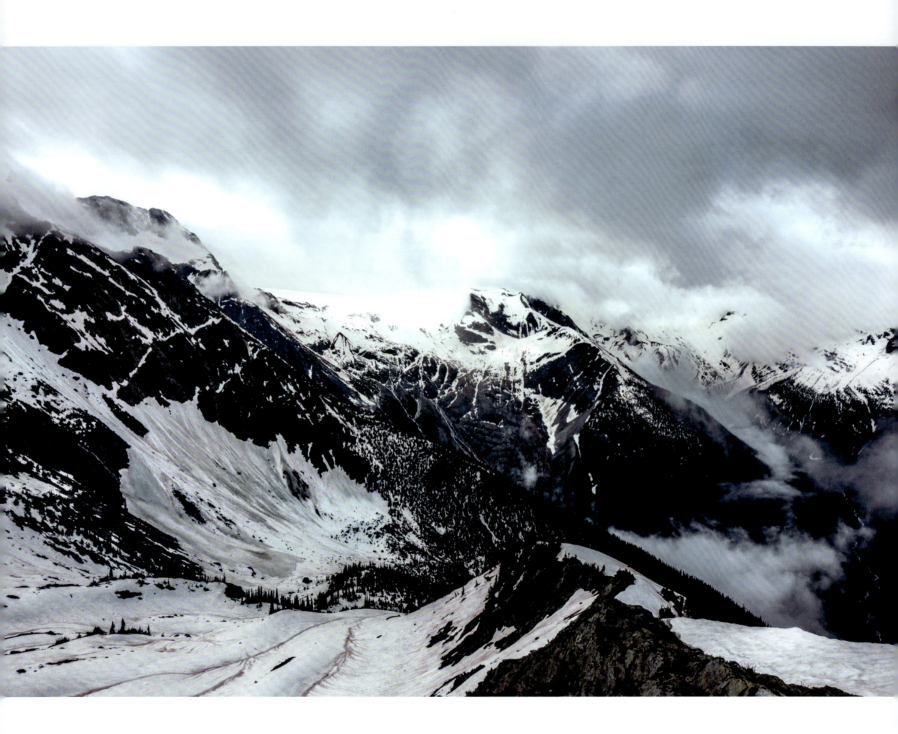

90 / BIG RIVER

OPPOSITE Winter's snow still lingers in the high country in July in the northern Selkirk Mountains, British Columbia.

TOP Rime ice forms on everything exposed to cold wind near tree line in the Monashee Mountains, British Columbia.

BOTTOM Mount Columbia, at 12,293 feet high (3,747 meters) is the second highest peak in the Canadian Rockies.

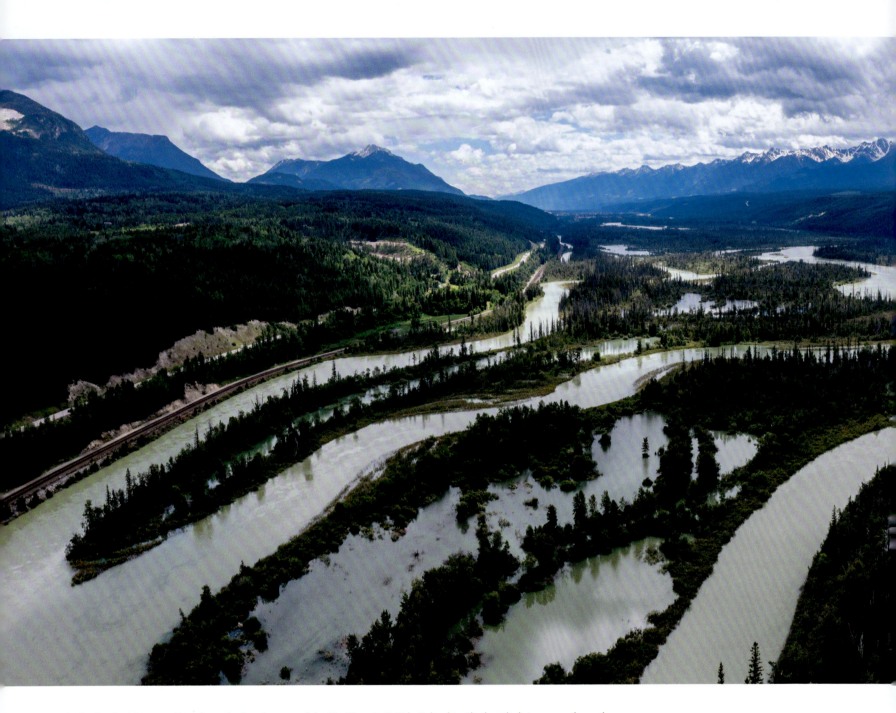

In the Rocky Mountain Trench, at the headwaters of the Big River in British Columbia, the braided river runs through a massive wetland between the Purcell Mountains to the west (right side of photo) and the Rocky Mountains.

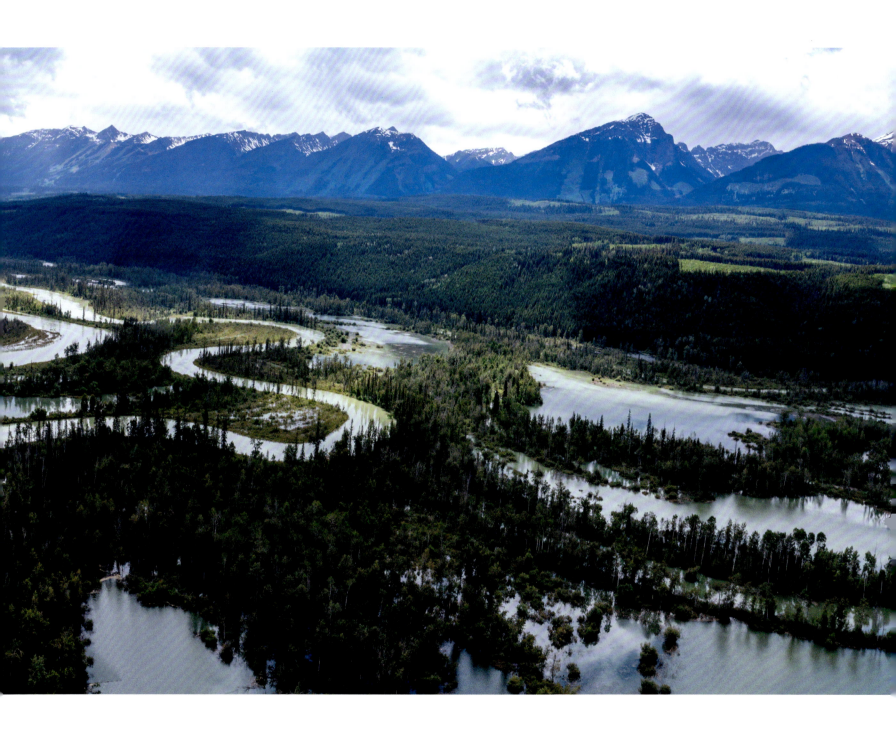

COLUMBIA RIVER HEADWATERS / 93

ABOVE Along with sediment, woody debris flows into the upper Big River in the Rocky Mountain Trench. These materials are vital for healthy river functions.

RIGHT Glacial sediments that flow into the river out of the Canadian Rockies bring nutrients and contribute to the diverse structure of the upper reaches of the natural river's course and flow. Downstream, Mica Dam blocks this sediment from enriching the river further.

OPPOSITE The Big River flows into Kinebasket Reservoir made by Mica Dam, the first of 14 reservoirs on the mainstem of the river from its source to the sea.

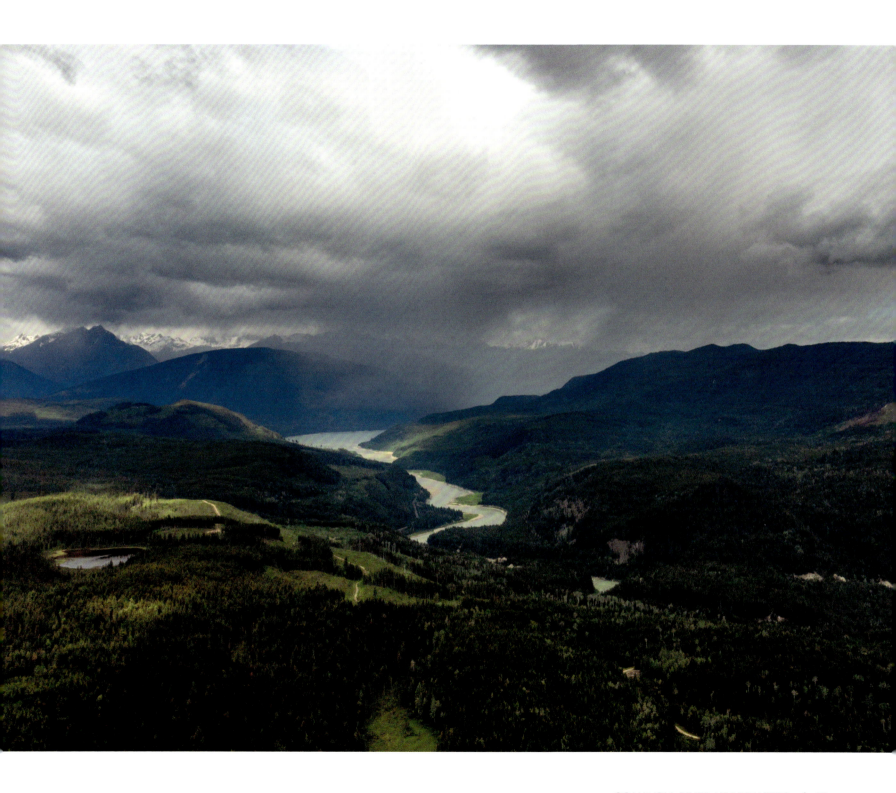

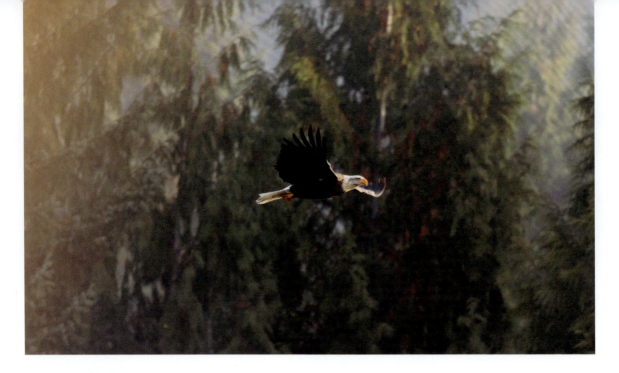

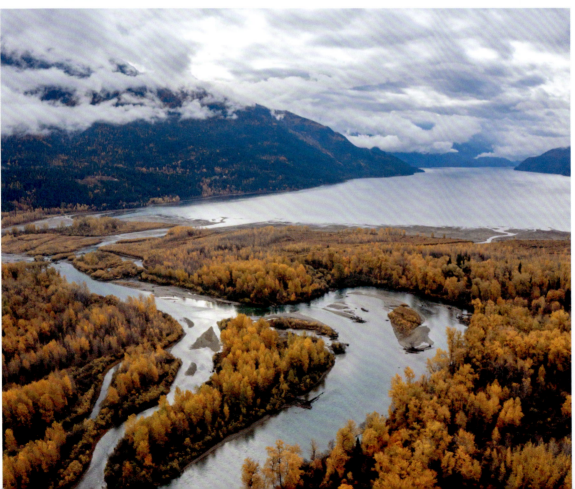

TOP A bald eagle flies through an inland temperate rainforest in the Kootenay River watershed.

BOTTOM Mouth of the Duncan River where it flows into Kootenay Lake, a natural lake the Kootenay River flows through

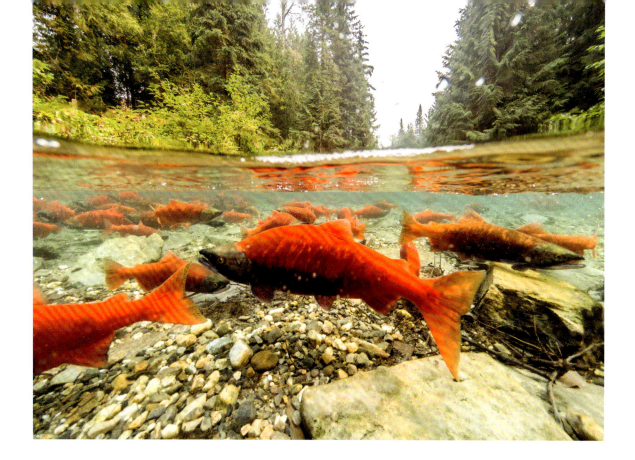

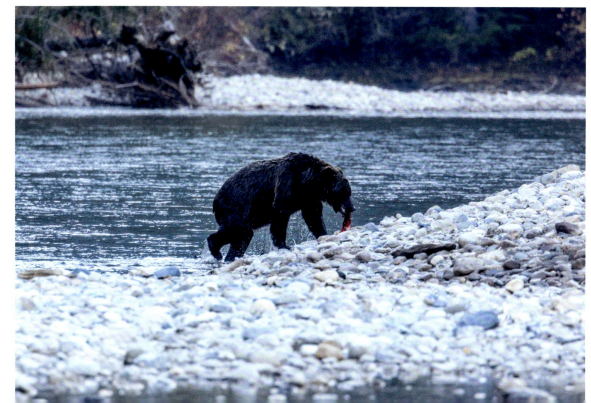

TOP Kokanee are sockeye that have evolved to live year-round in freshwater. Adults live in deep lakes rather than the ocean, returning to natal streams to spawn and die. Kokanee is an Anglicized version of *kəkńi*; the word for freshwater sockeye in Salish is *ńsəĺxĉiń*.

BOTTOM A grizzly bear feeds on kokanee.

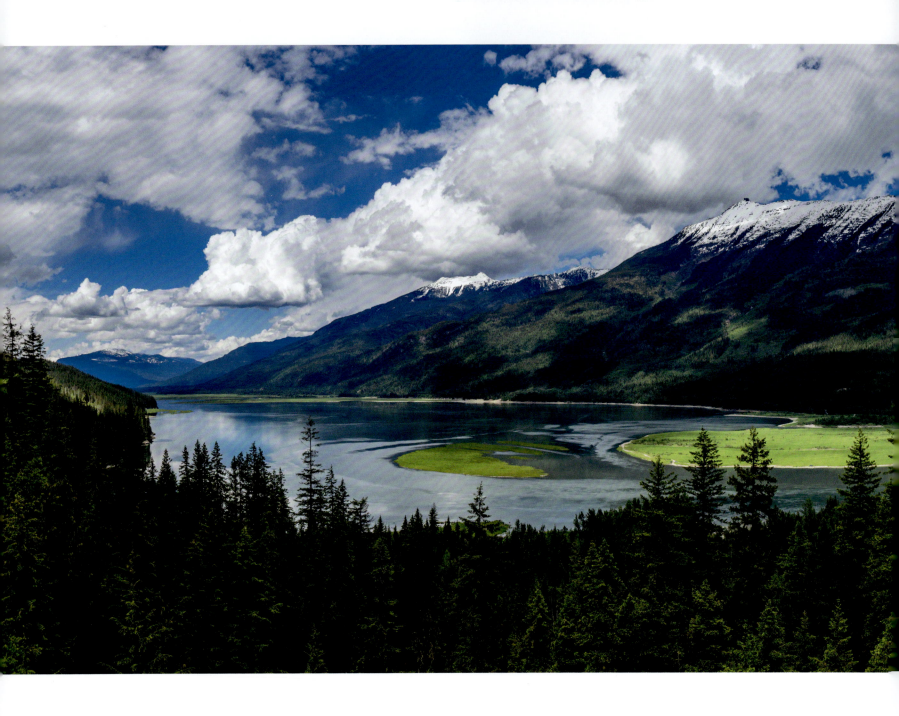

The snow-covered peaks of the Selkirk Mountains rise above the Arrow Lakes Reservoir on the Big River.

DOTT CRABBE

"I lived my whole life in the Arrow Lakes [Sinixt] territory. My mother and I were stricken from the [Colville Confederated] tribal rolls in 1952. My mom spoke the language but would never speak it with me because the Catholic Church told her not to.

"Living here suits me well because I like walking the beaches and picking mushrooms and fishing. I like seeing the lake every morning when I wake up.

"I started collecting artifacts after I was disenrolled. I was walking the beaches and would find where there had been campfires. When I found a pestle, it felt like it was a woman's tool. It helped me feel connected to my lineage."

In her nineties, Dott Crabbe reflects on a lifetime of memories and experiences along the Columbia River, a place that has sustained her ancestors for generations. She was photographed in her house above the Big River in Edgewood, British Columbia. Crabbe has been reenrolled as a member of the Colville Confederated Tribes.

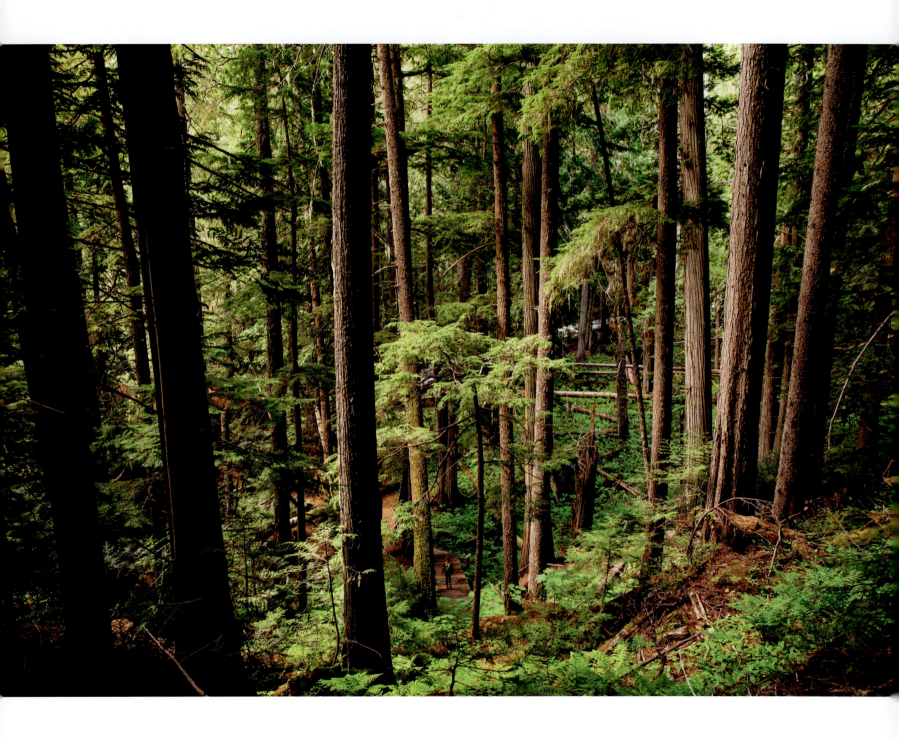

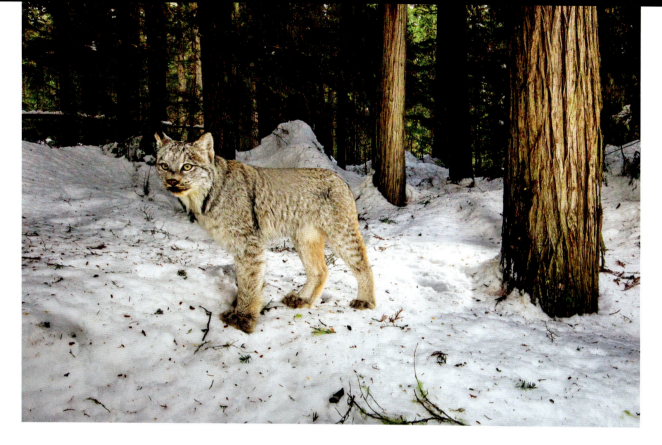

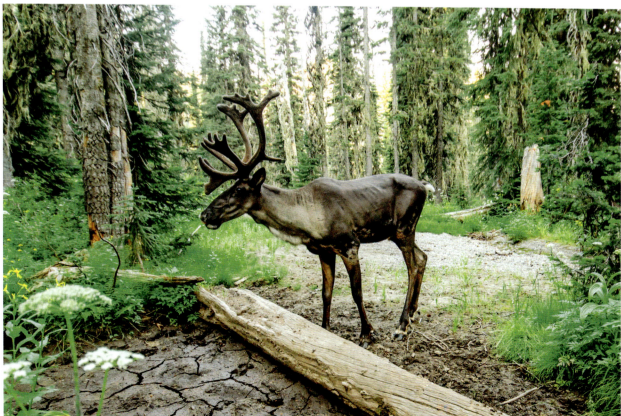

TOP A Canada lynx in a patch of inland temperate rainforest in the Purcell Mountains, Idaho

BOTTOM A bull mountain caribou visits a mineral lick in the Selkirk Mountains. This population of endangered caribou are uniquely adapted to survive the inland temperate rainforest.

OPPOSITE The high peaks and geographic location of the upper watershed have created a landscape that receives a huge amount of snow and rain and is home to the largest remaining inland temperate rainforest on Earth, including this stand of old-growth forest along Kokanee Creek in the Selkirk Mountains.

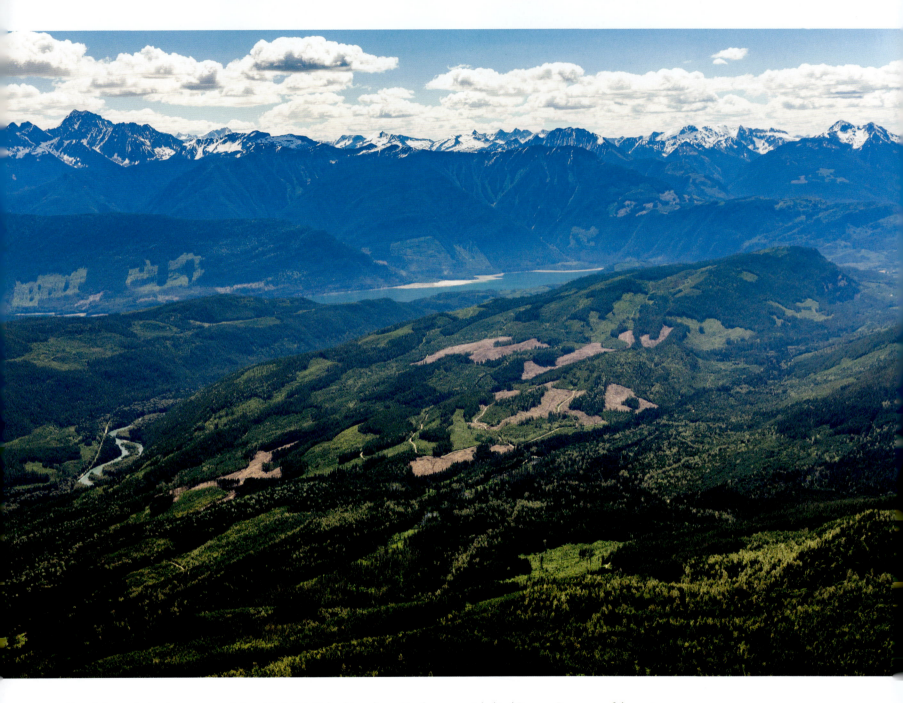

Heavily logged inland temperate rainforest in British Columbia, adjacent to the reservoir behind Duncan Dam, one of three storage dams created under the terms of the Columbia River Treaty that destroyed river valley ecosystems in British Columbia, Canada

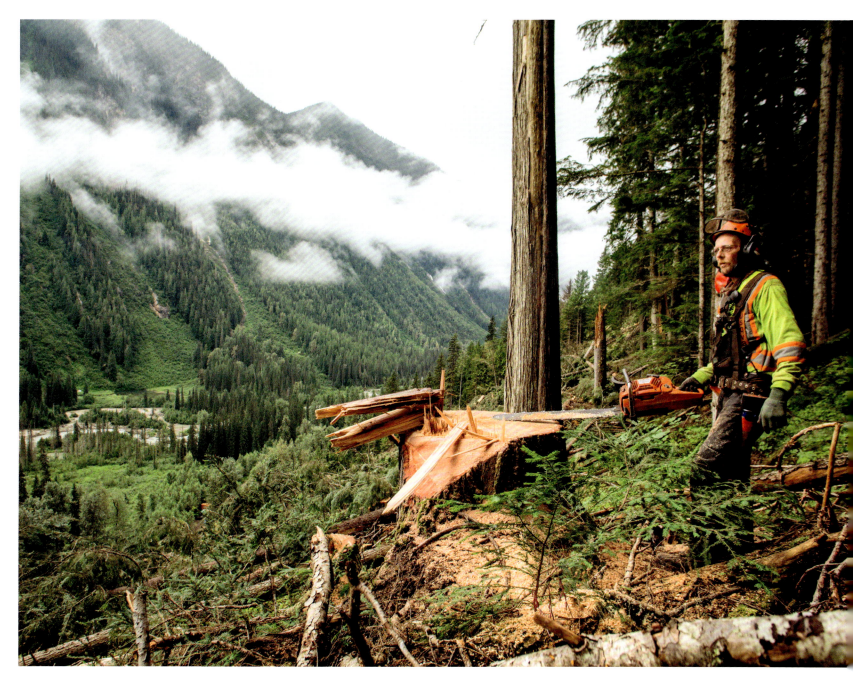

Logger David Walker in the Big Mouth Creek watershed south of Mica Dam (another Columbia River Treaty project) during an old-growth logging operation in British Columbia's Selkirk Mountains

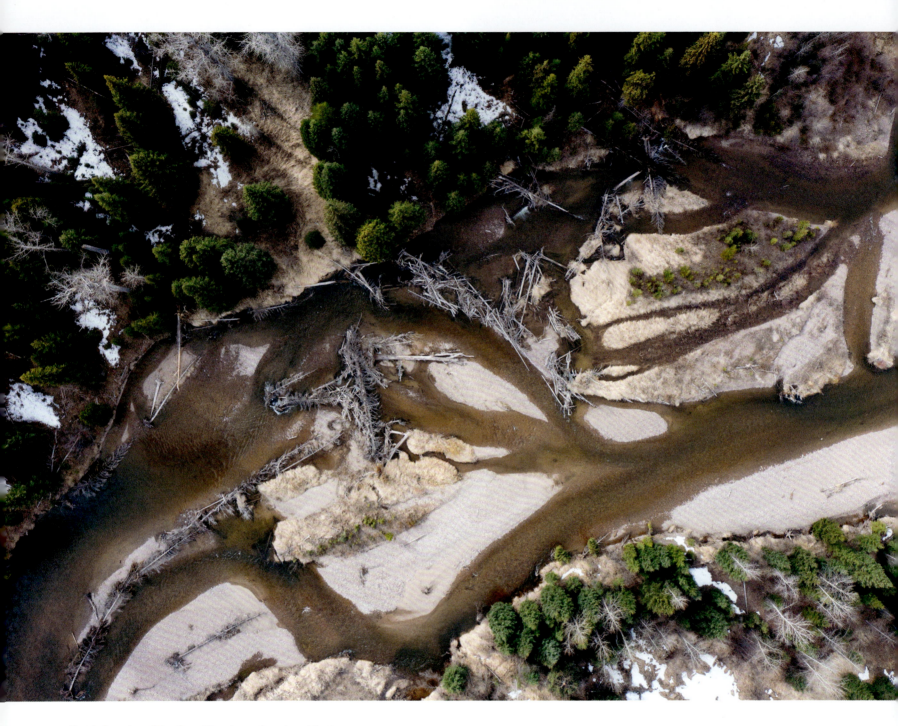

Braided section of the Swan River in northwestern Montana

CASEY RYAN

Casey Ryan is a member of the Confederated Salish and Kootenai Tribes in Missoula, Montana. He has worked extensively on water resource issues in the Pacific Northwest, with a particular focus on tribal water rights and management. One of Casey's notable accomplishments was leading the development of the Confederated Salish and Kootenai Tribes' water compact, which was ratified by the Montana State Legislature in 2015. The compact established the tribes' water rights and provided a framework for the management of water resources within their jurisdiction. Casey is photographed along Rattlesnake Creek in Missoula, Montana.

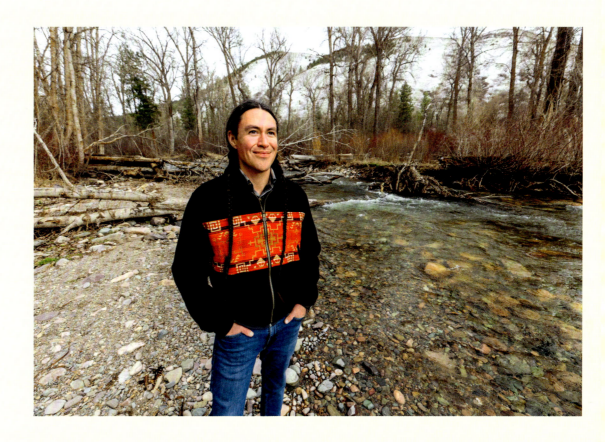

"I grew up near Nl'ay, The Place of the Small Bull Trout. In English the small creek here is called Rattlesnake Creek. As I grew up, this place was very special to me because it was both a playground and a classroom. During my many years in this place, I got to know the plants, the animals, and the rhythms of the seasons. As a child, I watched this creek slow to a trickle, and I also watched it flood our neighborhood. This place inspired in me a fascination with water and its ability to change landscapes.

"Today I work as a professional hydrologist for our tribes, helping to quantify, preserve, and sustainably manage streams and other water resources. I enjoy coming back to this place because it is where I first fell in love with rivers and water."

COLUMBIA RIVER HEADWATERS / 105

A male bison rolls in the dust during the late-summer rut in the nearly 19,000-acre Bison Range managed by the Confederated Salish and Kootenai Tribes.

A bison calf sticks close to its mother along the Flathead River in the Confederated Salish and Kootenai Tribes' Bison Range.

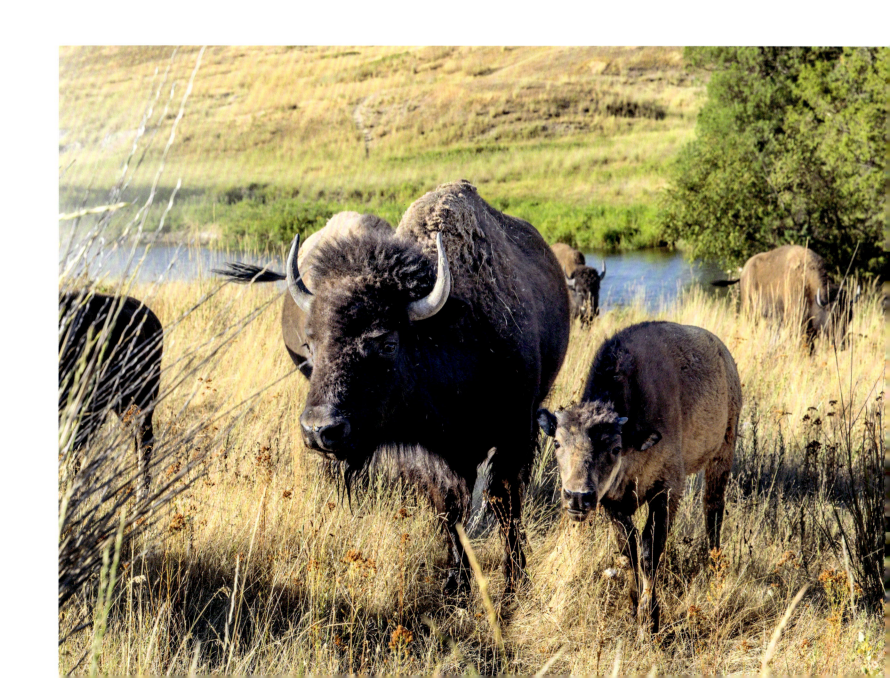

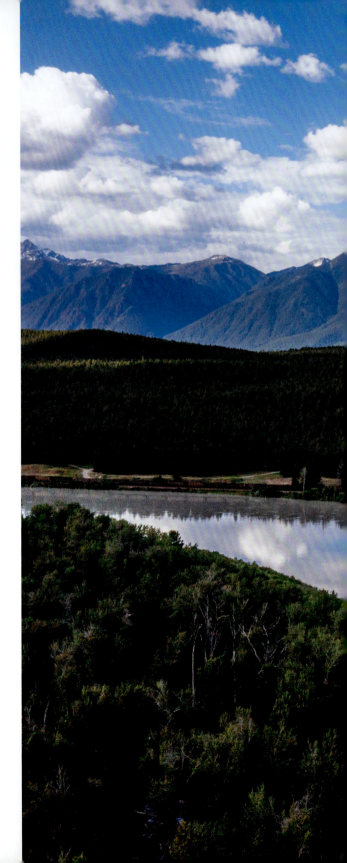

The Kootenay River, the homeland of the Ktunaxa, is one of the largest tributaries to the Big River. The Kootenay originates in the Canadian Rockies and crosses the international boundary twice before flowing into the mainstem of the Columbia.

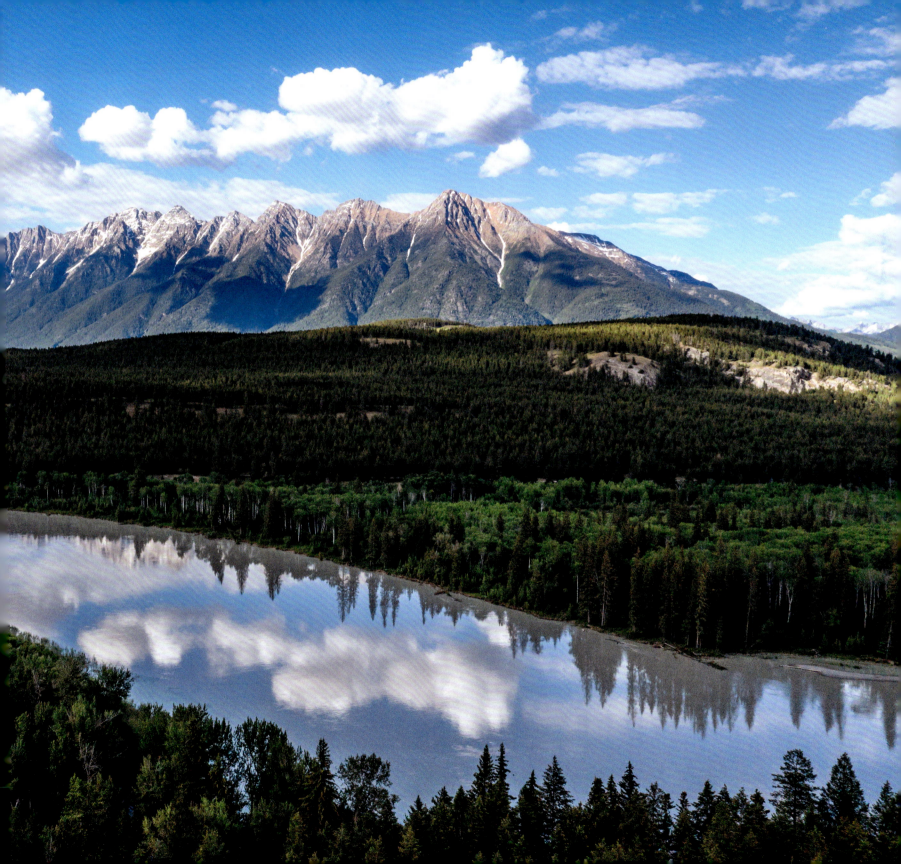

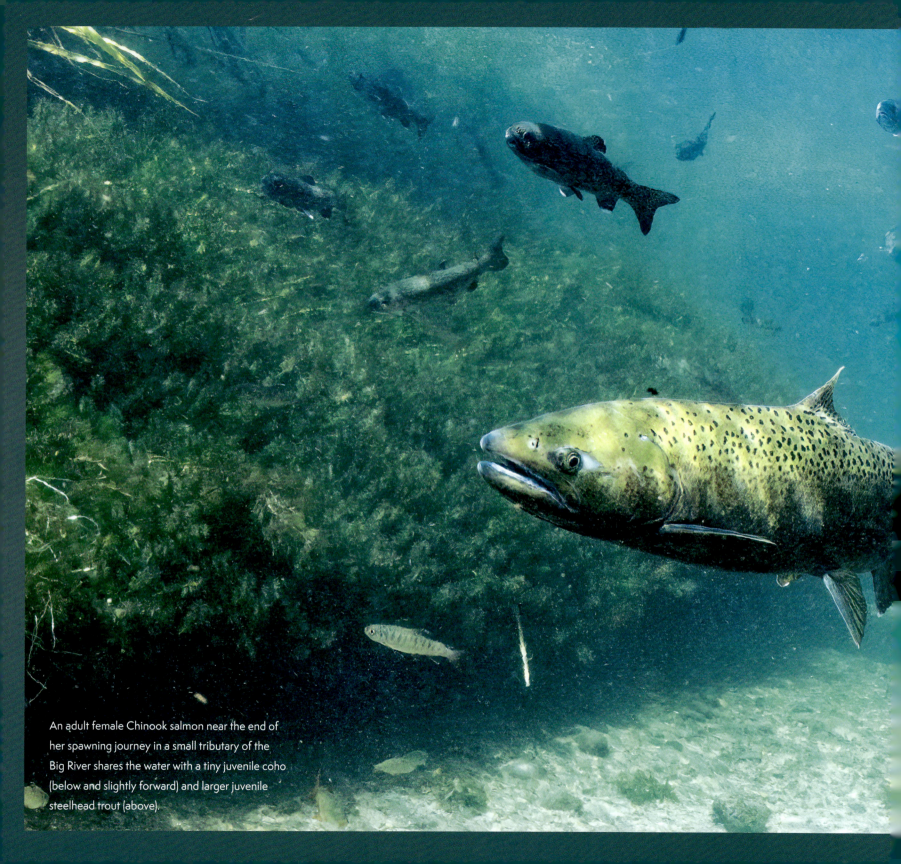

An adult female Chinook salmon near the end of her spawning journey in a small tributary of the Big River shares the water with a tiny juvenile coho (below and slightly forward) and larger juvenile steelhead trout (above).

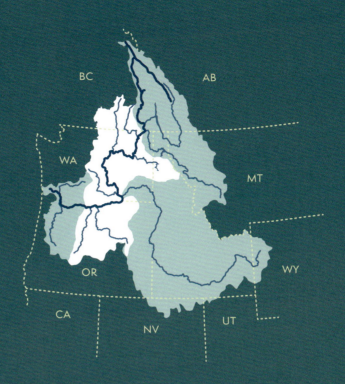

Part 2

COLUMBIA RIVER PLATEAU

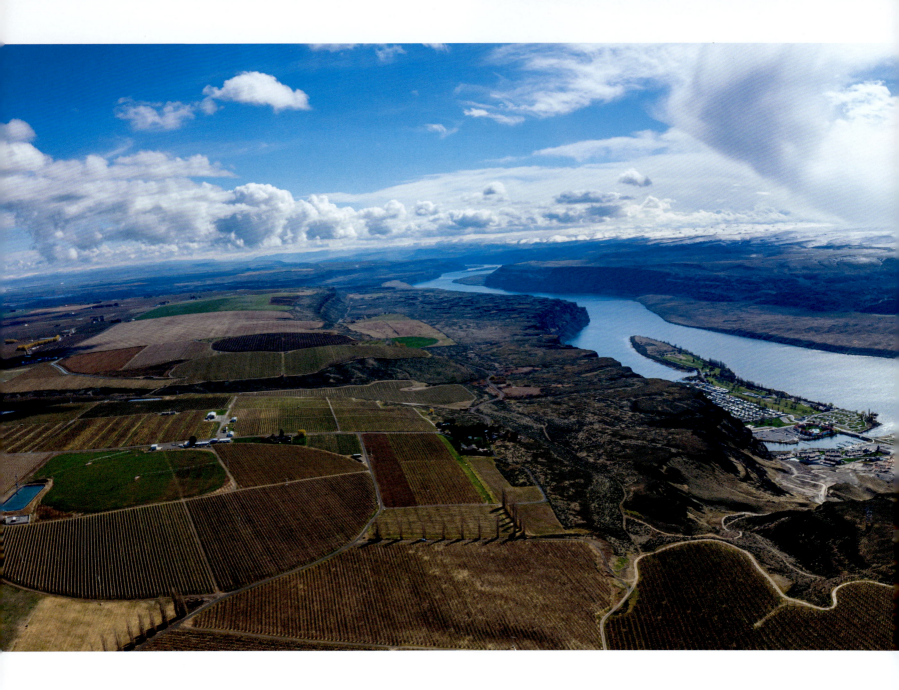

Agricultural land on the plateau above the Columbia River is irrigated with water diverted at Grand Coulee Dam. The foothills of the Cascade Range rise west of the river.

112 / BIG RIVER

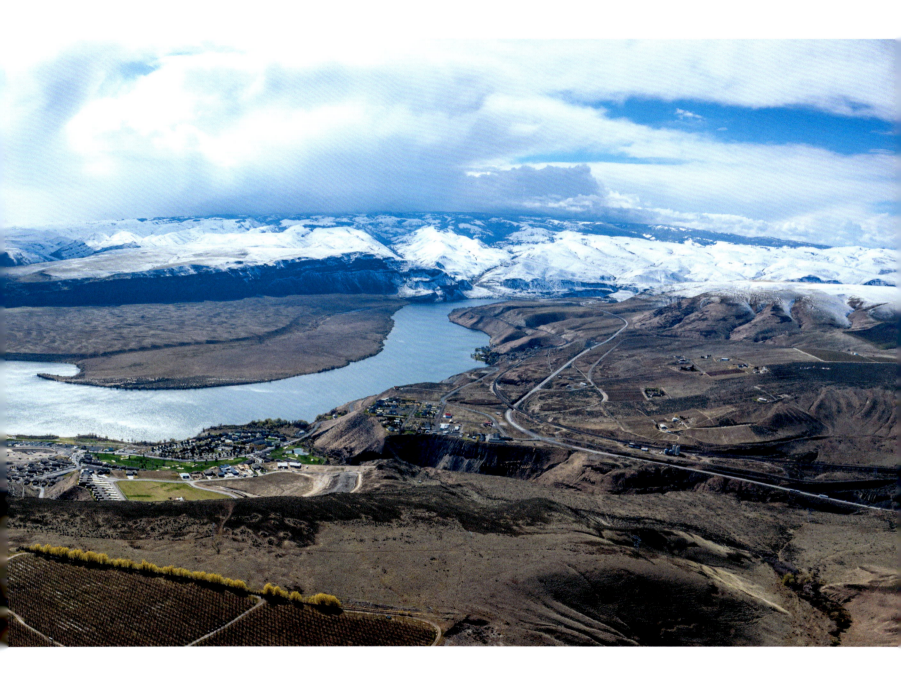

COLUMBIA RIVER PLATEAU / 113

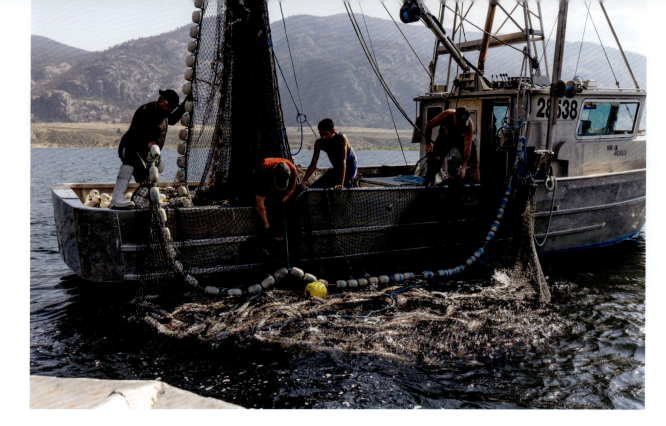

TOP The Okanagan Nation Alliance operates a commercial fishery and hatchery on Osoyoos Lake in British Columbia. The successful, tribal restoration of sockeye runs in the transboundary Okanagan River has also resulted in a thriving recreational fishery in Brewster, Washington, at the river's mouth.

BOTTOM Orion Squakin, member of the Penticton Indian Band, collects sockeye salmon caught as part of the Okanagan Nation Alliance's commercial fishing operation on Osoyoos Lake.

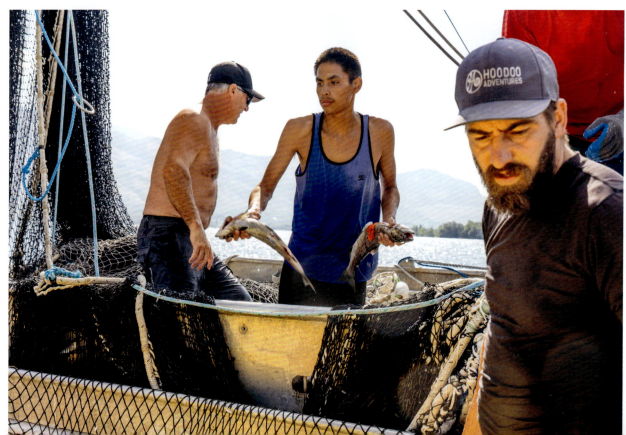

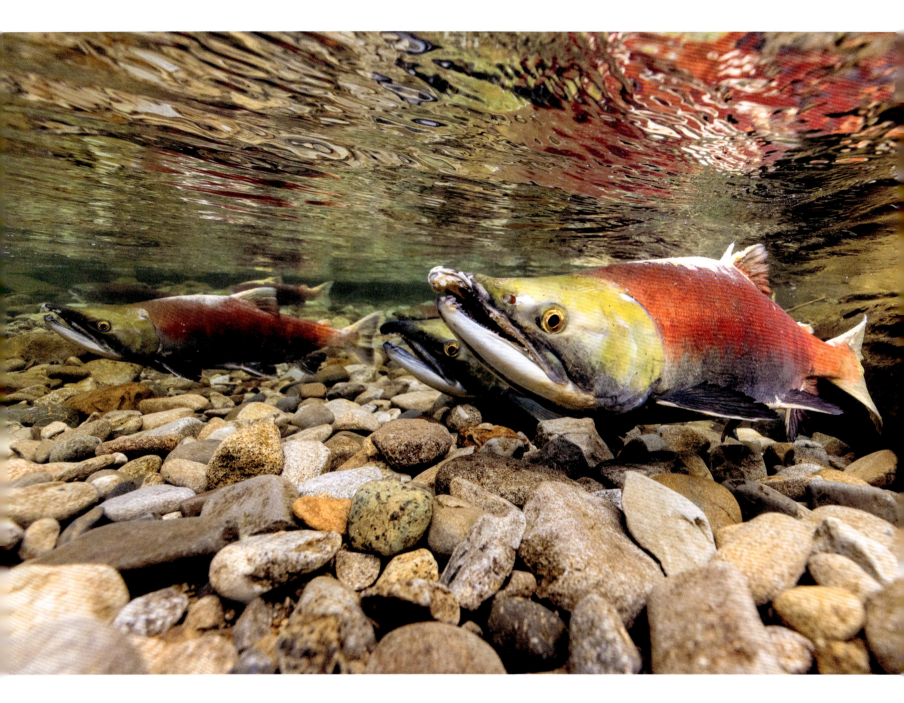

The clean cobbles of the Cle Elum River make ideal spawning habitat for sockeye salmon. The Yakama Nation has recently restored spawning streams, such as this one, that had been destroyed by irrigation projects.

COLUMBIA RIVER PLATEAU / 115

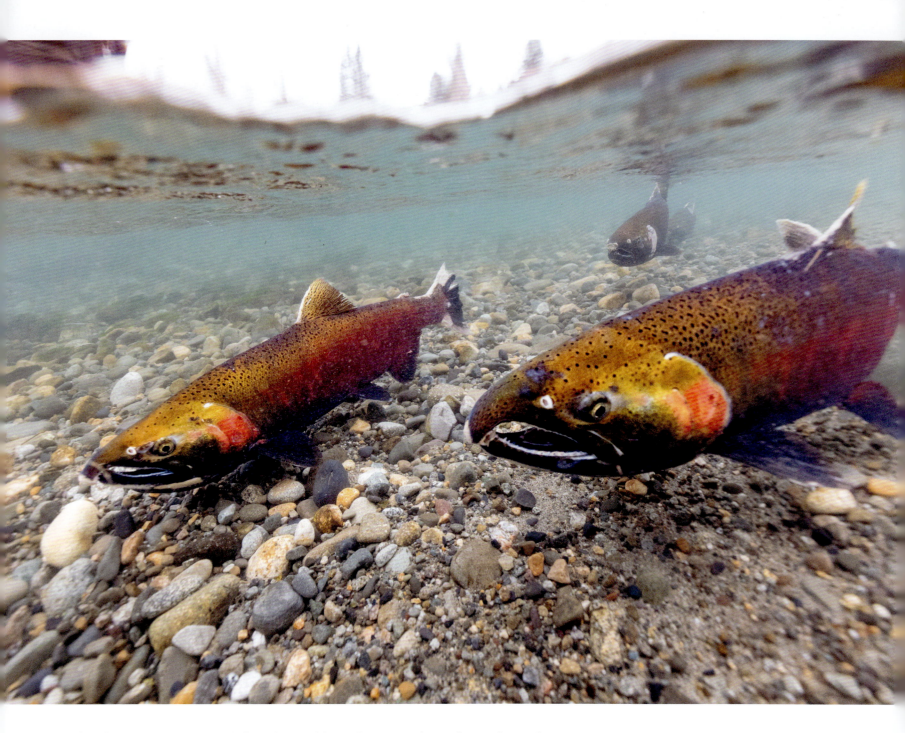
Coho salmon return to spawn in a shallow tributary of the Methow River in the North Cascades, Washington.

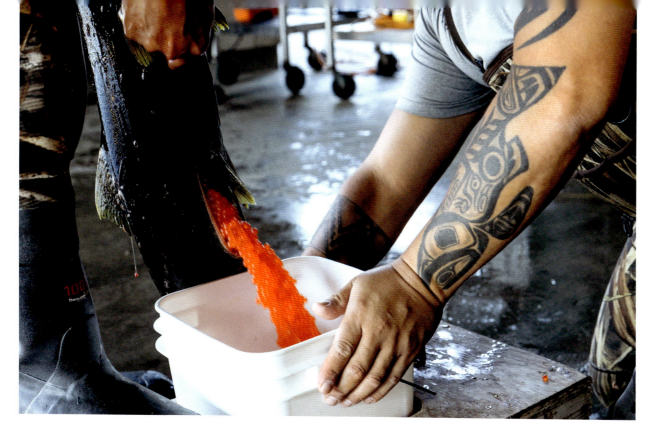

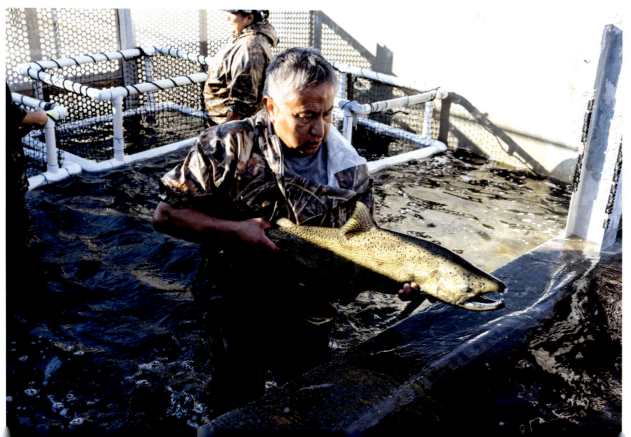

TOP Charles Strom, Yakima Basin production coordinator (holding spawning fish), and Simon Goudy, foreman (holding bucket), collect eggs from a Chinook salmon. A salmon tattoo on Simon's arm speaks to the cultural and personal importance of these fish.

BOTTOM Gabriel Swan, a fish culturist for the Yakama Nation, prepares a Chinook salmon for spawning at the Levi George Hatchery, operated and maintained by the Yakama Nation near the Yakima River.

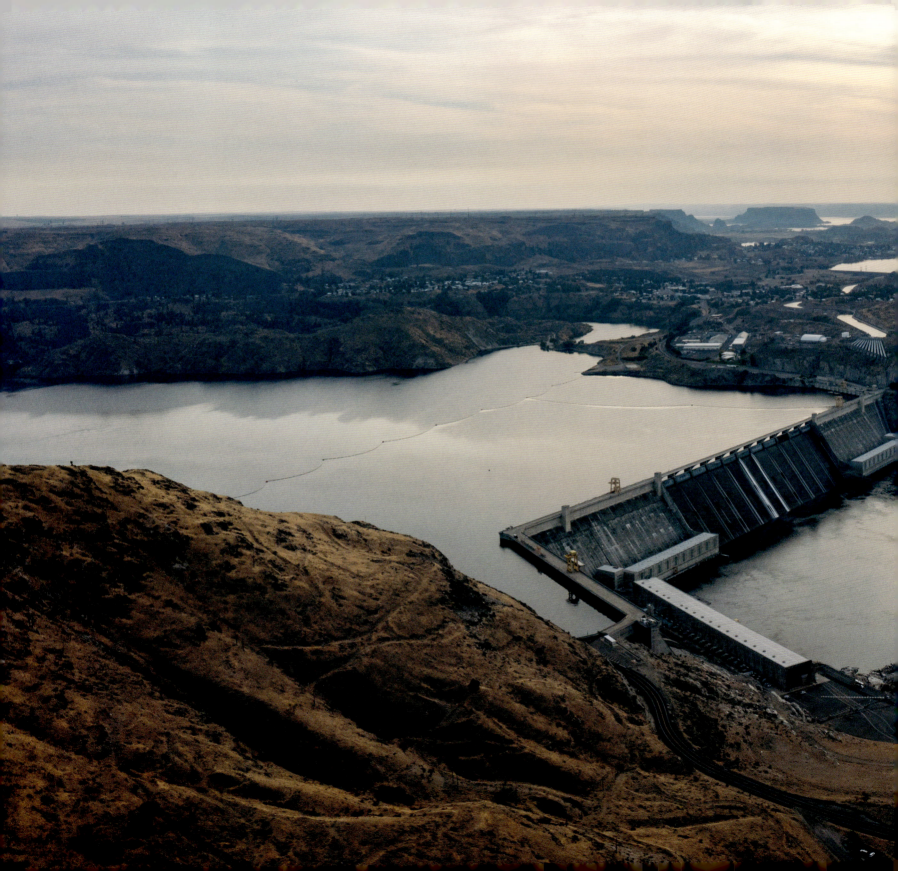

Grand Coulee Dam produces hydropower, and water held behind it is pumped up to the Banks Lake reservoir. From there, it flows in a gravity canal, to irrigate crops grown within the Columbia Basin Project. It was built without fish passage, destroying all the salmon runs upriver of it.

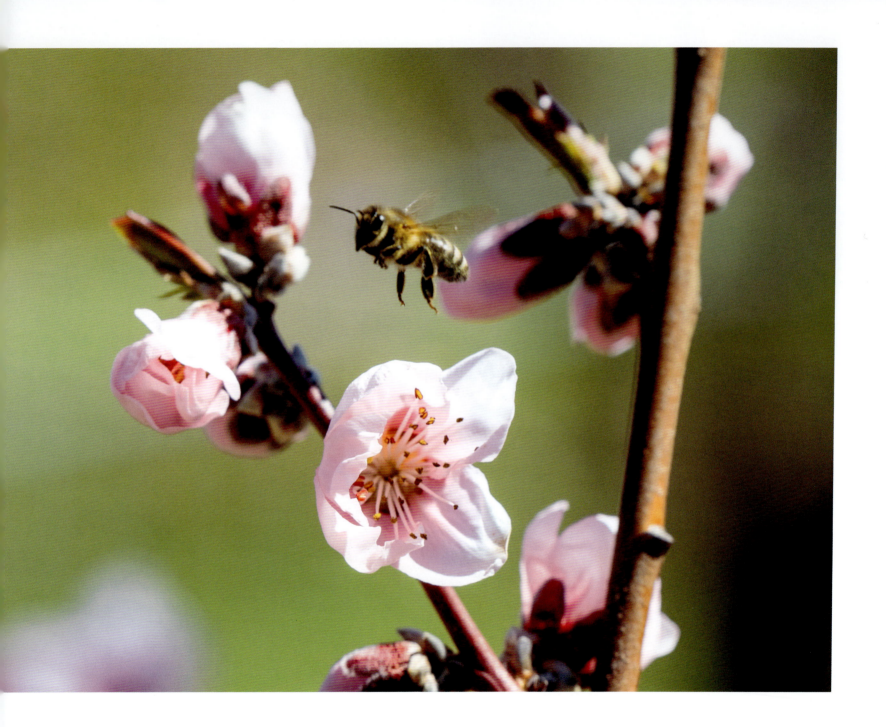

A bee visits apple blossoms on the Smallwood Farms orchard.

Blossoming fruit trees with irrigation lines on the Smallwood Farms orchard in the Okanogan River valley

DENNIS AND MALLORY CARLTON

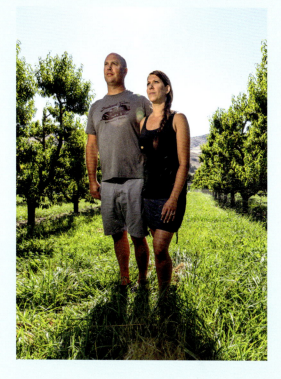

"The Columbia River Watershed is the backbone of our farm. Without it, our farm would not exist."

Dennis and Mallory Carlton, the owners of Smallwood Farms, are both from families with multiple generations of farming history in the Okanogan River valley. Here, they are in a stand of their fruit trees set up with a high-efficiency irrigation system to conserve water.

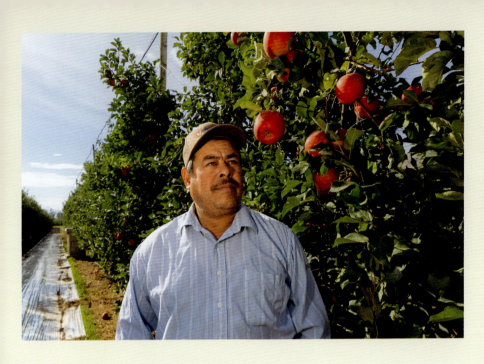

ANDRES PEREZ

"I enjoy the work and I enjoy seeing people put apples on the table for food."

Andres Perez is a foreman at Smallwood Farms.

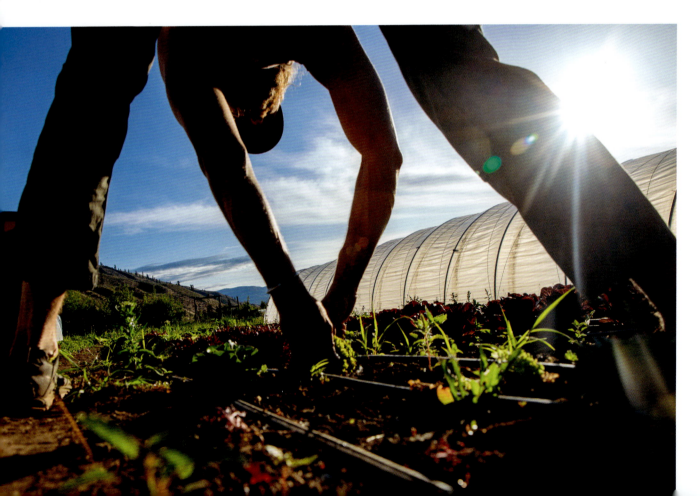

Eric Whittenbach thins lettuce growing along water-conserving drip irrigation lines running through the field on Willowbrook Farm in the Methow River watershed.

OPPOSITE Water pulled from a tributary to the Big River irrigates a valley bottom field while smoke from a fire in the Cascade mountains obscures the sun.

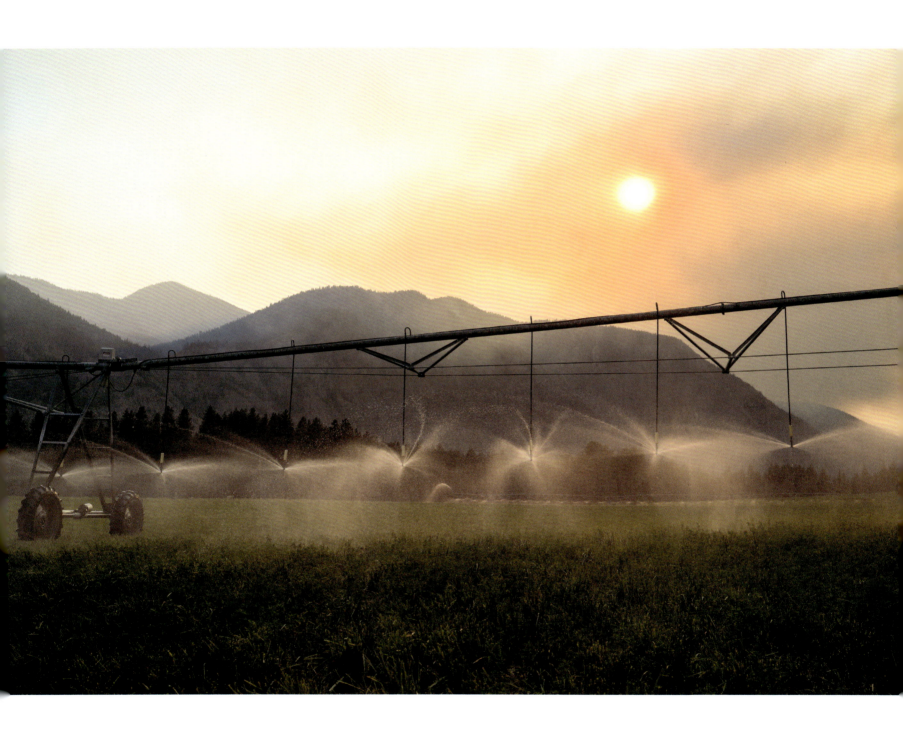

COLUMBIA RIVER PLATEAU / 123

The lakes of the upper Okanagan Valley are the destination of the largest sockeye salmon run in the watershed, recently restored through cooperative management of the US Colville Confederated Tribes and the Canadian Okanagan Nation Alliance.

COLUMBIA RIVER PLATEAU / 125

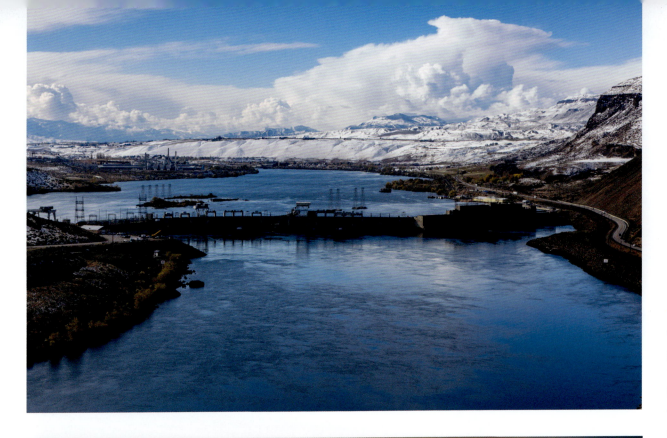

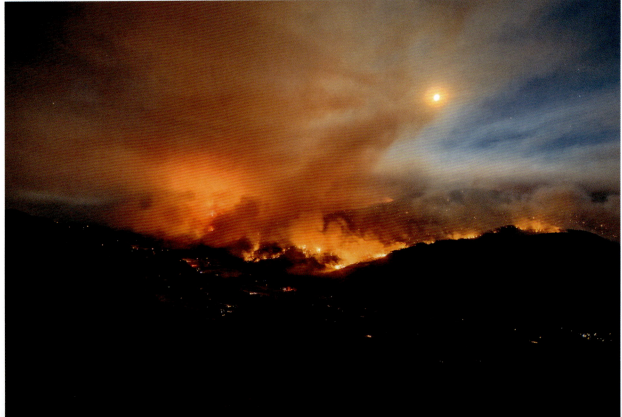

TOP Rock Island Dam creates hydropower, powering industry in the Pacific Northwest, including the aluminum plant on the left side of the river upstream.

BOTTOM Climate change and past fire suppression have led to a dramatic increase in mega wildfires across the forested portions of the Big River's watershed.

OPPOSITE Electricity-producing windmills dot the landscape in the Columbia Plateau, harnessing the reliable winds blowing inland through the Columbia River Gorge.

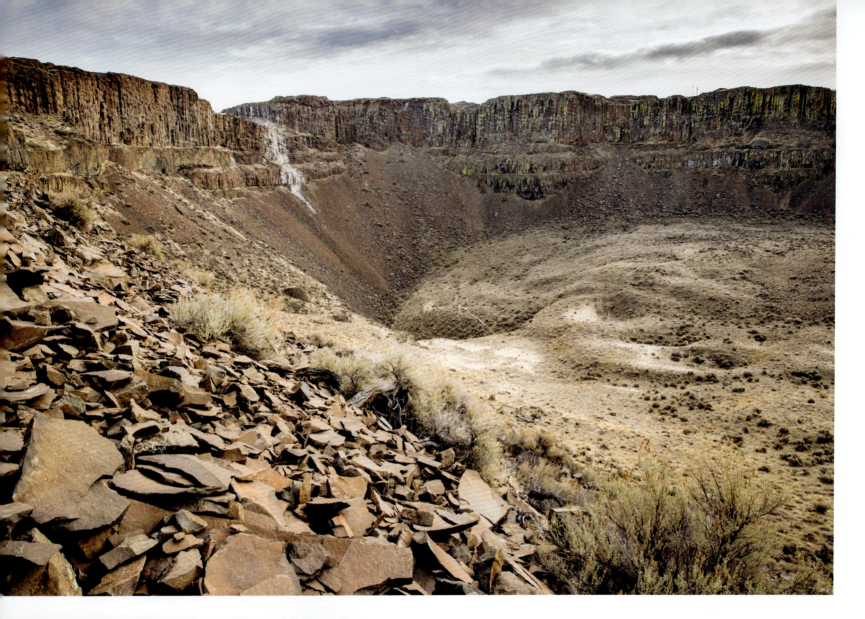

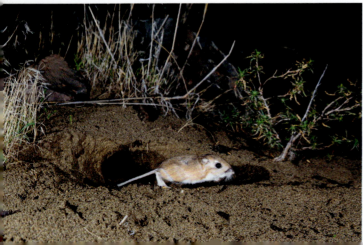

ABOVE A dry waterfall and the remnant of the plunge pool created by the Missoula Floods thousands of years ago in the Columbia Plateau

LEFT An Ord's kangaroo rat leaving its burrow. These rats are well adapted to the desert landscape along the Big River in the Columbia Plateau.

RIGHT These petroglyphs showing bighorn sheep were salvaged from along the river's edge before it was flooded behind the Wanapum Dam. They can now be viewed in Ginkgo Petrified Forest State Park in Vantage, Washington, while actual bighorn sheep can still be found wandering the nearby cliffs.

BELOW Bighorn sheep above the Wanapum Reservoir on the Big River in the Columbia Plateau, Washington

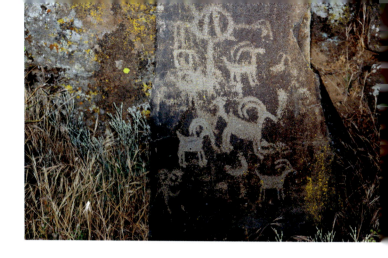

A mountain lion pauses on a winter day in the forest above a tributary to the Big River in the North Cascades, Washington.

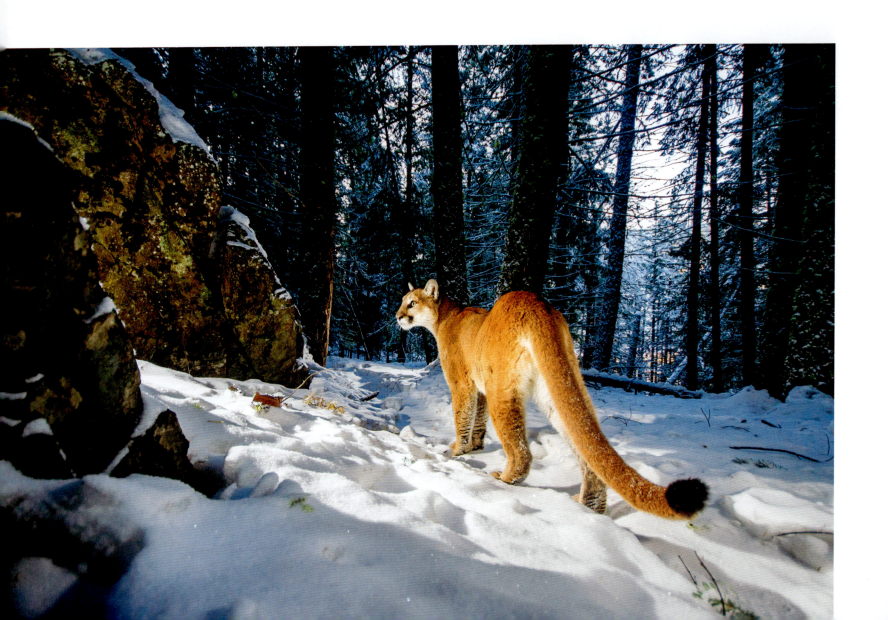

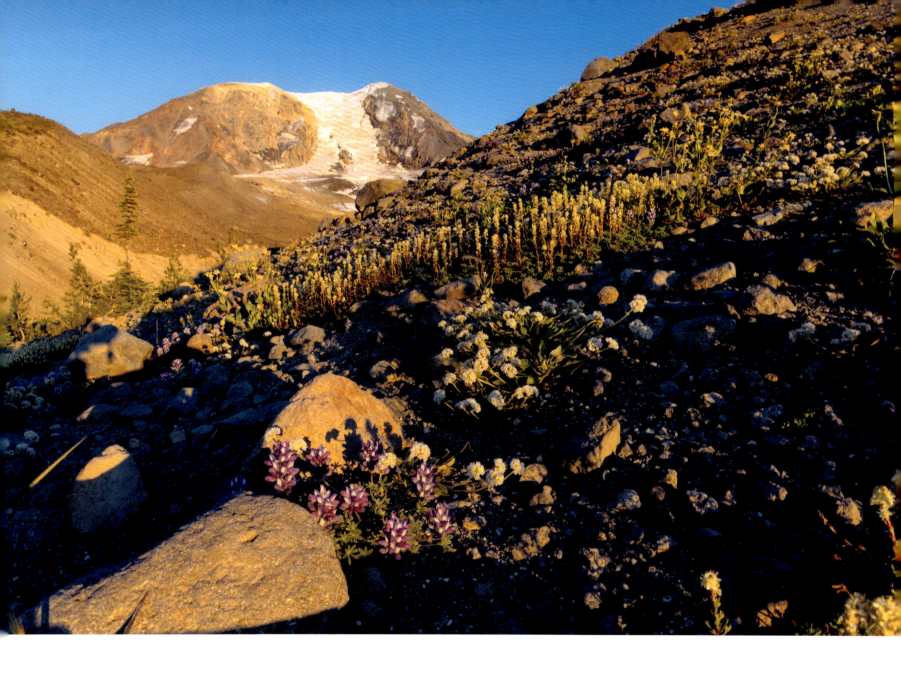

Wildflowers bloom on the alpine slopes below the volcano known as Pahto (Mount Adams) in the Sahaptin language traditionally spoken by many Indigenous people in this area. The peak marks the western boundary of the Yakama Nation's reservation in the southern Washington Cascades.

COLUMBIA RIVER PLATEAU / 131

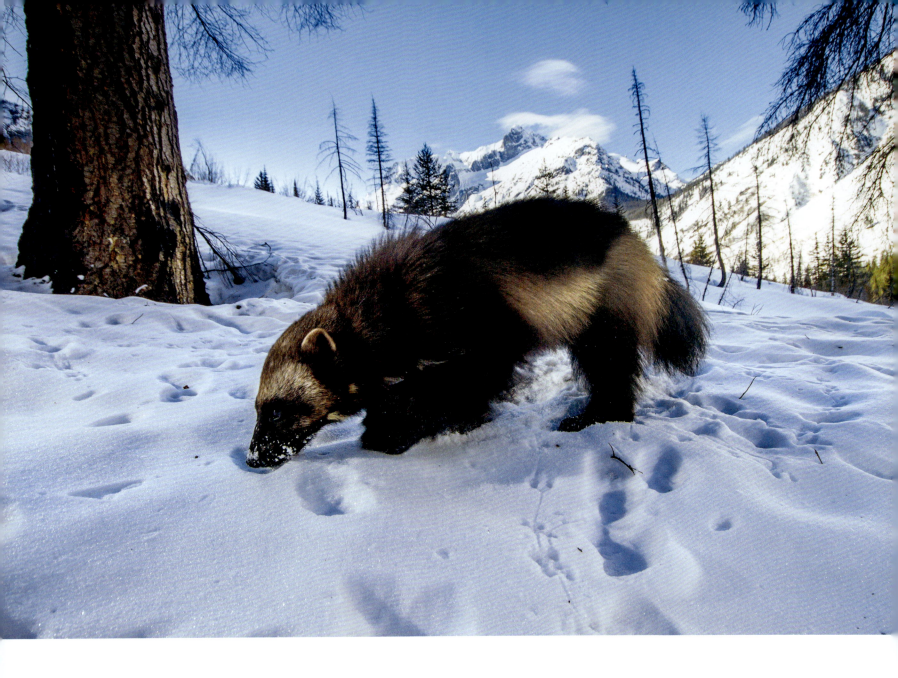

Wolverines, such as this one on the east slope of the North Cascades, can be found in the mountains in the northern portion of the watershed and have been slowly recolonizing areas in the southern portion of the watershed since they were extirpated in the 20th century by trapping and poisoning campaigns. Few animals are as well adapted to deep snow and winter conditions as wolverines are.

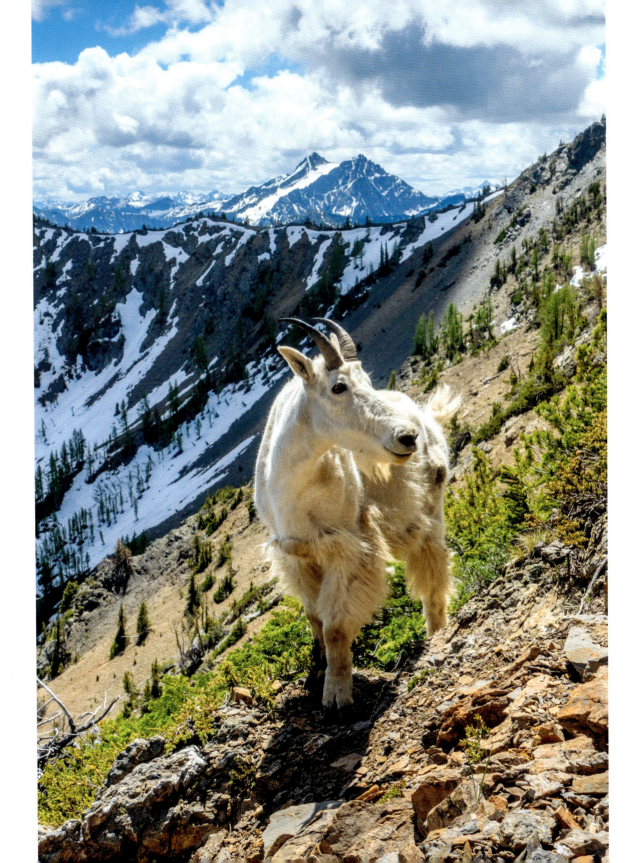

A mountain goat sheds his winter coat in the North Cascades, Washington.

133

Avalanche forecaster Drew Lovell inspects the winter snowpack on the east slope of the North Cascades. Winter snow across the watershed creates recreational opportunities and is the basis of much of the human economy downstream as it melts and flows, powering hydropower plants, irrigation systems, and traditional salmon-based subsistence economies.

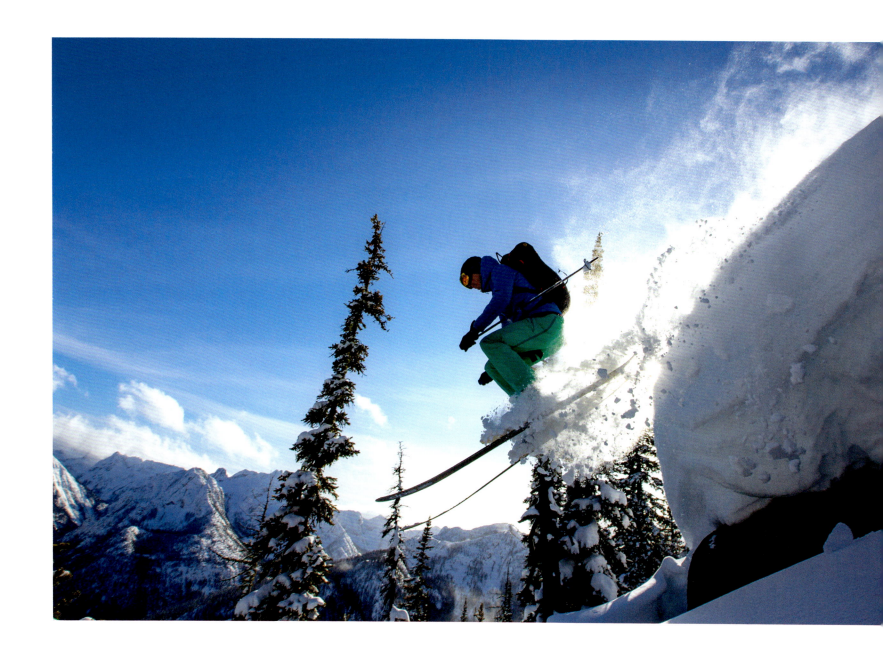

Backcountry skier Steph Williams in the North Cascades

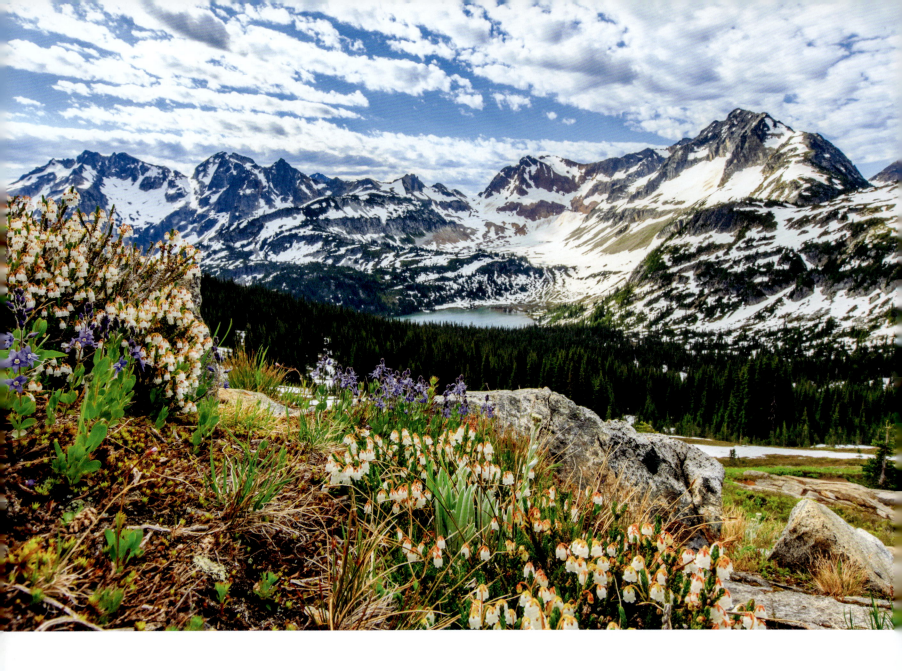

Wildflowers bloom in the brief mountain summer in the Glacier Peak Wilderness in the North Cascades.

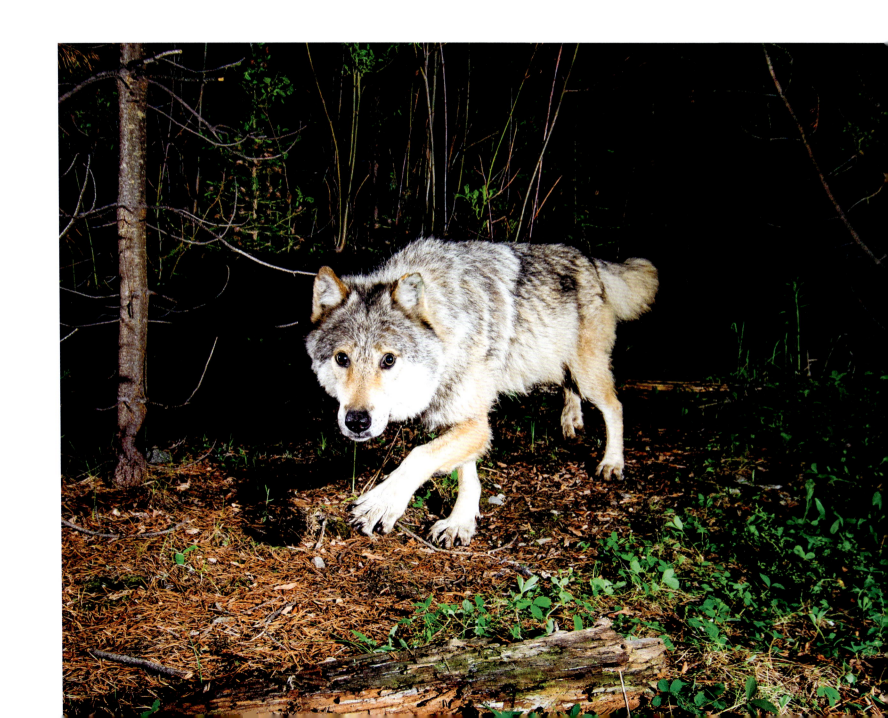

Gray wolf in the North Cascades, Washington

Harlequin ducks, such as these in the North Cascades, travel inland in the spring to breed on mountain creeks throughout the northern portion of the Big River watershed before returning to winter on the open ocean.

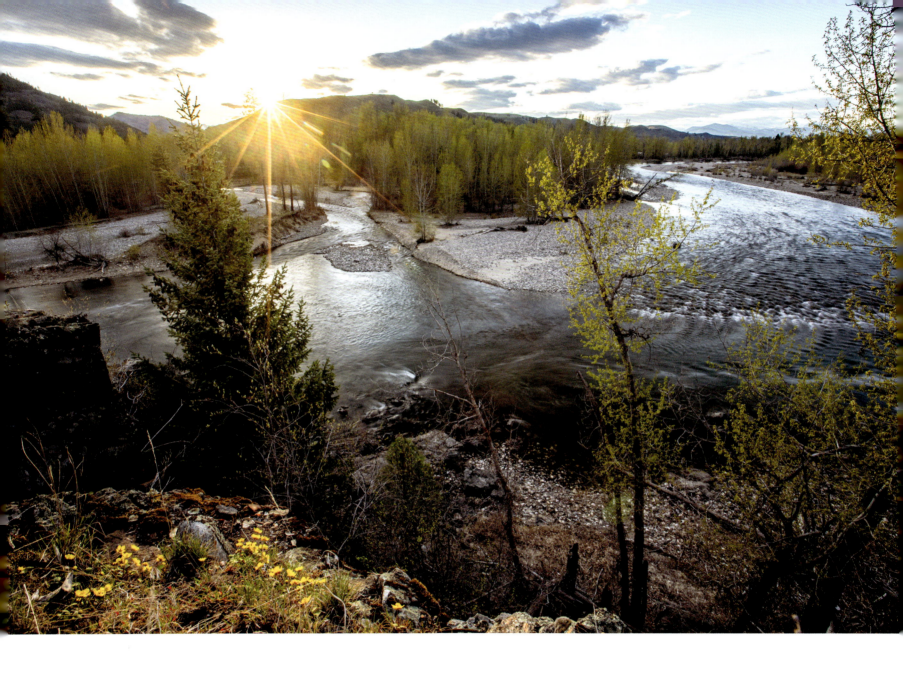

Sunset over the confluence of the Twisp and Methow Rivers

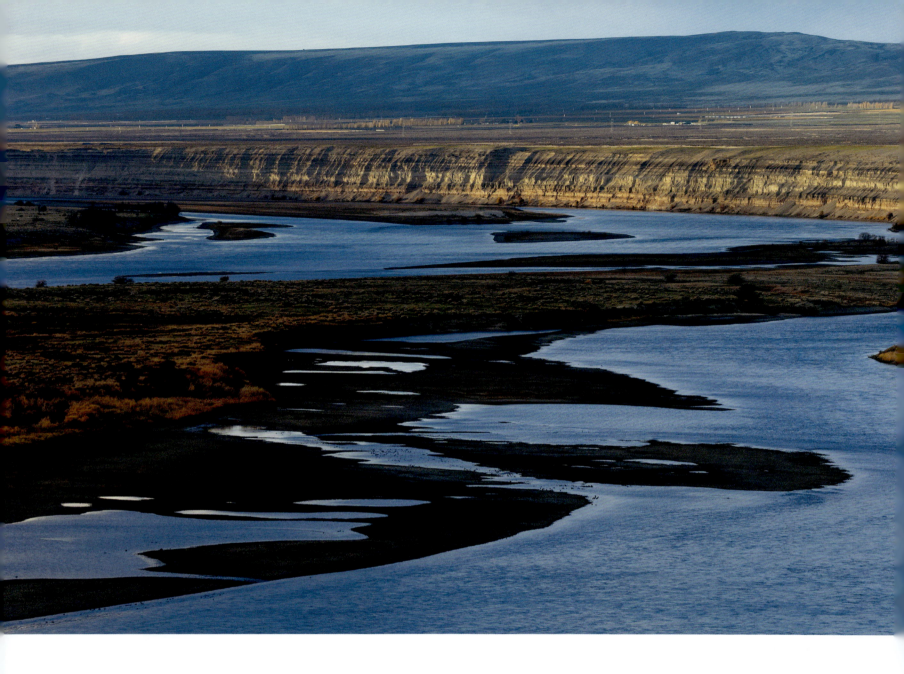

The only remaining free-running stretch of the Big River in the United States, the Hanford Reach flows past the White Bluffs under the Saddle Mountains. One side is a national monument operated by the US Fish and Wildlife Service. The other, controlled by the US Department of Energy, is one of the most radioactively polluted places in North America, where materials for the world's first nuclear bombs were produced. Work continues to protect the river from toxic seepage.

Canada geese take flight from the Hanford Reach.

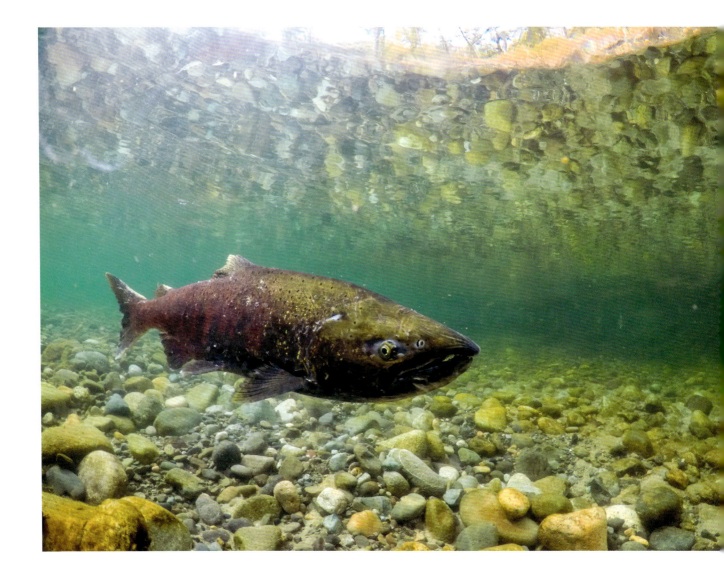

LEFT River cobbles at the Hanford Reach serve as important spawning habitat for Chinook salmon.

ABOVE A female Chinook salmon, having traveled hundreds of river miles and past eight dams, is finally getting close to the end of her upstream journey on a tributary of the Big River in the North Cascades.

COLUMBIA RIVER PLATEAU / 143

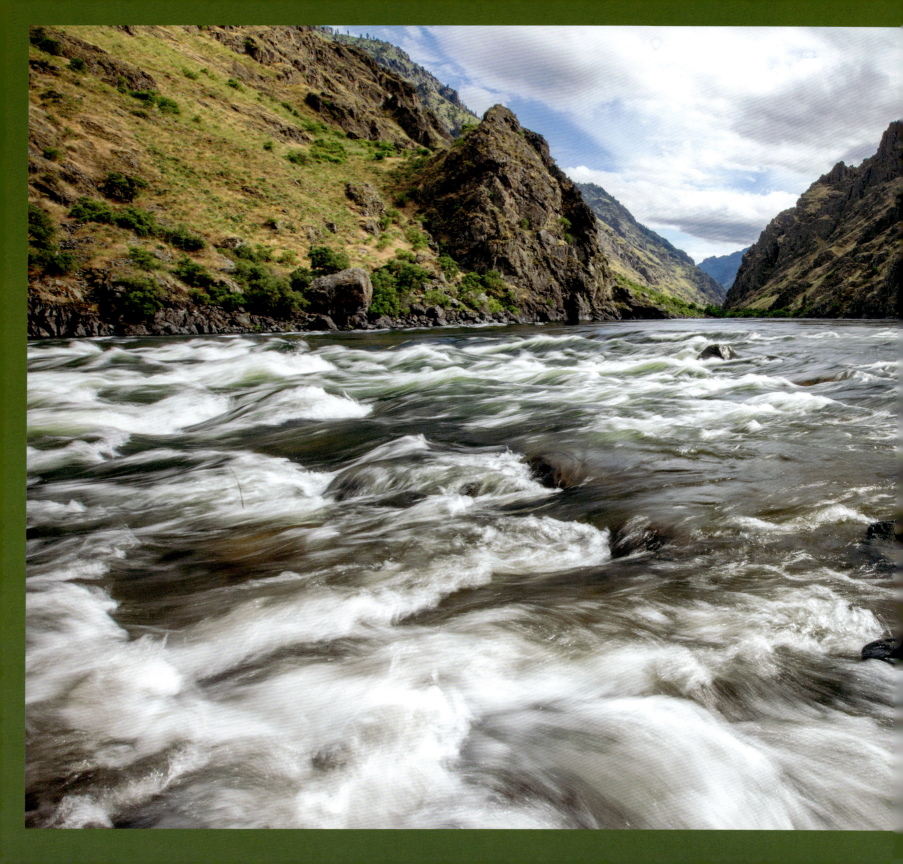

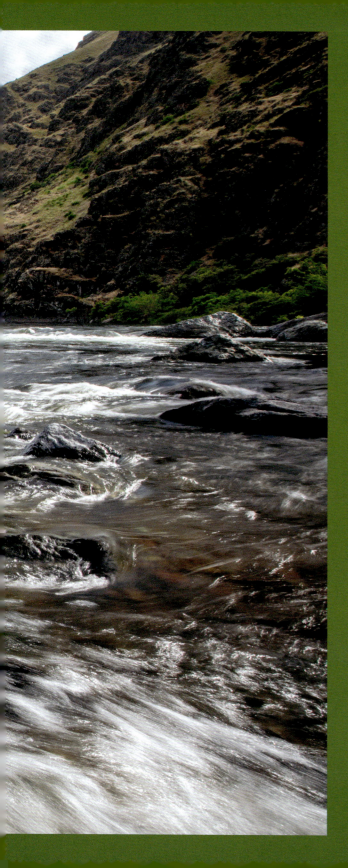
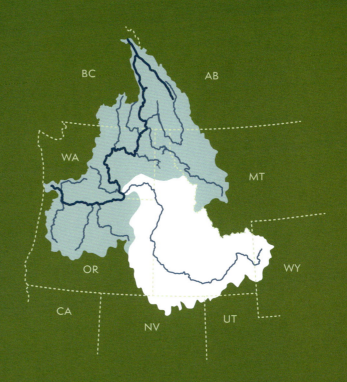

Part 3

SNAKE RIVER

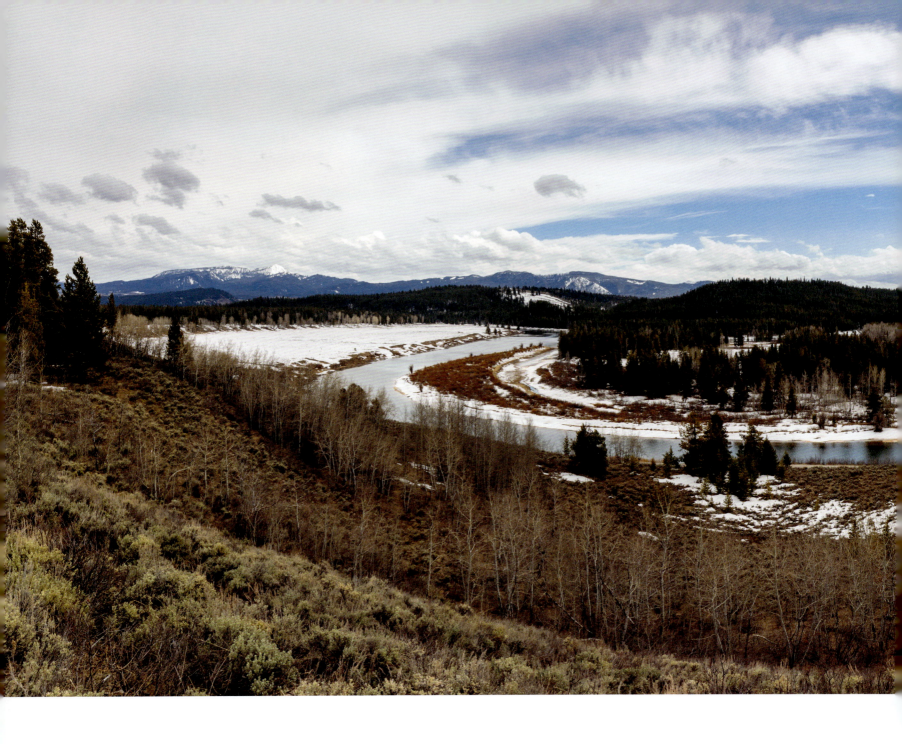

Horseshoe Bend on the Snake River with the snow-covered Teton Range of Grand Teton National Park in the distance

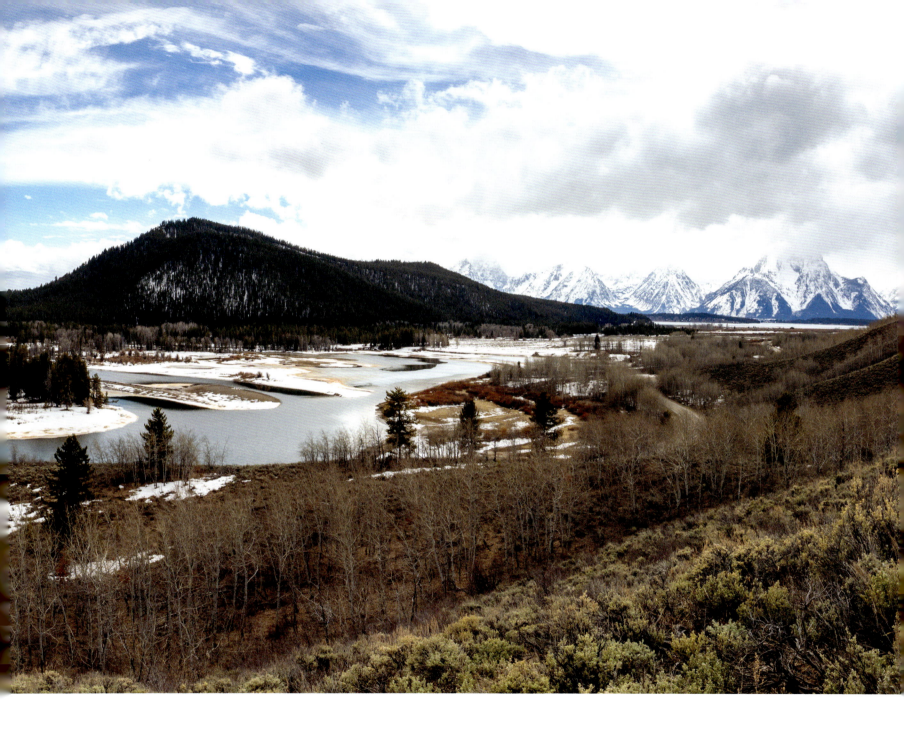

PREVIOUS SPREAD Saddle Creek Rapids on the Snake River in Hells Canyon

SNAKE RIVER / 147

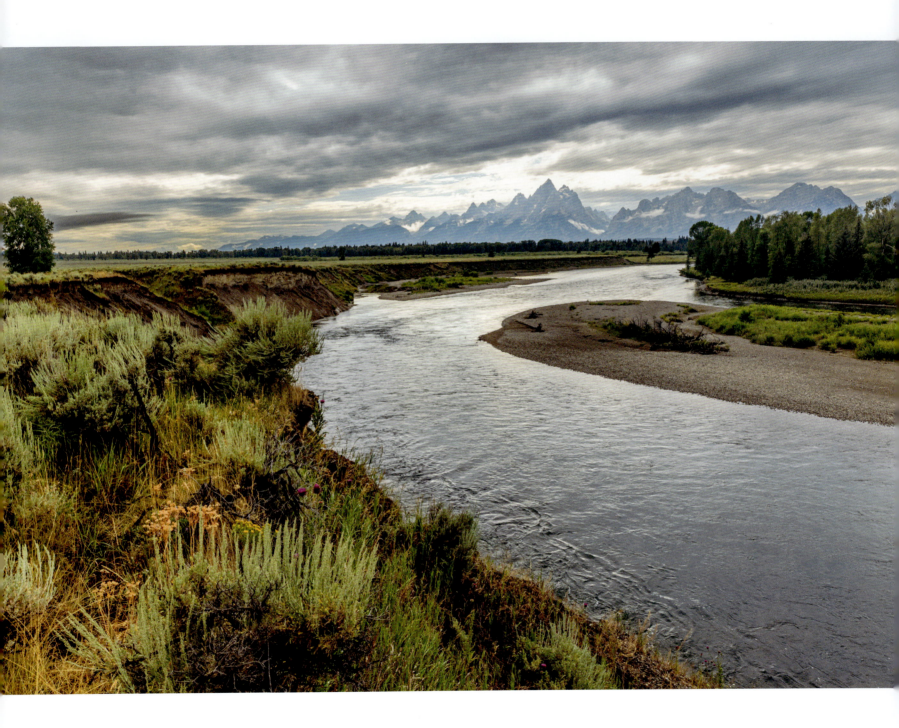

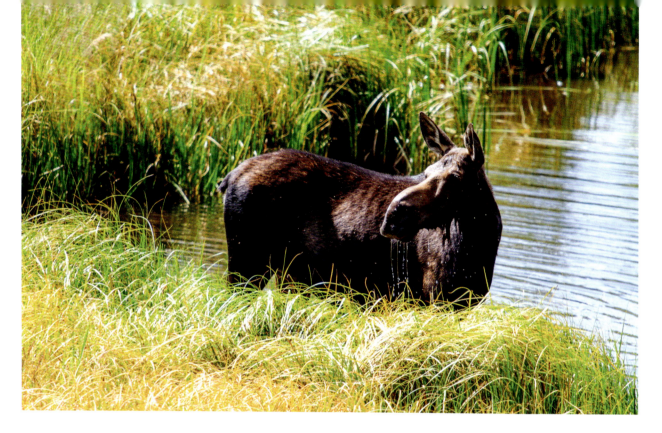

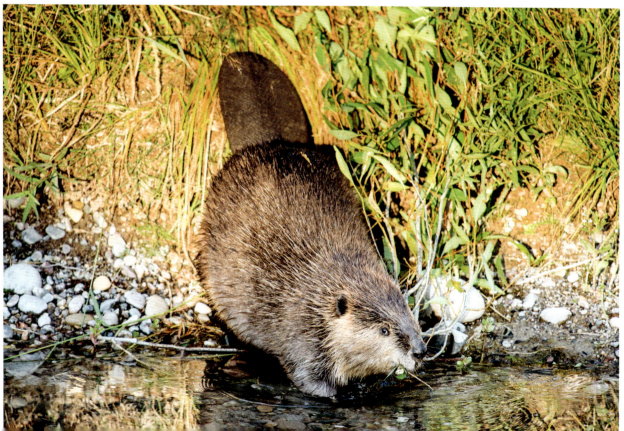

TOP A cow moose browses in a wetland created by beavers in the Snake River floodplain in Grand Teton National Park, Wyoming.

BOTTOM A beaver drags a freshly cut willow branch to the Gros Ventre River, Wyoming.

OPPOSITE Sagebrush and wildflowers along the Snake River with the Teton Range beyond

TOP Redfish Lake, Sawtooth Mountains, Idaho, is the destination for the Snake River's last remaining, and extremely endangered, sockeye salmon run, as well as a nonanadromous population of this species.

BOTTOM In 2021 the Boundary Fire scorched nearly 88,000 acres of forests around the Middle Fork Salmon River in the Frank Church–River of No Return Wilderness in central Idaho.

OPPOSITE Wildfire smoke makes for impressive sunsets in the Salmon River Mountains in central Idaho, which includes the largest roadless area in the contiguous United States.

150 / BIG RIVER

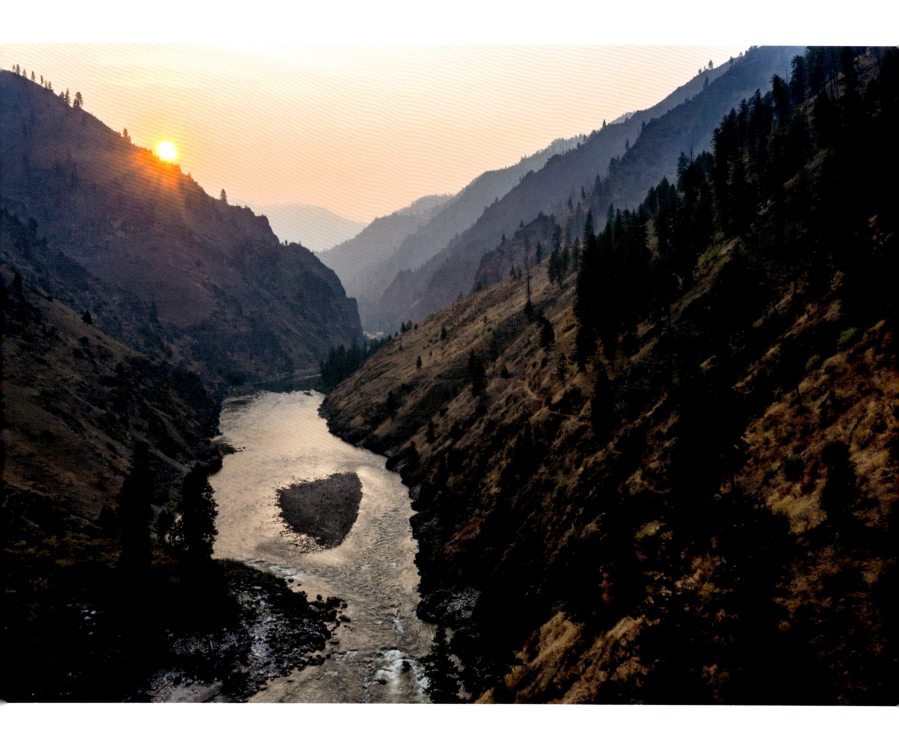

LEFT An American dipper, North America's only aquatic songbird, hunts for aquatic invertebrates in cold, fast-flowing mountain streams throughout the Big River watershed.

ABOVE A family of river otters feeds on a mountain sucker fish on the Middle Fork Salmon River, Idaho.

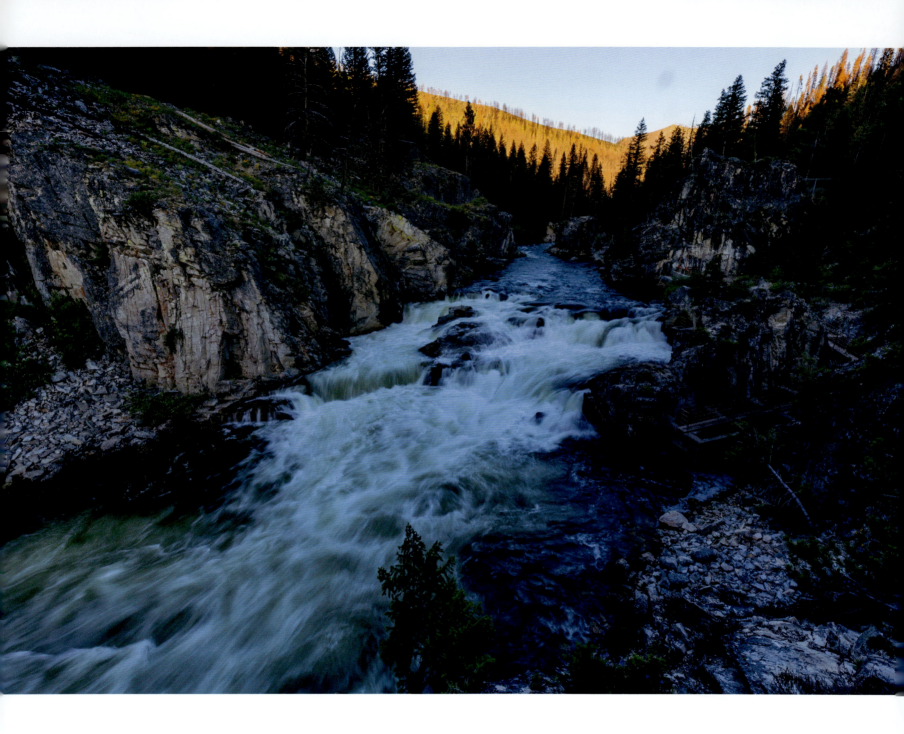
Salmon swim hundreds of miles from the Pacific Ocean before reaching Dagger Falls on the Middle Fork Salmon River in Idaho.

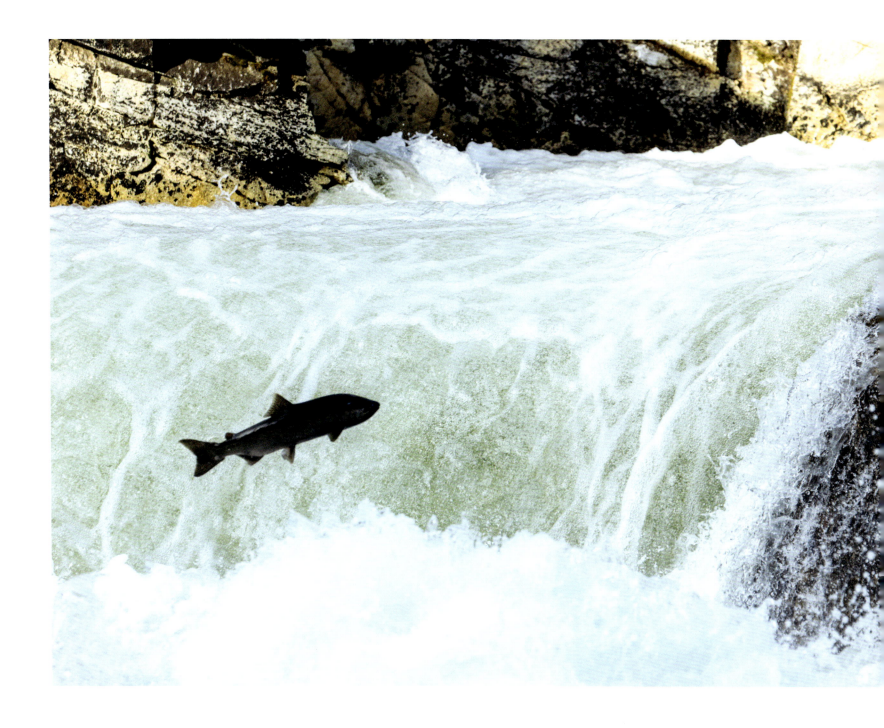

Undeterred by the frothing whitewater, a Chinook salmon makes its way up Dagger Falls.

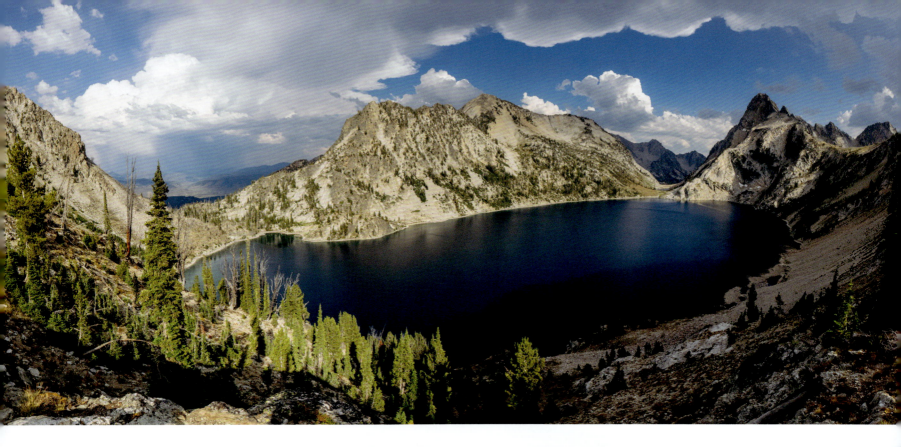

ABOVE Ice-age glacier-carved alpine lakes, such as Sawtooth Lake, dot the high country throughout the Sawtooth Mountains and other ranges in the Big River watershed.

RIGHT A Clark's nutcracker feeds on the cone of a whitebark pine. These two species are ecologically connected, with the nutcracker depending on the pine for a staple of their diet and the pine depending on the bird to disperse and plant their seeds across mountaintops.

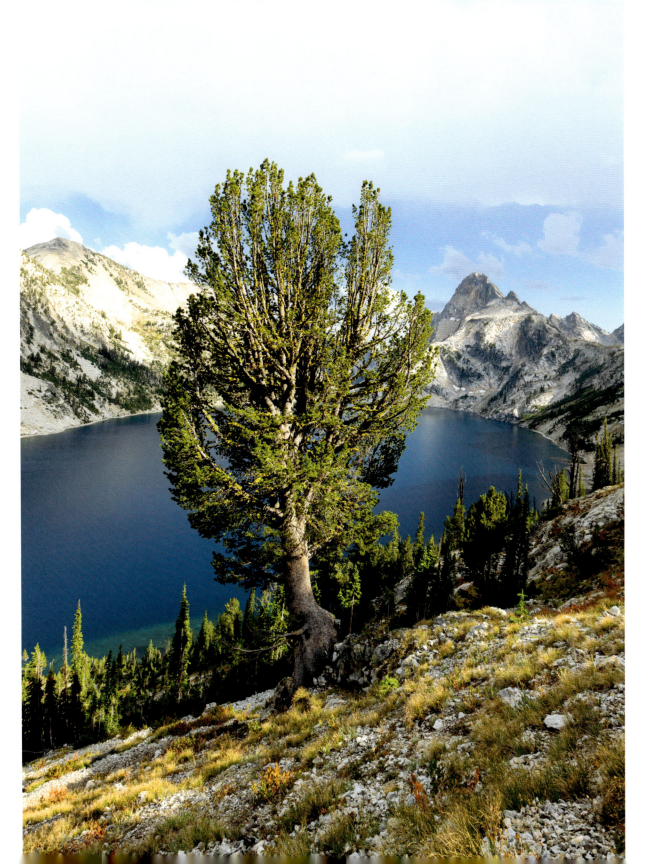

Whitebark pine, a keystone species found across the interior mountains of the watershed, grows at tree line, providing a rich bounty of food in its large seeds and helping retain the winter snowpack. Climate change and an introduced blister rust disease are threatening its survival.

The Owyhee River canyon cuts through some of the most remote country in the arid southern portion of the Big River's watershed on the Oregon, Idaho, and Nevada border.

BUSTER GIBSON

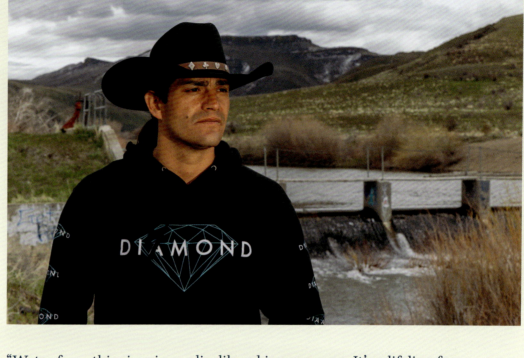

Buster Gibson is a member of the Shoshone-Paiute Tribes' Duck Valley Reservation and the director of the tribe's Fish and Game Department. Buster helped restart a salmon fishery on the reservation, with salmon relocated from downstream. He was photographed at an irrigation diversion dam on the Owyhee River on the reservation.

"Water from this river is our livelihood in every way. It's a lifeline for animals, ranching, and fish. I'm working hard to prove that it's clean enough for salmon. I'm trying to restore our peoples' use of the river but also our spiritual connection to the river because the river is our lifeblood.

"Everything we need comes downstream. When we say prayers into our water, it goes all the way downstream to the ocean. Restoring the river and the spiritual connection to the river grounds us and restores us. It's about respecting the river. We are river people. If you don't nurture and take care of it, it can be fickle. You need to respect and honor it.

"When we started [the ceremonial salmon fishery] there was one elder who remembered his parents catching salmon. There is a connection between healing the trauma of people and healing the land. To heal trauma you need to reteach about the connection to the land and water. But its hard to teach. When I first tried to bring salmon back here, I heard 'We don't eat fish.' That's the trauma speaking, the loss of the fish, the ceremony, and the connection."

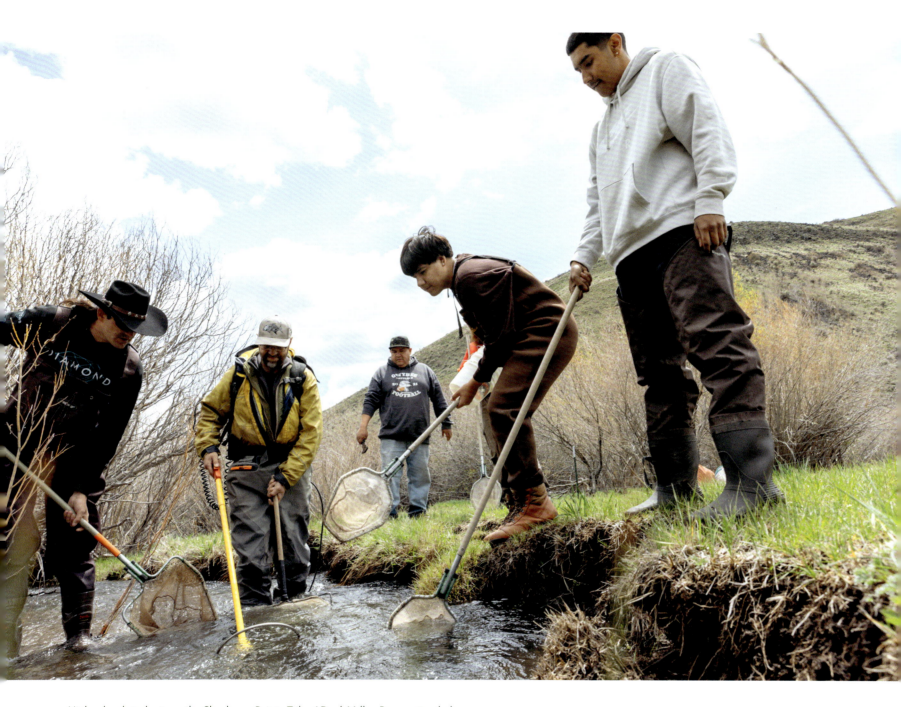
High school students on the Shoshone-Paiute Tribes' Duck Valley Reservation help researchers survey for redband trout in a creek on the reservation.

SNAKE RIVER / 161

TOP LEFT A desert horned lizard in the Owyhee River watershed BOTTOM LEFT A mule deer buck in velvet in the Snake River watershed, Wyoming RIGHT Male sage grouse displaying at a lek in the Owyhee River watershed. An icon of the American West, these birds rely on healthy sagebrush habitat, vast tracts of which can be found in the southeastern and central portions of the Big River watershed.

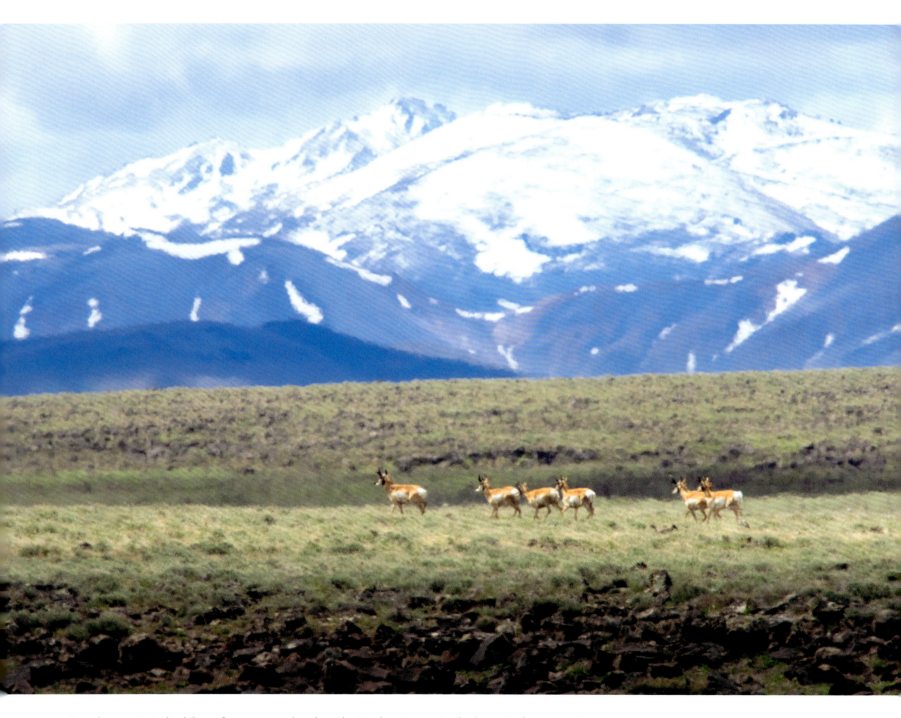
Pronghorn against a backdrop of snow-covered peaks in the Owyhee River watershed, near Anderson Crossing, Oregon

SNAKE RIVER / 163

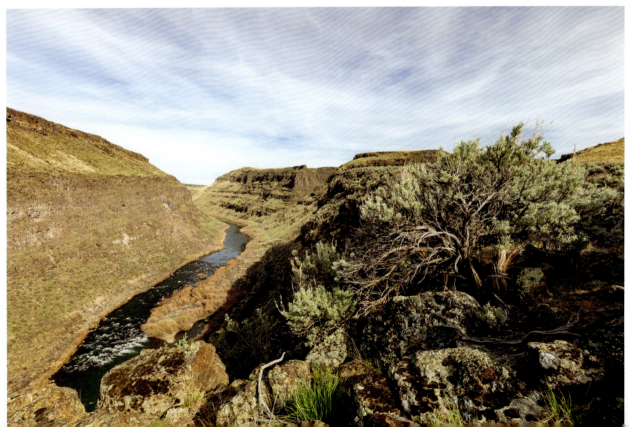

TOP A dusting of spring snow might be the only moisture this part of the Big River watershed in northern Nevada sees all year.

BOTTOM Owyhee River just upstream from Rome, Oregon

164

TIM DAVIS

Tim Davis is the founder and executive director of Friends of the Owyhee.

"I grew up in Adrian, a small town in Oregon's Malheur County near the mouth of the Owyhee River. I was raised with a deep love for the Owyhee and have spent my entire life in this landscape, from camping at Succor Creek as a child, to working for the Bureau of Land Management (BLM) fighting range fires as a young adult, then seeking an escape from the stress of a correctional officer's work as an adult.

"During my formative years a fascination for the rich human history of the Owyhee took root within me. Every spare moment not consumed by making a living or raising a family, was devoted to research, exploring the very essence of the Owyhee: its mesmerizing flora and fauna, awe-inspiring geology, and the vibrant cultures—both ancient and modern—that have graced its lands. As I grew up I began to understand the unmatched solitude the Owyhee provides as a pristine landscape largely unspoiled by human hands."

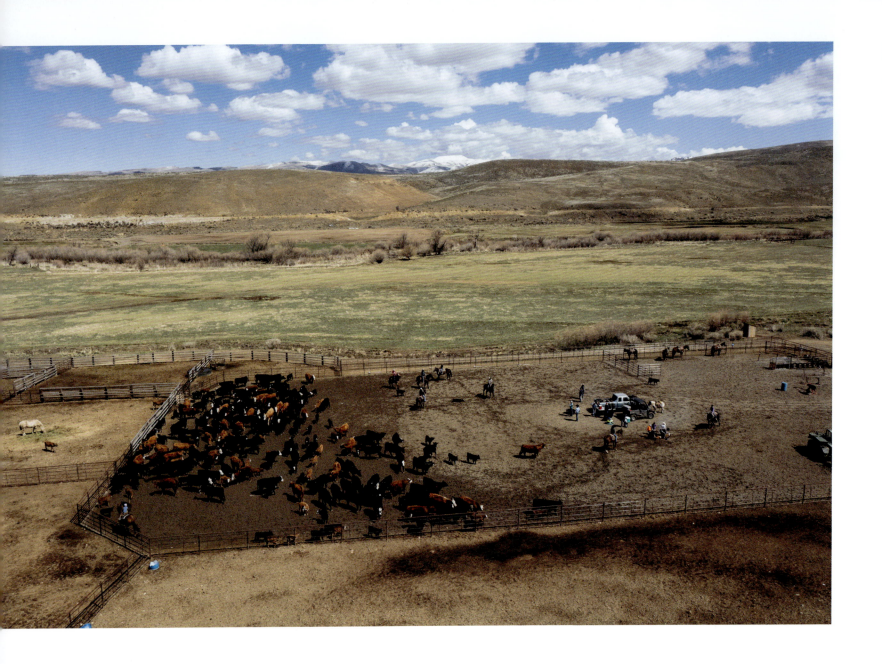

Cattle being processed on the family-owned Mackenzie Ranch located on Succor Creek, a tributary to the Snake River

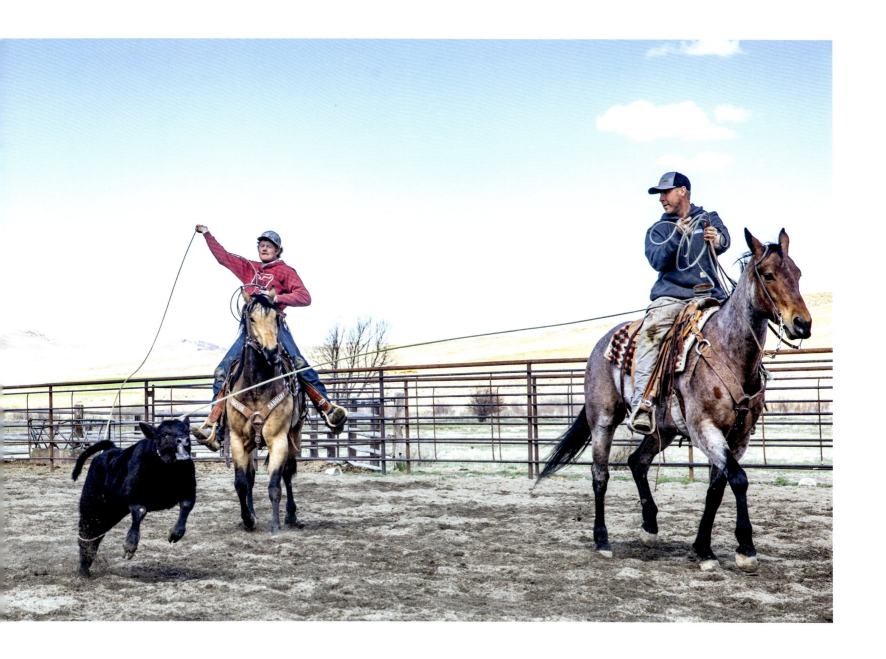

Ryan Mackenzie (on the head) and Jaylen Eldridge (on the heel) rope a calf on the family-owned Mackenzie Ranch. (See profile on page 27.)

SNAKE RIVER / 167

The Hells Canyon Dam on the Snake River was built without fish passage and, therefore, destroyed all the salmon runs above this point on the river.

OPPOSITE The Snake River flows out after being released from behind Hells Canyon Dam. The dam's power-generating station is visible to the left.

168 / BIG RIVER

SNAKE RIVER / 169

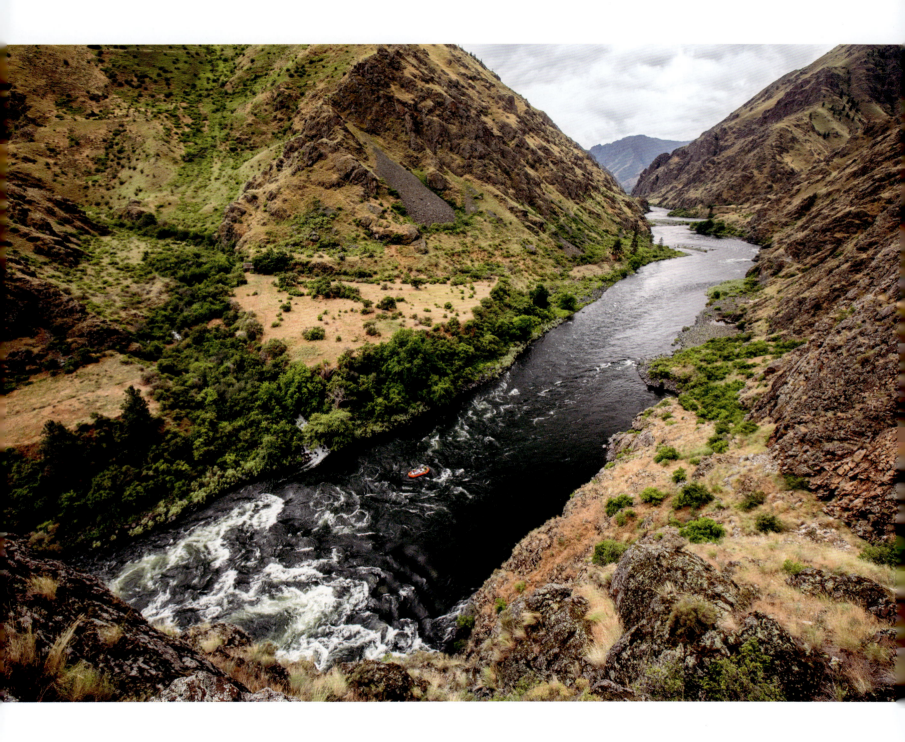

Prickly pear cactus blooms far above the Snake River in Hells Canyon.

OPPOSITE A recreational rafter enters a rapid on the Snake River, which flows freely through Hells Canyon.

BASIL GEORGE

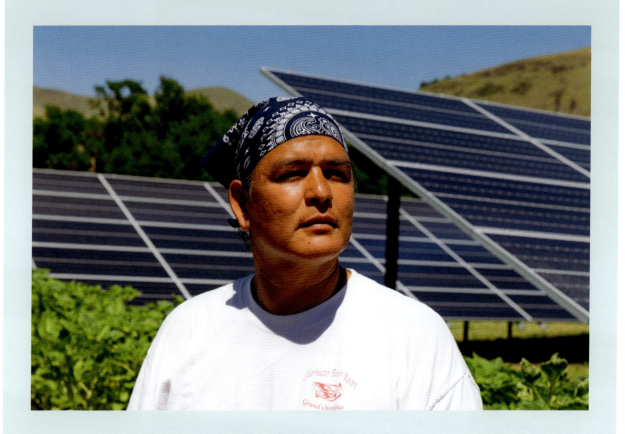

"I've done everything in construction and decided to try solar out. I like working outside and building things. You know this will be sustainable for a generation. I am doing what I do now and my children are learning about sustainability. I like that we as a tribe took initiative. That's something we should have done a long time ago—replace the power from the dams."

Basil George, Nez Perce tribal member and operations crew leader for Nimipuu Energy, a tribe-to-tribe energy cooperative established by the Nez Perce Tribe in 2022 in Lapwai, Idaho, with the goal of replacing all the power generated by the Snake River dams with solar power.

The Snake River flows through Hells Canyon, the deepest canyon in North America, on the border between Idaho and Oregon.

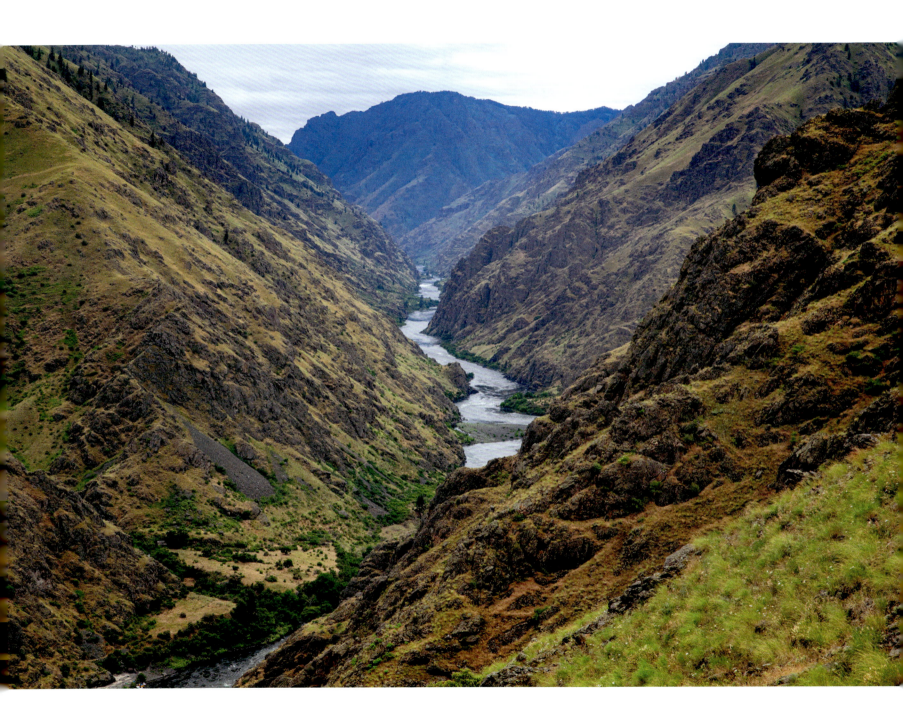

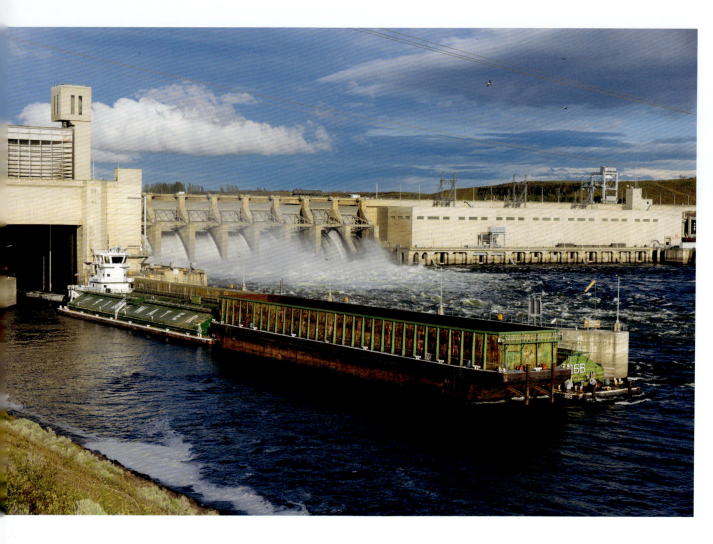

ABOVE A tugboat pushes two barges out from the navigation lock on Ice Harbor Dam, the lowest of the dams on the Snake River. The continued operation of a series of dams on the lower Snake River is a point of much debate. While the dams create hydropower and transportation access for commercial shipping, they are also contributing to the decline of numerous endangered salmon runs in the watershed.

RIGHT Fish ladders, like this one at Ice Harbor Dam, allow adult salmon to climb over the dam, but the slack water beyond poses other challenges for in-migrating adults and out-migrating juveniles.

RUSSELL GILLIAM

"With only six inches of rain here in our region, these rivers give life to everyone here. Without them, it would be very difficult to live here.

"These rivers are very important to everybody as far as fishing and enjoyment, recreation, and power … I really appreciate what they did when they built this [system of dams]. It's kind of awe-inspiring.

"On my days off I have my own boat. I'm out fishing. I'm enjoying these rivers as much as I can. I was out the last two days salmon fishing."

Russell Gilliam, of Pasco, Washington, has worked as a lock operator for more than two decades at the Ice Harbor Dam.

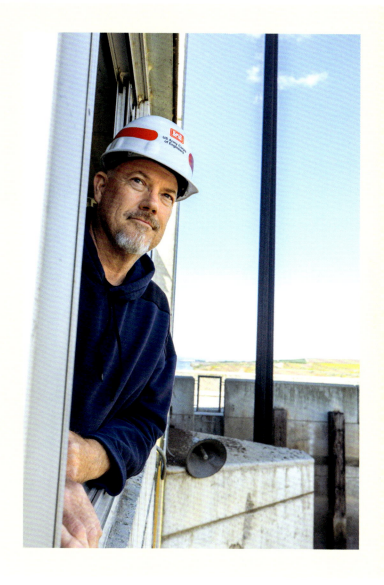

SNAKE RIVER / 175

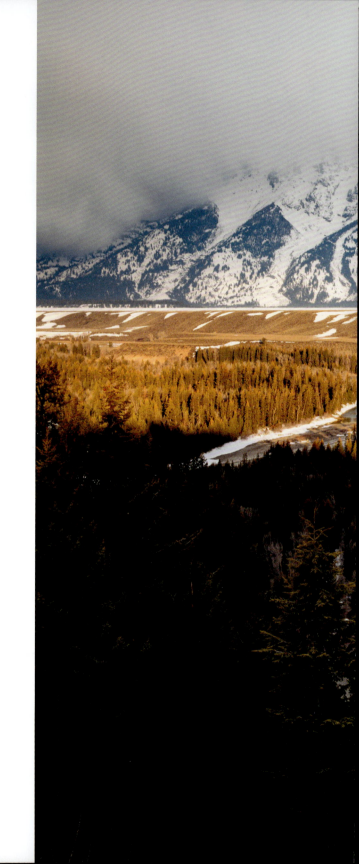

Sunrise over the Snake River and Teton Range at a location made famous by an Ansel Adams photo

176 / BIG RIVER

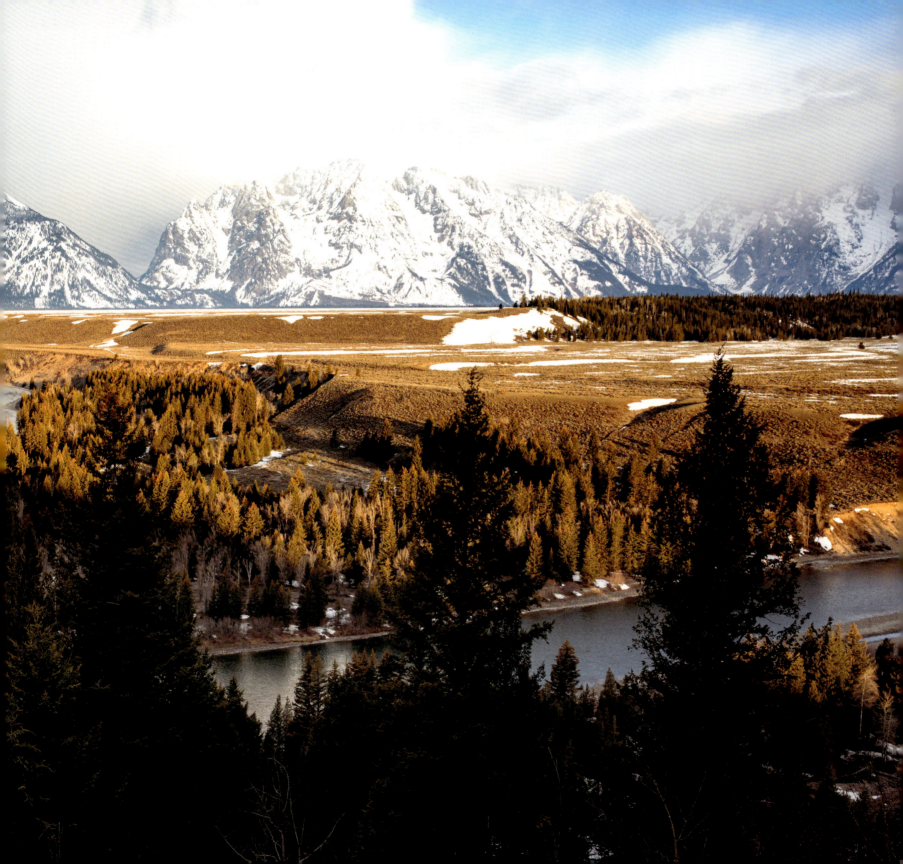

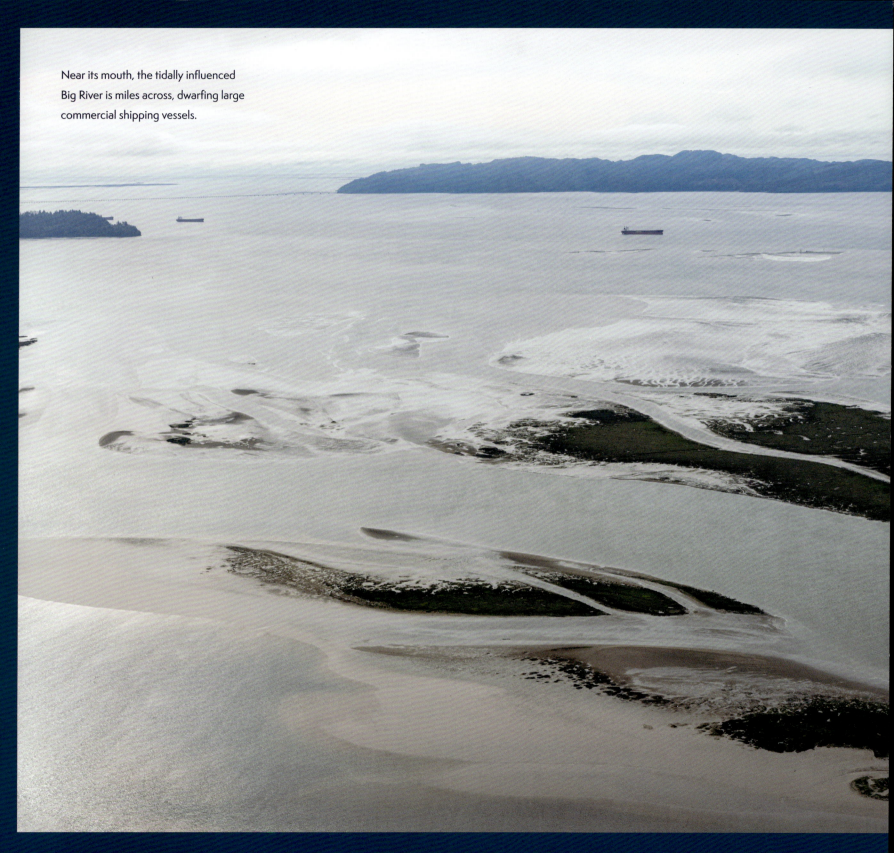

Near its mouth, the tidally influenced Big River is miles across, dwarfing large commercial shipping vessels.

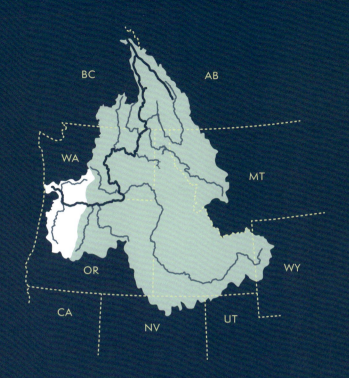

Part 4

LOWER COLUMBIA RIVER BASIN

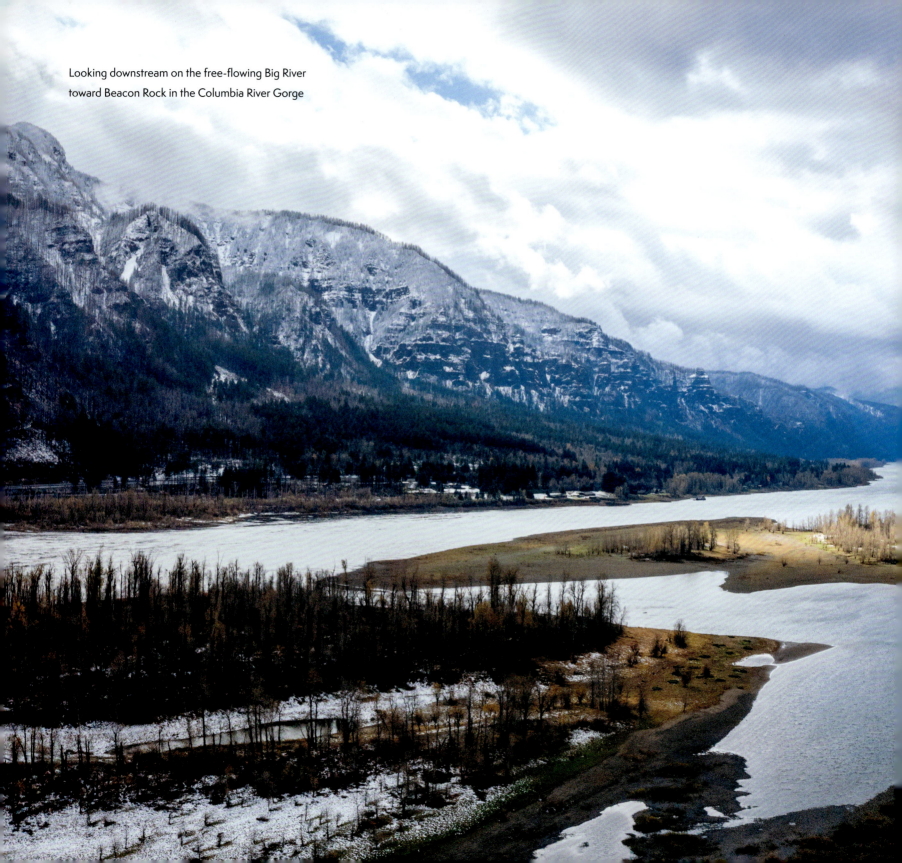
Looking downstream on the free-flowing Big River toward Beacon Rock in the Columbia River Gorge

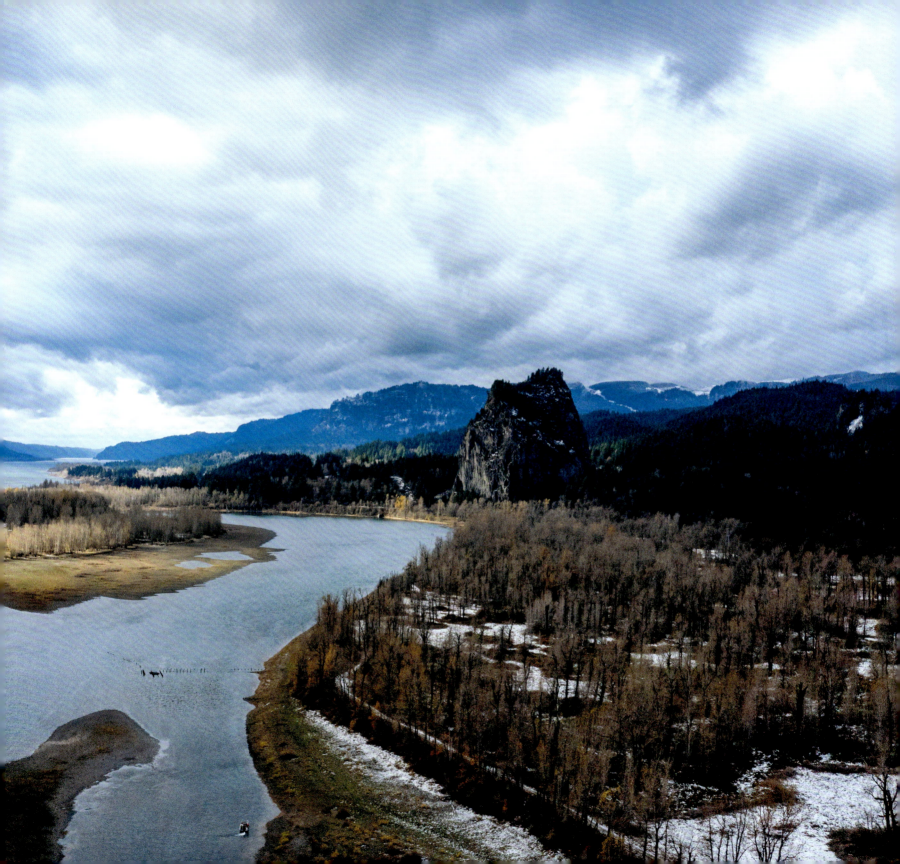

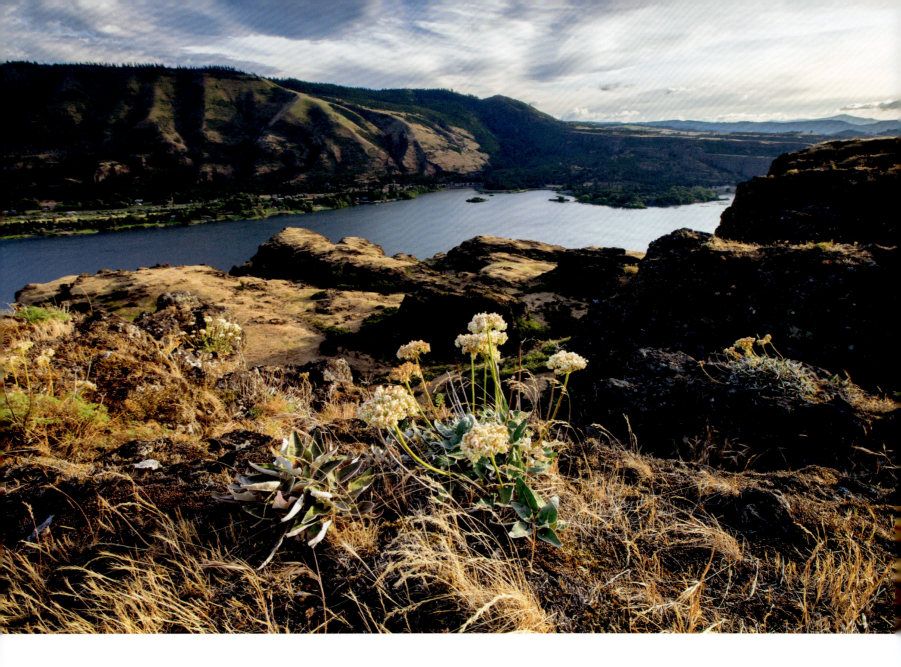

Northern buckwheat flowers stand out in the dry grassland on the north side of the Columbia River Gorge. The cooler and moister south side can be seen across the river in Oregon.

The sun sets over the Columbia River in spring through grass and wildflowers in a grove of Oregon white oaks on the Washington side of the Columbia River Gorge.

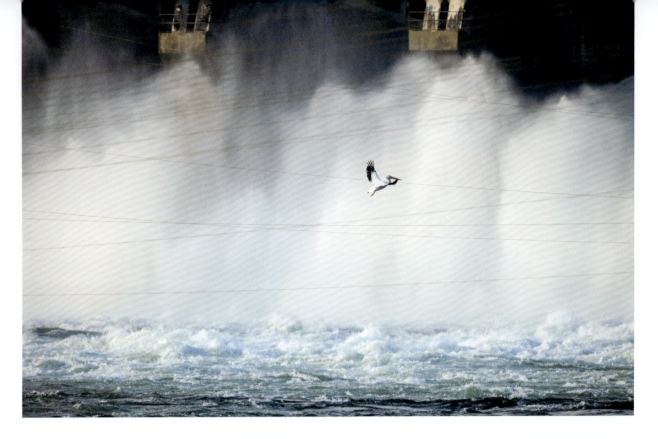

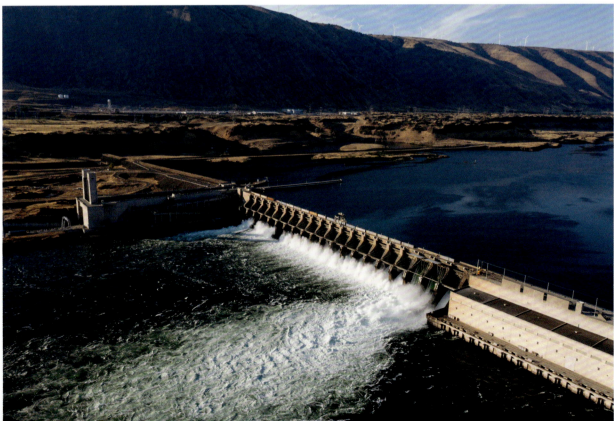

TOP An American white pelican flies by the John Day Dam. Dazed fish having come over the dam's spillways make for good fishing for pelicans and other piscivorous birds.

BOTTOM The John Day Dam blocks the mainstem of the Big River between Washington and Oregon just downstream from the confluence with the John Day River.

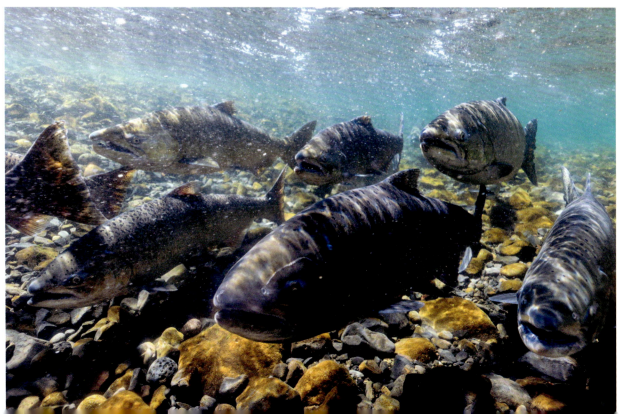

TOP An American dipper with a chum salmon egg in the Columbia River Gorge

BOTTOM Adult Chinook salmon return to the hatchery where they were reared on a tributary creek just below the Bonneville Dam.

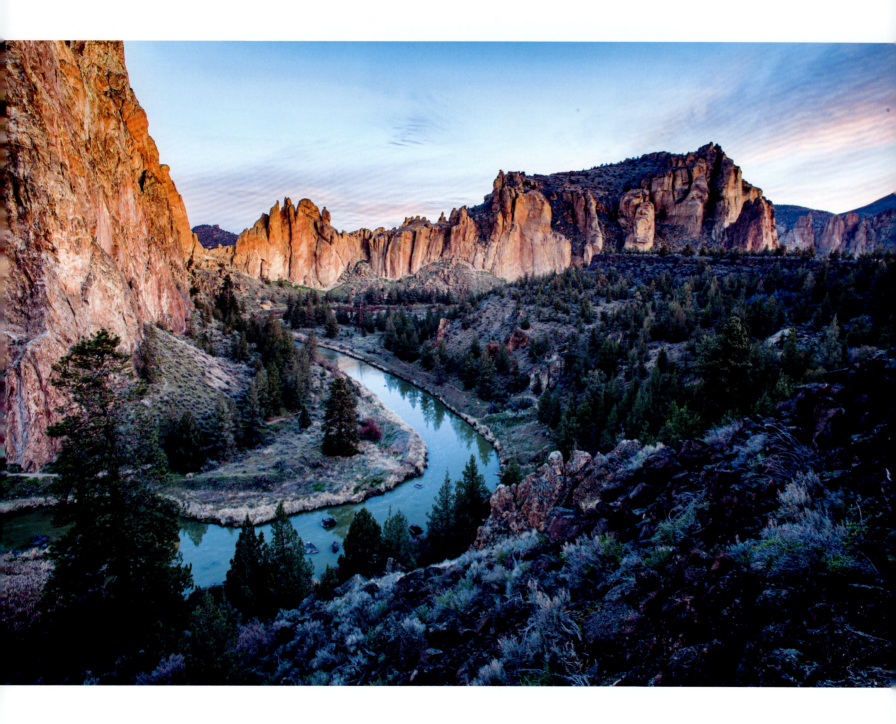

186 / BIG RIVER

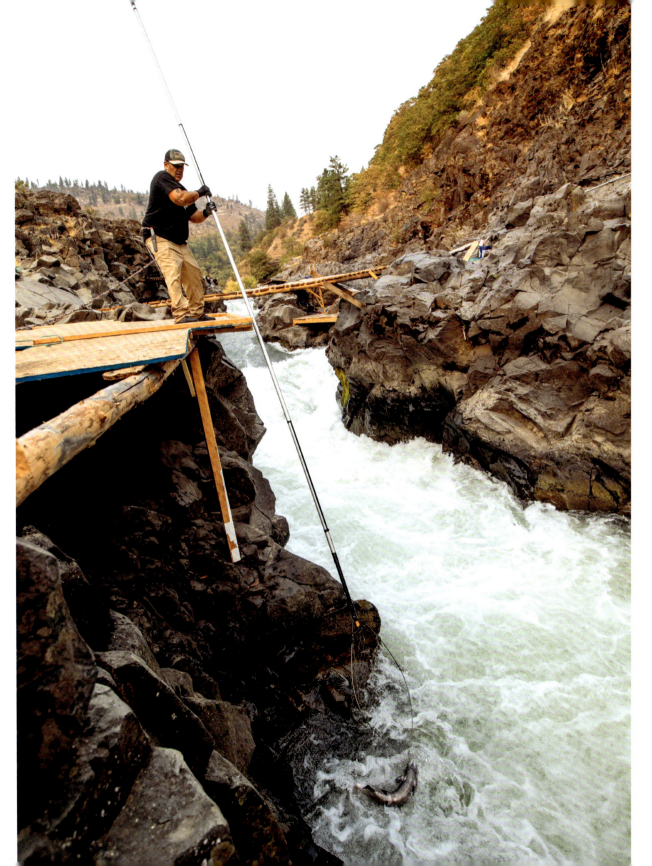

Ira Yallop uses a dipnet to catch coho salmon off his fishing platform along the Klickitat River, a traditional fishing location for the people of the Yakama Nation.

OPPOSITE The Crooked River flows past cliffs of tuft, a rock made of compressed volcanic ash, in Smith Rock State Park, Oregon.

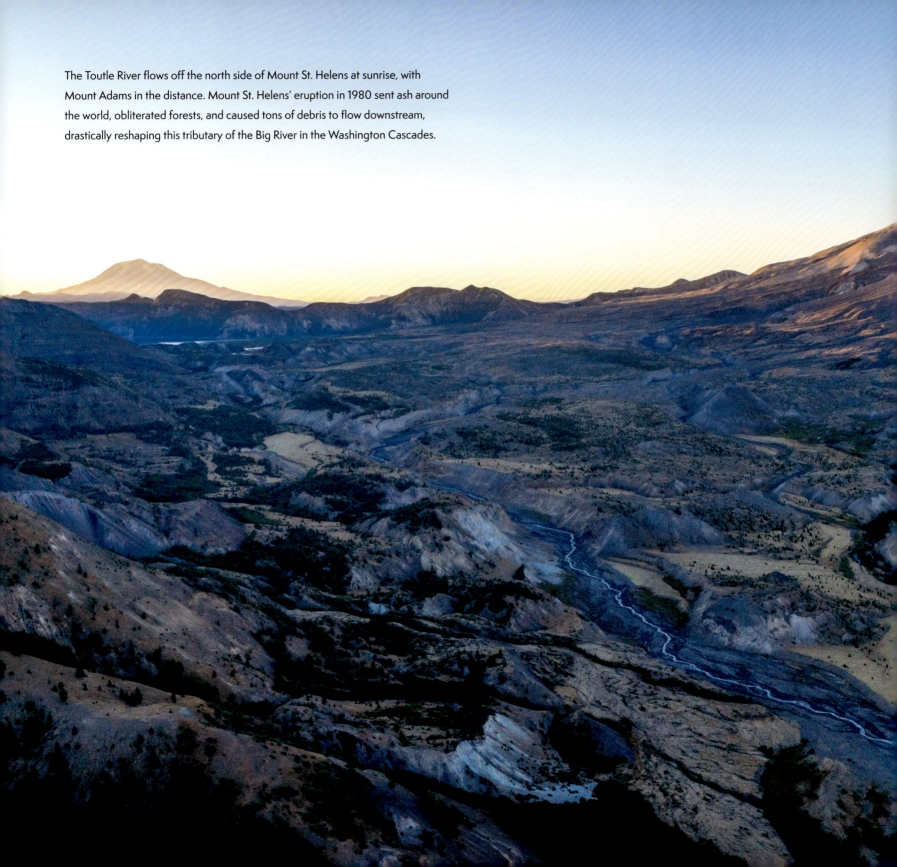

The Toutle River flows off the north side of Mount St. Helens at sunrise, with Mount Adams in the distance. Mount St. Helens' eruption in 1980 sent ash around the world, obliterated forests, and caused tons of debris to flow downstream, drastically reshaping this tributary of the Big River in the Washington Cascades.

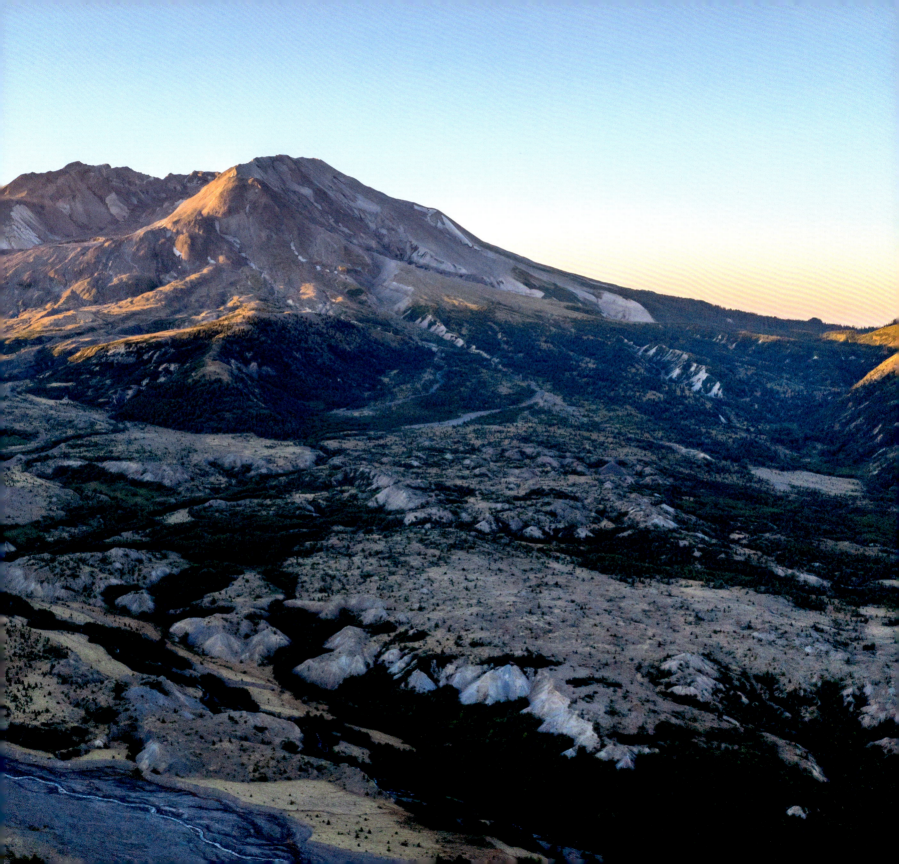

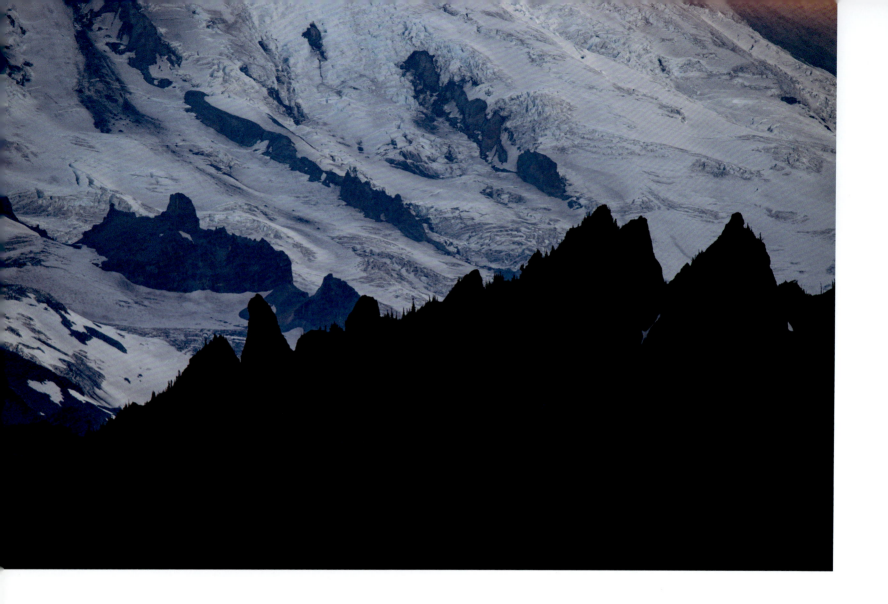

Glaciers on the southeastern flank of Tahoma (Mount Rainier) feed the Cowlitz River, one of the last major tributaries that joins the Big River before it flows into the Pacific Ocean. Tahoma translates to "mother of all waters" in the Coast Salish languages spoken by several tribes whose traditional territory includes this mountain.

The Muddy Fork of the Cowlitz River carries glacial silt off Mount Rainier through coastal temperate rainforest.

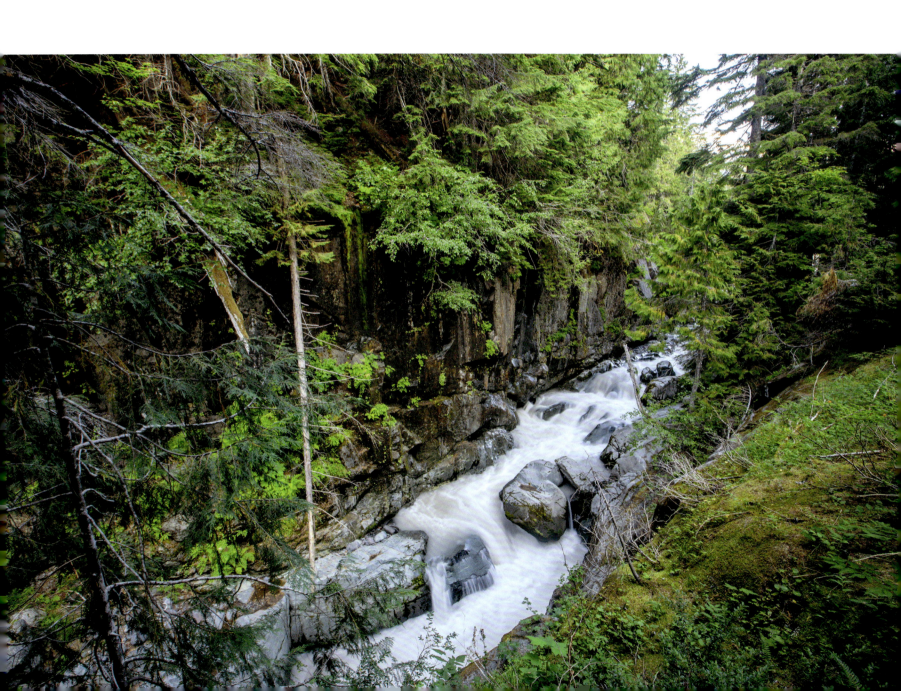

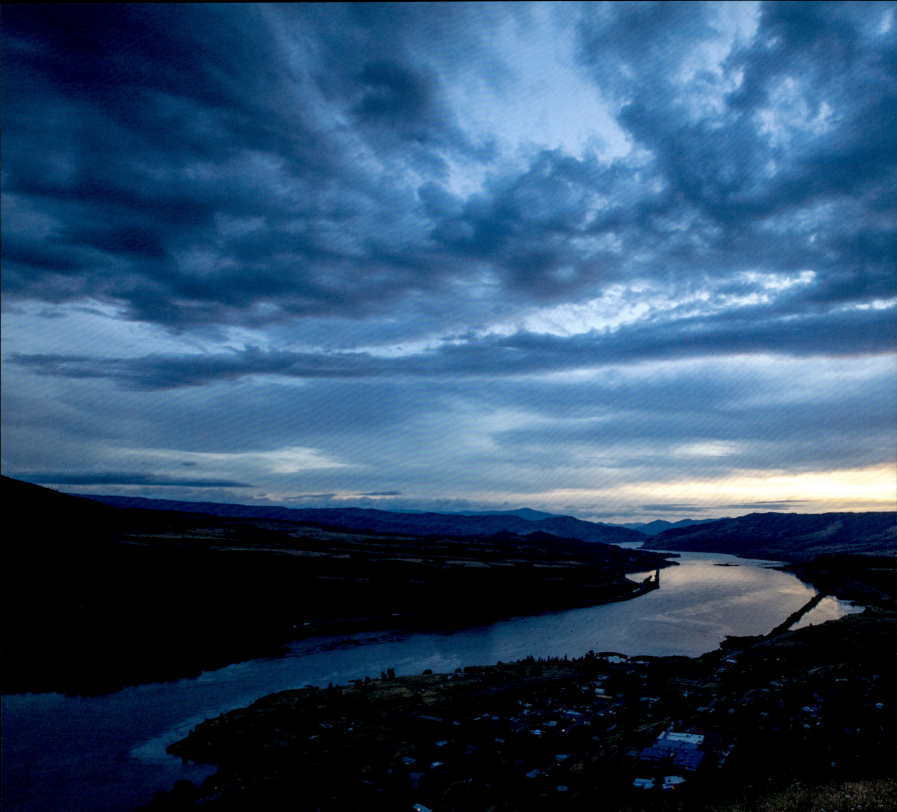

PALOMA AYALA

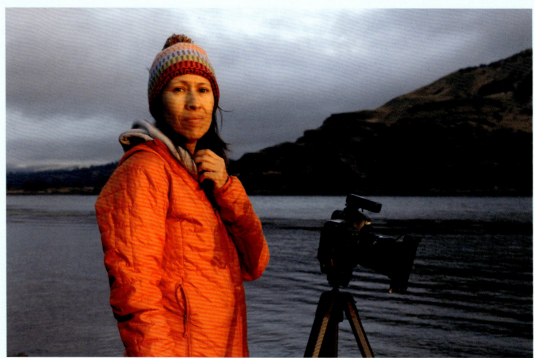

"After 12 years of living here, I see the threats more and more with issues like climate change. We do as much as we can to care for the river. I see it from different angles—it's the place where we recreate. It's other people's livelihood. There are many different ways to see this river. I love to document the landscape over time—I come here sometimes every day. I love to see the changes."

Paloma Ayala, photographer and former board member of Columbia Riverkeepers, captures landscape images along the Big River in Mayer State Park upstream from Hood River, Oregon. Ayala contributes photos to local organizations that are caring for the river.

OPPOSITE Sunset over the Big River near Lyle, Washington

Vast wetlands still exist along the mainstem of the Big River, photographed just downstream of the junction with the Willamette River. Mount St. Helens is in the distance on the left.

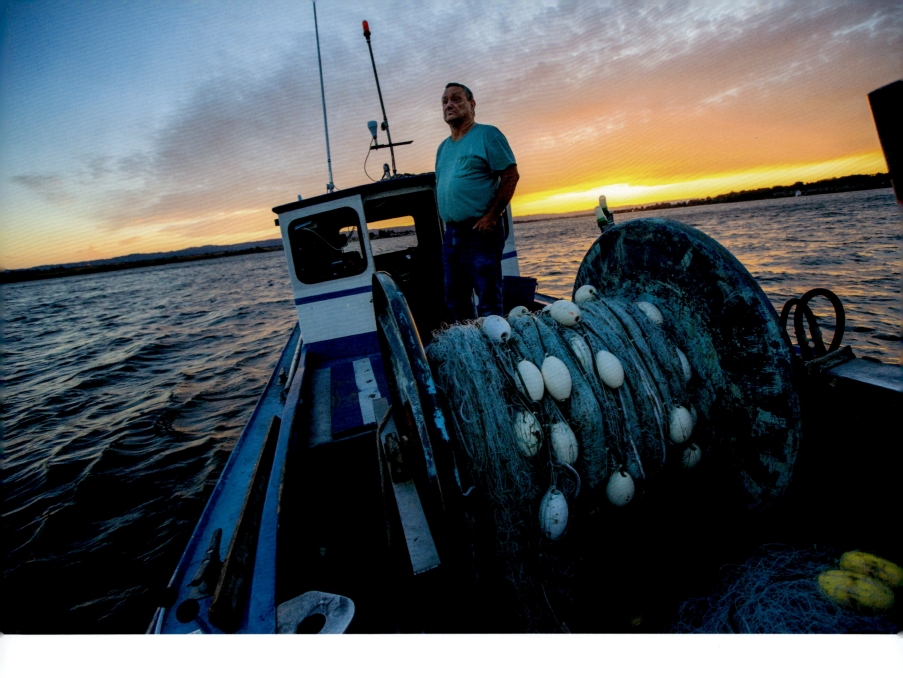

Russ Ipock looks out over the river on his way out to a one-night commercial gillnet fishing season on the river near Vancouver, Washington.

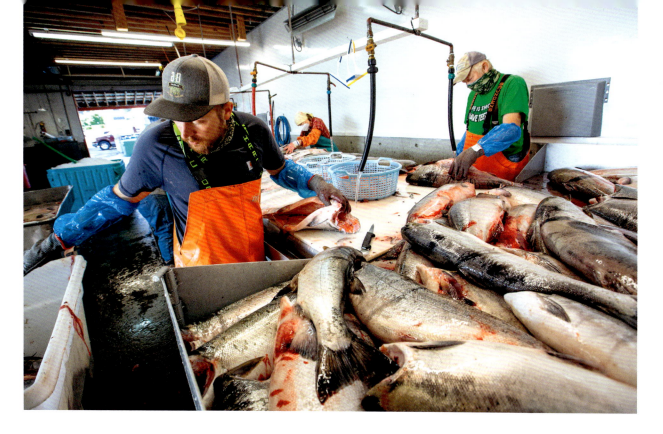

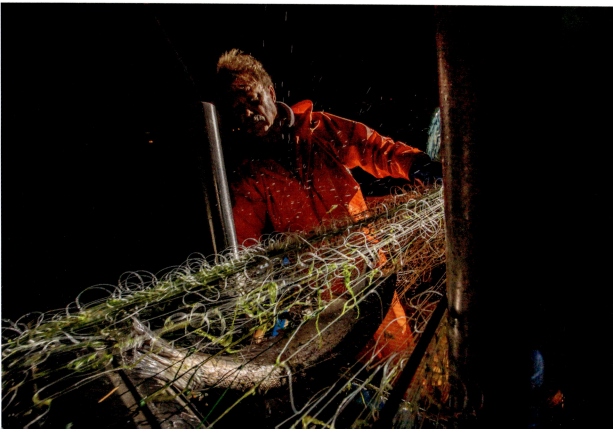

TOP Fishhawk Fisheries' processing plant is the last fish processer left in Astoria, Oregon, that processes Chinook salmon and a few sturgeon caught commercially in the Big River.

BOTTOM Commercial gillnet fisherman Bryce Devine brings in his catch of Chinook salmon on a one-night fishing season on the Big River near Vancouver, Washington.

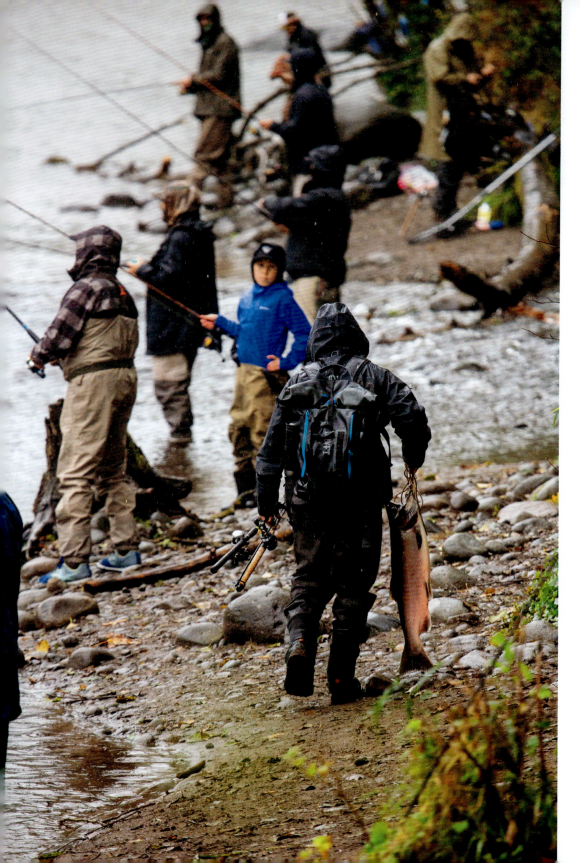

LEFT Recreational fishing for coho salmon on the Sandy River, Oregon

ABOVE A fleet of recreational fishing boats ply the waters of the Willamette River near Portland, Oregon.

NGUYEN NINH

"The Columbia River is very beautiful to look at and fun for lots of people who enjoying fishing during summertime. It is very relaxing. I'm loving it."

Nguyen Ninh, a recreational fisherman from Clackamas, Oregon, holding a pair of Chinook salmon he caught in the Big River.

LOWER COLUMBIA RIVER BASIN / 199

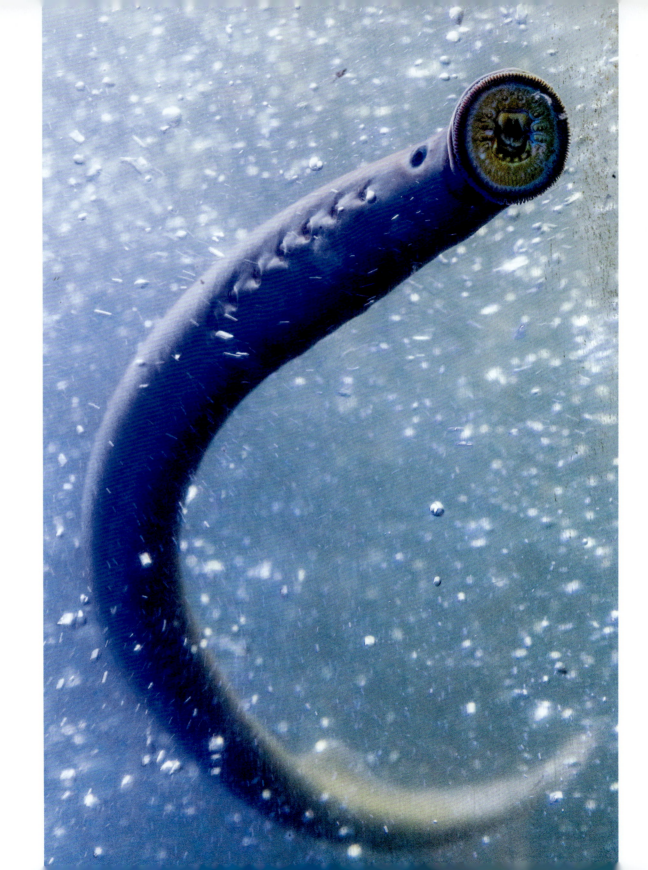

A Pacific lamprey in the fish ladder at MacNary Dam in Oregon. Lampreys use their mouths to attach to rocks as they climb up waterfalls and rocky river terrain during their spawning migration. Several Indigenous tribes of the Columbia River basin are spearheading an effort to reverse the drastic decline of this culturally important food source.

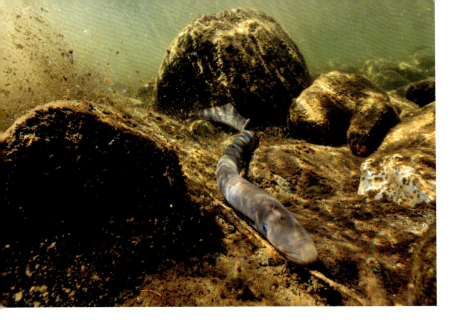

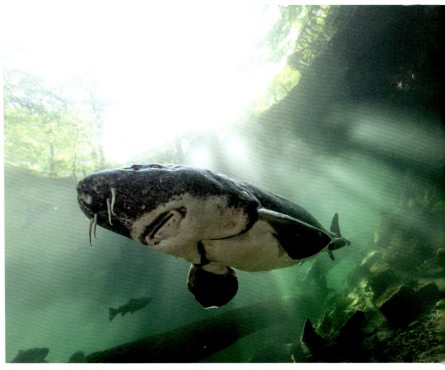

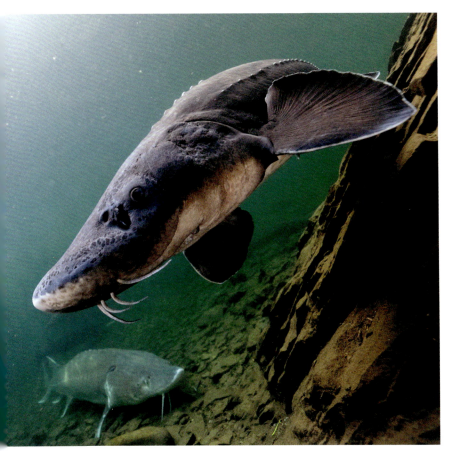

TOP LEFT A Pacific lamprey swims along the bottom of the Wenatchee River in Washington. These eel-like fish are anadromous and spend the first three to seven years of their life as filter feeders in fresh water before they migrate to the ocean. Just like salmon, they return to fresh water to spawn and then die, bringing ocean nutrients and energy to inland ecosystems.

TOP RIGHT White sturgeon swim in the dappled light of the Sturgeon Pond at Bonneville Fish Hatchery in Oregon. These cartilaginous creatures are the largest and longest-living fish in the Columbia River, with four barbels on the underside of their snout acting as chemosensory organs.

LEFT Two white sturgeon at the Bonneville Fish Hatchery. Like salmon, many populations of white sturgeon are anadromous. They live most of their life in large river estuaries and travel to fresh water for spawning. Dams throughout the Basin have blocked their migratory movement, in part due to fish ladders being designed for salmon and steelhead. Studies also suggest that trapping silt-rich spring floodwater behind dams may impact their maturation and overall health.

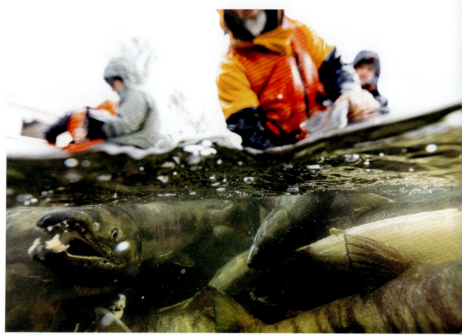
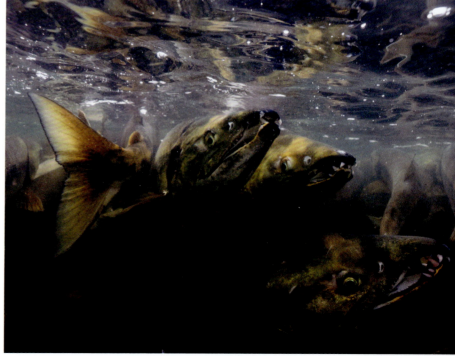

ABOVE Chum salmon spawning in a shallow side channel of the lower mainstem of the Big River

TOP RIGHT Employees of the Washington Department of Fish and Wildlife survey chum salmon in the mainstem of the river upstream from Vancouver, Washington.

TOP LEFT Chum salmon in the mainstem of the Big River upstream from Vancouver, Washington

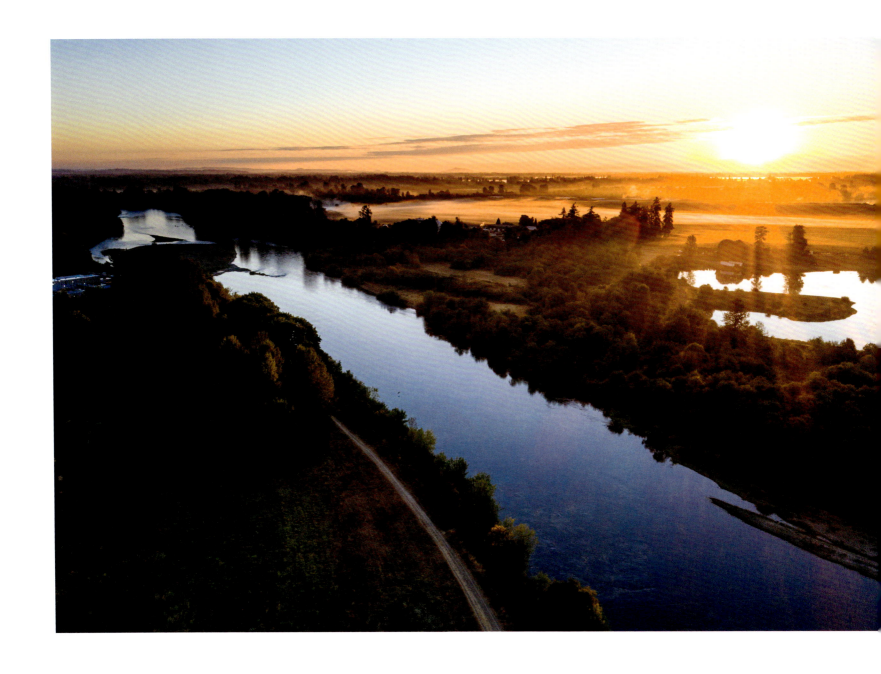

The Willamette River runs through fertile agricultural land in the Willamette Valley near Corvallis, Oregon.

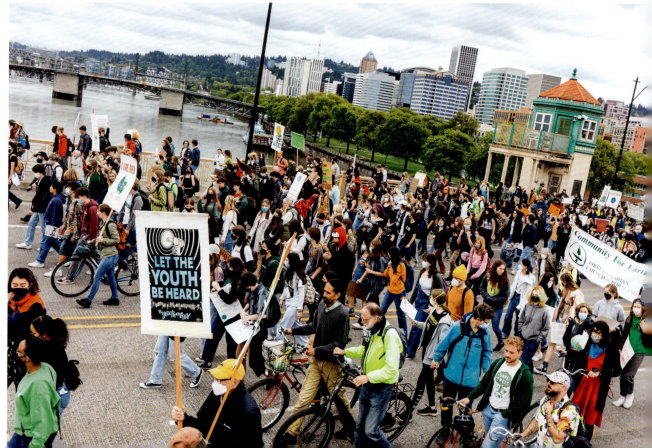

TOP Abandoned buildings and industrial infrastructure around Willamette Falls, a place important to local tribes for subsistence fishing and cultural activities

BOTTOM As part of a student-led climate strike, youth activists cross the Willamette River in downtown Portland, Oregon.

BRENNA BELL

Brenna Bell is a sixth generation Willamette Valley Oregonian who loves forests, mountain streams, relationships, words, and dairy goats. She has worked as an outdoor camp counselor, waitress, environmental attorney, and community organizer, and is raising her family on a small community farm in the hills of southwestern Portland near a lush creek that eventually flows into the Columbia.

"The waters and forests of the western Cascades have nourished my entire life, and I have worked hard to nourish them in turn. From tree-sits and road blockades to courtrooms and newsrooms, my life work is to change our cultural, legal, and economic relationship with forests and waters from one of transaction and exploitation to one of connection and reciprocity. And I have learned the true meaning of reciprocity from these watersheds—they have been my mentors. Eagle Creek, Multnomah Creek, Clackamas River, White River have all mentored me on the path of activism and connection. They taught me how to sing my song."

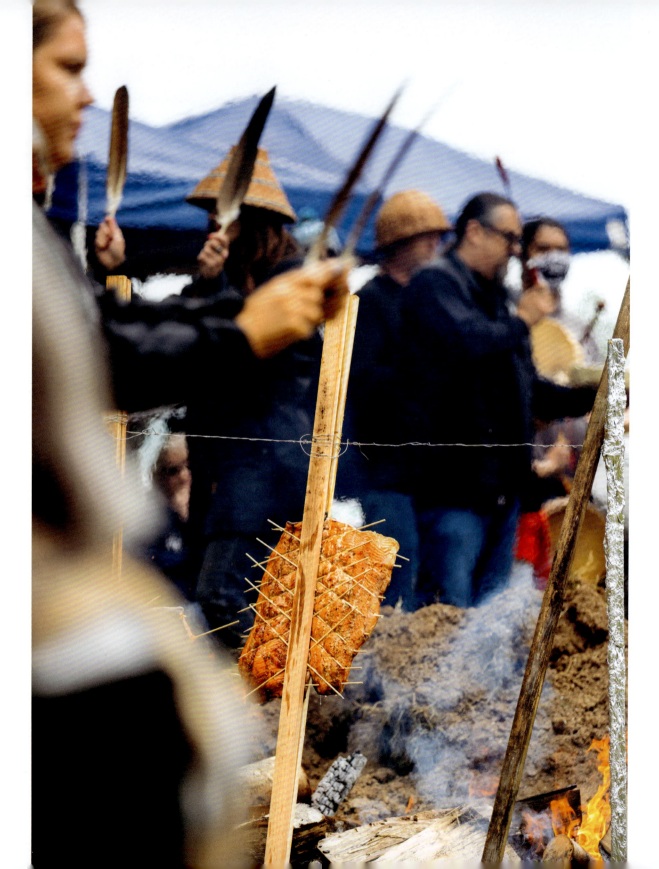

Chinook Nation members celebrate the start of salmon harvest season in their traditional territory at the mouth of the river. The first salmon is traditionally prepared and shared among the community and its bones are returned to the water out of respect and thanksgiving to the fish for feeding the people. The Chinook Nation has been fighting for federal recognition from the United States. Without that recognition, the state and federal government consider tribal members fishing outside of state-sanctioned recreational fishing seasons a violation of colonial laws.

SAM ROBINSON

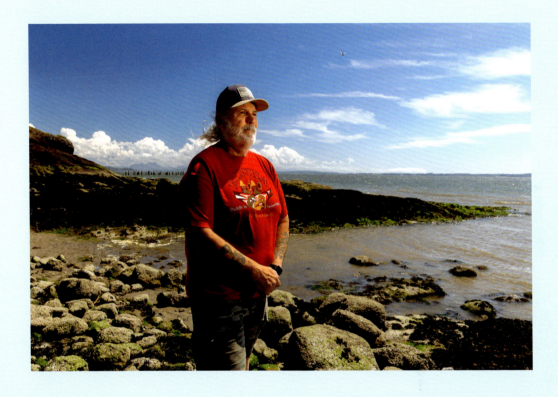

Sam Robinson, vice chairman of the Chinook Indian Nation, stands at Chinook Point, a site where his people have carried out ceremonies for generations.

"This river needs a lot of healing and we can help with that. It's important for us that this river gets taken care of—that's why getting federal status is important. We need to be able to carry on the work of our ancestors.

"It's one of our spiritual places—you can feel the ancestors here. We do the work, carrying on what our ancestors did here. We just hope that we are doing it right. When I travel up and down the river on a canoe, I am connected to them. This river is so giving to us. And each side stream also has something to give to us. It was a highway for the Chinook. We still travel up and down the river."

TOP Caspian terns at the mouth of the river. The world's largest breeding colony of Caspian terns is found on an artificial island created by the Army Corps of Engineers just upstream from the mouth of the river.

BOTTOM A male California sea lion pops up for a look around at the mouth of the Big River. California sea lions travel as far up the river as Bonneville Dam and up the Willamette River to Willamette Falls to fish for salmon.

OPPOSITE Cape Disappointment Lighthouse sits at the mouth of the river to help guide boat traffic through these dangerous waters.

Looking south over Cape Disappointment to the mouth of the Big River

210 / BIG RIVER

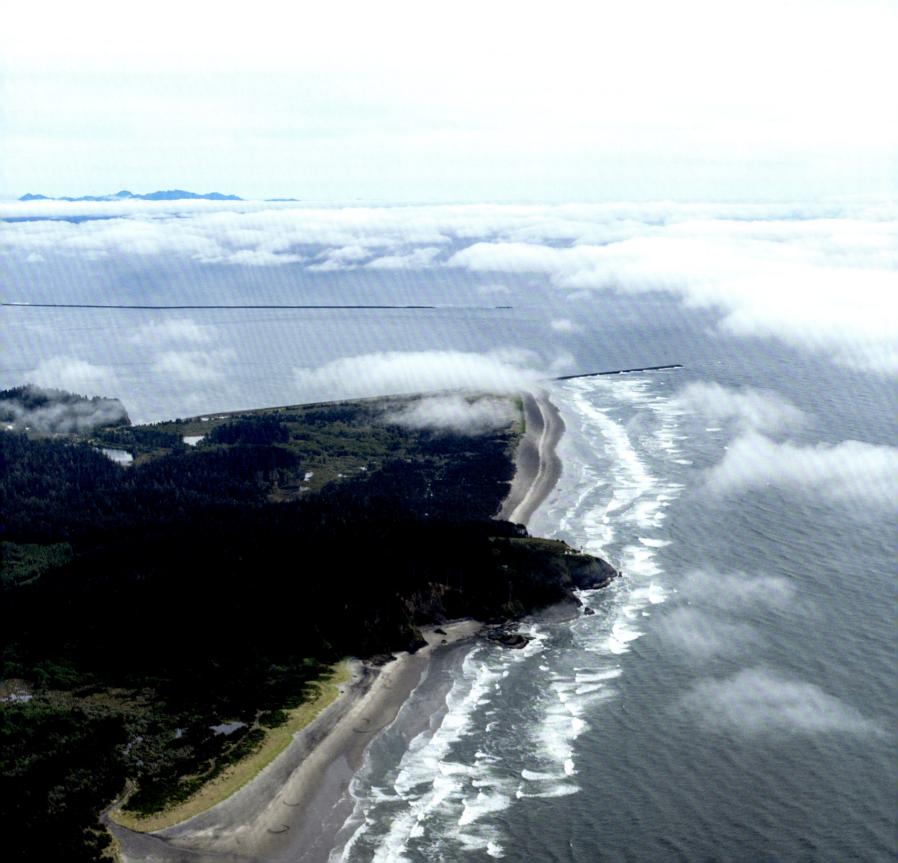

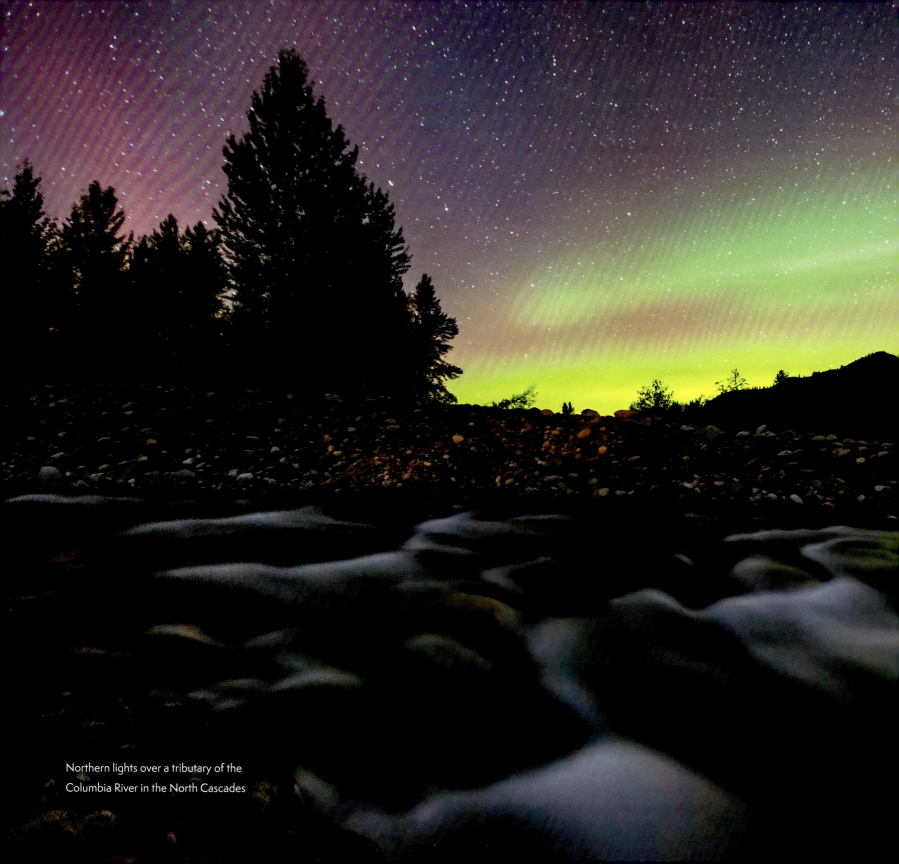

Northern lights over a tributary of the Columbia River in the North Cascades

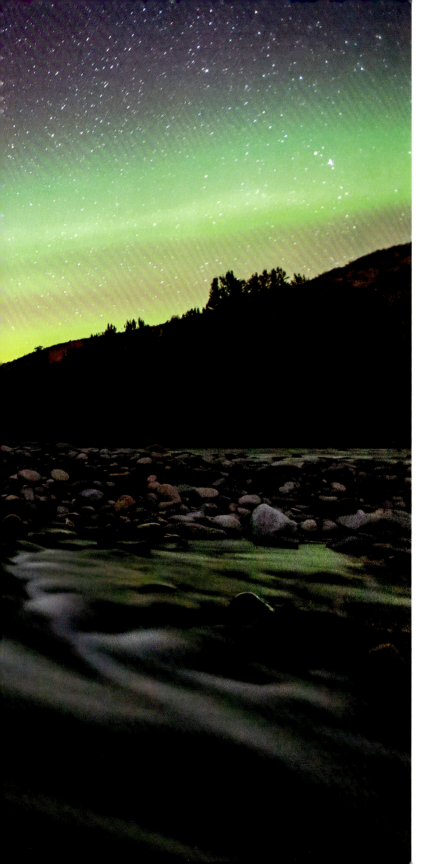

AN EXCERPT FROM

ONE RIVER, A THOUSAND VOICES

Claudia Castro Luna

O Great River

O Giver of Life

O Keeper of Time

Then, then, as you shall again flow
supreme, singular to your mission
that being your effulgent return
first to ocean, the great water
then to cloud, diaphanous water
then to rain and snow, shaped water
to return back down mountains,
channeling rills over mossy hills,
feeding rivulets, quietly resting
for a moment in the swirl of a chilly eddy,
hustling on to streams, eventually to your own
mighty torque and rhythm whose thunderous physics
bolt you forward through canyons,
around bends, past floodplains
shaping plateaus and prairies, to estuary and delta
finally to empty yourself unrelenting

for the future

Ponderosa pines frame the Big River near the international boundary.

ACKNOWLEDGMENTS
David Moskowitz

While protocols for getting permission from humans to photograph them are well established, how to do this for the many other beings in this watershed is less clear. In all my photography work, I attempt to do no harm to the creatures and landscapes I photograph. I am grateful for the intimate moments in the lives of beings and wild places I had the opportunity to experience and photograph. I am also grateful to have the opportunity to help share with you the stories they gifted to me.

The Big River watershed is the traditional territory of dozens of sovereign Indigenous nations. Substantial portions of the watershed are unceded territory of these people. I made efforts whenever possible to coordinate my photography and research with the people on whose traditional territory I was working and attempted to get guidance on culturally relevant content to cover, as well as feedback on how to do so in a culturally sensitive way. I am thankful for the support and encouragement I received from across the watershed in this regard. I am specifically grateful to the Chinook Indian Nation, the Confederated Tribes and Bands of the Yakama Nation, the Nez Perce Tribe, Confederated Tribes of the Colville Reservation, Okanagan Nation Alliance, and Shoshone-Paiute Tribes of the Duck Valley Reservation. I used Native Land Digital (https://native-land.ca) extensively, an amazing resource for understanding the territories of Indigenous nations across North America, including in the Big River watershed. However, any omissions in what I covered, or errors in how I covered it, are my responsibility alone.

Many organizations supported my fieldwork for this project with assistance for specific photography opportunities and understanding the nuances of various conservation and cultural issues and specific parts of the watershed. These include: Columbia Riverkeeper, Conservation Northwest, Oregon Natural Desert Association, Swan Valley Connections, Cascades Wolverine Project, Friends of the Owyhee, Wildsight, Yellowstone to Yukon Conservation Initiative, Columbia Land Trust, Methow Conservancy, Willow Brook Farm, Smallwood Farms, Columbia River Inter-Tribal Fish Commission, Cape Disappointment United States Coast Guard Station, Washington Department of Fish and Wildlife, Idaho Department of Fish and Game, Oregon Department of Fish and Wildlife, Bonneville Hatchery, Winthrop National Fish Hatchery, and the Confederated Salish and Kootenai tribes of the Flathead Reservation's Bison Range. Support for aerial photography around the mouth of the river was donated by LightHawk Conservation Flying and their volunteer pilots Jane Rosevelt and Dan Marks.

Many individuals helped me in large and small ways both in the field and behind the scenes. Thank you to Nyn Tomkins for your extensive research assistance and help with numerous field trips. Thank you for your help with fieldwork: Jeff Rose, Darcy Ottey, Anna Machowicz, Samantha Goff, Steph Williams, Drew Lovell, Ira Yallop, Louis George, Mikey Whitney, Sage Raymond, Jackson Riley, Kevin Riley, Kevin van Bueren, Bryce Devine, Russ Ipock, Cory Destein, Alfred Thieme, Andrew Matala, Ralph Lampman, Jason McCommons, Jeff Wirth, and Sean Toomey. Thanks for guidance, direction, and various types of support in and out of the field from Shelly Boyd, Tim Davis, Lace Thornberg, David A. Moskowitz, David Lindley, Davis Washines, Nate Bacon and Christina Stout, Greg Utzig, Julius Strauss, Michael Humling, Abigail Groskopf, Stormy Fuller, Kent Woodruff, Mac Shelton and Frauke Rynd, Adam Lieberg and Rebekah Rafferty, Steve Fick, Randy Lewis, Steve Smith, Casey Ryan, Brenna Bell, Mark and Julie Mackenzie, Buster Gibson, Russell Gilliam, Sam Robinson, Bruce Jones, Dott Crabbe, Crystal Spicer, Mary Anne Coules, Janet Black Eagle, Graeme Lee Rowlands, Alfred Joseph, Dennis and Mallory Carlton, Paloma Ayala, and Ubaldo Hernandez, Amiran White, Nathan Ulrich, Daniel Green, Kate Self, Eric Whittenbach, Joanna Bastion, Neal Wight, Lytle Denny, Philip Milburn, and Tom Reichner. Thank you to Mark Darrach for acting as my botanical consultant both in the field and reviewing images of plants and wildflowers.

I am grateful once again for the support and patience for this project from family and friends, specifically Darcy Ottey, Johanna Goldfarb, Ralph Moskowitz, Kerry Levin, Marianne Moskowitz, Grae Kindel, and Rosa Levin. In all of my photography endeavors, the photography lessons I got from my uncle, Aaron Goldfarb, shaped my approach to this project, perhaps more so here than in any previous project given his rich approach to water in his own photography. Similarly, the lessons I got from my time studying with Charles Worsham continue to be fundamental to my understanding of the importance of aesthetics in communicating visually. Feedback, lessons, and inspiration from friend and photographer Sarah Rice have also fundamentally shaped my approach to my work in everything from composition to making deeper connections with the humans whose stories I have been entrusted to help tell.

Thank you to the North American Nature Photography Association for funds provided through the Philip Hyde Conservation Grant to support my work on this story. Along with the folks mentioned above, I am grateful to the incredible support energetically and financially of Joshua Nicklin, Blake Bertram, Steve Engel, Peter Loft, Jack McLeod, Randy Beacham, Eric Downes,

Mallory Clarke, Linda Machia, Paul Allen and Jan Sodt, Robin Boyer, Pamela Gray, Nate Harvey, Charles Bauman, Pam Hawes, Marcus Reynerson, Kevin Riley, Johanna Goldfarb and Kerry Levin, Ralph Moskowitz, and Nyn Tomkins.

Once again working with the dedicated and exceptional folks at Braided River has been extraordinary throughout this project, including Helen Cerullo, Erika Lundahl, Laura Shauger, Emily White, and Amelia von Wolffersdorff. Similarly working with Eileen Delehanty Pearkes along with the staff at Braided River to develop the themes and flow of the book was deeply educational and inspiring, helping shape my own approach to the visuals for the book. Conversations with fellow Braided River photographer David Showalter were also critical in shaping my approach to this project.

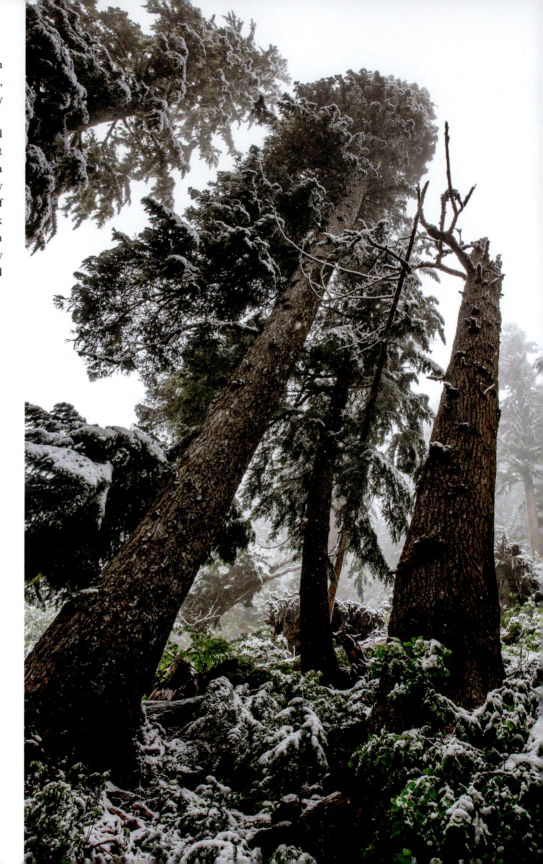

Coastal temperate rainforest in the Cowlitz River watershed

A NOTE ABOUT THE PHOTOGRAPHY

David Moskowitz

This project has been the most ambitious and complicated of my photographic career. My aim as a documentary photographer is to present the world to viewers as I encounter it. For this project, however, several elements moved away from simple documentation of the world as we humans typically see it walking around during the daylight hours. Camera traps offered me the opportunity to capture the secret lives of wildlife at night, while flash photography similarly let me document the world of gillnet fishermen, plying their trade in the darkness on the mainstem of the river. Flights, generously donated by Lighthawk Conservation Flying and others, along with the use of a photography drone (DJI Mavic Pro 2), allowed me the opportunity to share an aerial view of the watershed I believe is critical to appreciate the scale of the geography and the ways water shapes the landscape. To get down to eye level with fish required underwater photography on a scale I had not previously endeavored to create. Finally, producing a series of portraits of "river people" required careful coordination and staging to create a cohesive series of images of individuals from across the watershed with vastly different relationships with the river in contexts that were both relevant to them and that showed the connections they all have to this one collective watershed.

I used a variety of mirrorless and DSLR Canon bodies and lenses for the majority of the images. I toned images in Adobe Lightroom. My love of strong contrast in landscape images means several involved layering multiple exposures of the same image to capture the full range of light. For some underwater images, I used Topaz AI denoising software as part of image processing to balance low light and turbid water.

In the end, I wanted a series of images that gave the viewer as wide a variety of unique perspectives as was possible. I wanted to let the many voices of this watershed, from salmon in the river, to humans on the banks, to glaciers on the mountaintops, all have the opportunity to share their perspective with you. I worked very hard to listen to and watch the people, creatures, and places and take my cues from them about what stories they wanted to share.

A male chinook tends to a female on her redd (visible by the lighter colored rocks around her where she excavated the river bottom) in the Methow River.

NOTES

NAMING THE RIVER

p. 17 **In 1792, American fur trader Robert Cook named:** Harrison, *The Columbia River*.

THE GRACE OF WATER

p. 42 **Extremely important water purifiers who birth millions of tiny babies:** Nedeau, Smith, and Stone, *Freshwater Mussels of the Pacific Northwest*.

p. 42 **an immense one that formed behind an ice dam:** Foundation for Water and Energy Education and US Geological Survey.

p. 42 **Geologists theorize that one of these flood events:** US Geological Survey.

p. 45 **A large amount of new evidence gathered:** Raff, *Origin*; Zimmer, "Ancient Footprints Push Back Date of Human Arrival in the Americas."

p. 46 **When scientists accessed and studied the bones, they pieced together:** "Kennewick Man."

p. 46 **the use of the now-refuted practice of skull-shape analysis:** Personal communication, Richard Hart.

p. 46 **Then, in 2015, more precise DNA analysis linked:** Thompson, "Genome Analysis Links Kennewick Man to Native Americans"; Blakemore, "Over 9,000 Years Later, Kennewick Man Will Be Given a Native American Burial."

p. 48 **Recent research by a retired hydrologist has revealed:** Gillmor, "Ground Water to Columbia Lake in the Vicinity of Canal Flats."

p. 48 **In 1836, a baby girl was born at the headwaters of the Columbia River:** Carter and McCormack. *Recollecting*.

p. 51 **Pioneers arrived at a steadily increasing pace:** Leighton, *West Coast Journeys, 1865–1879*.

p. 51 **In 1855, after a series of wars, strife, and conflict, Washington's new territorial governor gathered:** Personal communication, Richard Hart.

p. 52 **The first cannery opened:** Kurlansky, *Salmon*.

p. 55 **The north changes the world:** Louie, "Tales of Coyote."

p. 55 **Settlers, by contrast, found that multiple river rapids:** Brown, *The Hand of Catherine*.

p. 56 **The dam rose higher:** Pearkes, *A River Captured*.

p. 56 **Bonneville Lock and Dam, constructed:** "Fish Passage at Dams," Northwest Power and Conservation Council.

p. 56 **A delegation from the Colville Confederated Tribes:** Pearkes, *A River Captured*.

p. 56 **The numbers of salmon returning:** Kurlansky, *Salmon*.

p. 56 **And then came the 1948 flood:** Oregon History Project.

p. 59 **More dams preceded or followed:** Kurlansky, *Salmon*.

p. 63 **Meanwhile, the mid-Columbia tribes hired lawyers:** Kurlansky, *Salmon*.

p. 65 **Today, the Columbia Basin Project irrigates:** Foundation for Water and Energy Education; stats are up to date as of February 2022.

p. 65 **Snake River barges transport:** Foundation for Water and Energy Education; stats are up to date as of February 2022.

p. 67 **Most recently, in 1996 and 2012:** Foundation for Water and Energy Education.

p. 68 **Ten years ago, Urban Eberhart:** Fountain, "Climate Change Is Ravaging the Colorado River."

p. 74 **By the mid- to late 1990s, a species review:** Lichatowich, "An Unfinished Story."

p. 74 **In terms of viability:** Personal communication, David A. Moskowitz.

p. 75 **Several years later, biologist Jeff Cederholm:** Levy, "Pacific Salmon Bring It All Back Home."

p. 77 **In the "American" portion:** Northwest Power and Conservation Council.

p. 77 **In Canada, where hundreds of miles:** Pearkes, *A River Captured*.

p. 77 **The 1980 Power Act had invited justice:** Harrison, "BPA Commits $420 Million to Columbia Fish Accord Extensions."

p. 78 **Developed originally in Europe:** Kurlansky, *Salmon*.

p. 78 **we are now treating:** Personal communication, David A. Moskowitz.

p. 79 **Due to tribal advocacy, Chief Joseph Hatchery:** "Chief Joseph Hatchery."

p. 81 **Before restoration, 25,000:** Personal communication, David A. Moskowitz.

p. 81 **Central to the process:** Okanagan Nation Alliance.

RESOURCES

Blakemore, Erin. "Over 9,000 Years Later, Kennewick Man Will Be Given a Native American Burial." *Smithsonian Magazine*, April 28, 2016.

Brown, George Thomas. *The Hand of Catherine: Columbia's Daughter, Catherine Roussil-Chalifoux-Comartin*. Fairfield, WA: Ye Galleon Press, 1998.

Carter, Sarah, and Patricia A. McCormack, eds. *Recollecting: Lives of Aboriginal Women of the Canadian Northwest and Borderlands*. Athabasca, AB: Athabasca University Press, 2011.

"Chief Joseph Hatchery." Colville Confederated Tribes Fish and Wildlife. n.d. www.cct-fnw.com/salmon-hatchery.

"Fish Passage at Dams." Northwest Power and Conservation Council, n.d., www.nwcouncil.org/reports/columbia-river-history/fishpassage.

Flores, Lola, Johnny Mojica, Angela Fletcher, et al. *The Value of Natural Capital in the Columbia River Basin: A Comprehensive Analysis Ecosystem-Based Function Integration into the Columbia River Treaty*. Tacoma: Earth Economics, 2017.

Foundation for Water and Energy Education, fwee.org.

Fountain, Henry. "Climate Change Is Ravaging the Colorado River: There's a Model to Avert the Worst." *New York Times*, September 5, 2022. www.nytimes.com/2022/09/05/climate/colorado-river-yakima-lessons-climate.html.

Gillmor, E. "Ground Water to Columbia Lake in the Vicinity of Canal Flats." Columbia Lake Stewardship Society, September 2018. columbialakess.com/wp-content/uploads/2018/09/groundwater-contribution-to-columbia-lake-1.pdf.

Harrison, John. "BPA Commits $420 Million to Columbia Fish Accord Extensions." Northwest Power and Conservation Council. October 12, 2108. www.nwcouncil.org/news/2018/10/12/bpa-commits-450-million-columbia-fish-accord-extensions.

———. *The Columbia River*. Charleston, SC: Arcadia Publishing, 2021.

Hart, Richard. Colville Confederated Tribes historian. Personal communication with Eileen Delehanty Pearkes.

"Kennewick Man." Wikipedia, en.wikipedia.org/wiki/Kennewick_Man.

Kurlansky, Mark. *Salmon: A Fish, the Earth, and the History of Their Common Fate*. Ventura, CA: Patagonia Books, 2020.

Leighton, Caroline C. *West Coast Journeys, 1865–1879*. Seattle: Sasquatch Books, 1995.

Levy, Sharon. "Pacific Salmon Bring It All Back Home." *Bioscience* 47, no. 5 (1997): 657–60. doi.org/10.2307/1313204.

Lichatowich, Jim. "An Unfinished Story: Managing Annihilation of Wild Pacific Salmon." Salmon History, 2019, www.salmonhistory.com/Managed_Annihilation_Final_Corrected_12_2_2019.pdf.

Louie, Martin. "Tales of Coyote: Eastern Washington Traditions as Told by Martin Louie Sr." In *A Columbia River Reader*, edited by William L. Lang. Tacoma: Washington State Historical Society, 1992.

Moskowitz, David A. Executive director of The Conservation Angler. Personal communication with Eileen Delehanty Pearkes.

Nedeau, Ethan, Allan K. Smith, and Jen Stone. *Freshwater Mussels of the Pacific Northwest*. Washington, DC: US Fish and Wildlife Service, n.d. www.fws.gov/pacific/columbiariver/musselwg.htm.

Northwest Power and Conservation Council, nwcouncil.org.

Okanagan Nation Alliance, syilx.org.

Oregon History Project, oregonhistoryproject.org.

Pearkes, Eileen Delehanty. *A River Captured: The Columbia River Treaty and Catastrophic Change*, 2nd ed. Victoria, BC: Rocky Mountain Books, 2023.

Raff, Jennifer. *Origin: A Genetic History of the Americas*. New York: Hachette, 2022.

Thompson, Helen. "Genome Analysis Links Kennewick Man to Native Americans," *Smithsonian Magazine*, June 18, 2015. www.smithsonianmag.com/science-nature/genome-analysis-links-kennewick-man-native-americans-180955638.

US Geological Survey, usgs.gov.

Waples, Robin S., George R. Pess, and Tim Beechie. "Evolutionary History of Pacific Salmon in Dynamic Environments," *Evolutionary Applications* April 2008: 189–206.

Zimmer, Carl. "Ancient Footprints Push Back Date of Human Arrival in the Americas." *New York Times*, September 23, 2021. www.nytimes.com/2021/09/23/science/ancient-footprints-ice-age.html.

LEARN MORE AND GET INVOLVED

Bringing the Salmon Home: The Columbia River Salmon Reintroduction Initiative, columbiariversalmon.ca: Builds on the unique values, responsibilities, and authorities of five governments, including the Syilx Okanagan Nation, Ktunaxa Nation, Secwépemc Nation, Canada, and British Columbia, to evaluate the feasibility of and options for reintroducing salmon to upper Columbia River region.

Canadian Columbia River Inter-Tribal Fisheries Commission, ccrifc.org/salmon-restoration: Protects, conserves, manages, harvests, and enhances the water, fisheries, and aquatic resources of the Canadian Columbia River basin according to traditional law and custom and the laws of Canada as they evolve from court decisions. Members include the Ktunaxa Nation Council and Secwepemc communities whose traditional territories include part of the Columbia Basin in Canada.

Columbia Basin Trust, cbt.org: Established by the 1995 Columbia Basin Trust Act in British Columbia, the trust supports a legacy of social, economic, and environmental well-being, for upper Columbia River residents and communities negatively impacted by Columbia River Treaty storage reservoirs.

Columbia River Inter-Tribal Fish Commission, critfc.org. Coordinates management policy and provides fisheries technical services for the Yakama, Warm Springs, Umatilla, and Nez Perce tribes. Its mission is to ensure a unified voice in the overall management of fishery resources and protect reserved treaty rights through the inherent sovereign powers of the tribes.

Columbia Riverkeeper, www.columbiariverkeeper.org: Protects and restores the water quality of the Columbia River and all life connected to it, from the headwaters to the Pacific Ocean.

Columbia River Transboundary Water Governance and Ethics Symposium 2023, columbiabasingovernance.org: A platform for speakers at a recent symposium that may develop into a broader resource.

Conservation Northwest, conservationnw.org: Protects, connects, and restores wildlands and wildlife from the Washington coast to the British Columbia Rockies. Has a campaign aiming to protect sagebrush lands in the Columbia Basin watershed.

Columbia River Basin Restoration Program, www.epa.gov/columbiariver: In 2016, the US Congress amended the Clean Water Act to form the Columbia River Basin Restoration Program. Learn more about the program through this online portal.

CREST (Columbia River Estuary Study Taskforce), www.columbiaestuary.org: A community organization based in Astoria, Oregon, that specializes in environmental planning and habitat restoration for fish and wildlife.

Friends of the Owyhee (Idaho/Oregon), www.friendsoftheowyhee.org. Promotes conservation advocacy, stewardship, and responsible recreation in the Owyhee region. Collaborates with with conservation and recreation groups, landowners, ranchers, Indigenous Tribes and Nations, sportsmen and women, and government agencies to ensure the Owyhee's unique ecological, cultural, and recreational resources are protected for future generations to experience and enjoy.

Kootenay Resilience, kootenayresilience.org: A Canadian upper Columbia environmental collaborative focused on ecological impacts from dams in the Canadian portion of the watershed.

Lower Columbia Estuary Partnership, www.estuarypartnership.org: An organization made up scientists, educators, and community members that works to protect and restore the lower Columbia River, from the Bonneville Dam to the Pacific Ocean.

Northwest Power and Conservation Council, nwcouncil.org: Established by the federal 1980 Power Act, The Northwest Power and Conservation Council is a consortium of four US states that operates a website rich in historical and contemporary information on fish and wildlife issues.

Oregon Natural Desert Association, onda.org: Defends public lands from threats, partners with public and private land managers to preserve natural values, encourages the exploration of wild places, and restores lands and waters to give desert wildlife safe habitat in which to thrive.

Save Our Wild Salmon, www.wildsalmon.org: A diverse, nationwide coalition working together to restore wild salmon and steelhead to the rivers, streams, and marine waters of the Pacific Northwest for the benefit of our region's ecology, economy, and culture.

Upper Columbia United Tribes, ucut.org: Leaders in the effort to restore salmon to the upper Columbia River area, UCUT provides a source for technical reports and cultural information about the plan to restore salmon and minimize the impact of invasive species.

Wildsight, wildsight.ca: Works locally, regionally, and globally to protect biodiversity and encourage sustainable communities in Canada's Columbia and Rock Mountain regions.

Yellowstone to Yukon's Columbia Headwaters Campaign, y2y.net/work/hot-projects/upper-columbia: Works to connect and protect the Columbia for wildlife and people.

IN APPRECIATION

Thank you to the many donors, including individuals, conservation partners, Tribes and First Nations, and foundations whose generosity helped to bring this book to life. To learn more about how you can contribute to the ongoing efforts to protect North America's wild and sacred lands and waters, visit BraidedRiver.org/donate.

$10,000+ LIFE SOURCE GIFT

Pendleton and Elisabeth Carey Miller Charitable Foundation

Tom and Sonya Campion

$5,000+ SALMON RUN GIFT

$2,500+ WATERSHED GIFT

$1000+ TRIBUTARY GIFT

Helen and Arnie Cherullo
TJ and Tanya King
Joan Miller
Ron and Eva-Marie Sher
Iris Wagner
Elizabeth Watson

HEADWATERS SUPPORTERS

Headwaters Fund supporters give unrestricted support at the $2,500 level or above each year to fund Braided River's books and campaigns, and are recognized in all books published during the calendar year of their annual gift.

Anonymous
Tom and Sonya Campion
Ellen Ferguson
Renee Harbers Liddell, Harbers Family Foundation
Don and Marci Heck

Jon Hoekstra and Jennifer Steele
Ann and Ron Holz
Gary Rygmyr and Jennifer Warburton
Ron and Eva-Marie Sher
Erin Younger and Ed Liebow

ABOUT THE AUTHORS & CONTRIBUTORS

Sarah Rice

David Moskowitz is the author and photographer of *Caribou Rainforest*, *Wildlife of the Pacific Northwest*, and *Wolves in the Land of Salmon*; coauthor of *Peterson's Field Guide to North American Bird Nests*; and producer of the film *Last Stand: The Vanishing Caribou Rainforest*. His photography has appeared in numerous media outlets and conservation campaigns in the United States and internationally. He is cofounder of the Cascades Wolverine Project.

Moskowitz holds a bachelor's degree in environmental studies and outdoor adventure education from Prescott College. A certified Senior Tracker through Cybertracker Conservation, he is an evaluator for this rigorous international certification program for wildlife tracking. He lives in northcentral Washington State. Learn more about his work at www.davidmoskowitz.net.

Amy Allcock

Eileen Delehanty Pearkes explores landscape, history, and the human imagination in writing, maps, and visual notebooks, with a particular focus on Indigenous culture and the power of water. A dual citizen of Canada and the United States, Pearkes has traveled across and researched the international Columbia River basin for more than two decades. She is the author of *The Geography of Memory*, *A River Captured: The Columbia River and Catastrophic Change*, and *The Heart of a River*.

Claudia Castro Luna served Washington State Poet Laureate for several years. She is the author of *Cipota Under the Moon*, *One River, A Thousand Voices*, and *There's a Revolution Outside, My Love*, among others. Born in El Salvador, Castro Luna arrived in the US in 1981. Living in English and Spanish, she teaches and writes in Seattle.

BRAIDED RIVER

BRAIDED RIVER, the conservation imprint of Mountaineers Books, combines photography and writing to bring a fresh perspective to key environmental issues facing western North America's wildest places. Our books reach beyond the printed page as we take these distinctive voices and vision to a wider audience through lectures, exhibits, and multimedia events. Our goal is to build public support for wilderness preservation campaigns, and inspire public action. This work is made possible through the book sales and contributions made to Braided River, a 501(c)(3) nonprofit organization. Please visit BraidedRiver.org for more information on events, exhibits, speakers, and how to contribute to this work.

Braided River books may be purchased for corporate, educational, or other promotional sales. For special discounts and information, contact our sales department at 800.553.4453 or mbooks@mountaineersbooks.org.

THE MOUNTAINEERS, founded in 1906, is a nonprofit outdoor activity and conservation organization, whose mission is "to explore, study, preserve, and enjoy the natural beauty of the outdoors . . ." Mountaineers Books supports this mission by publishing travel and natural history guides, instructional texts, and works on conservation and history.

See our website to explore our catalog of 700 outdoor titles:
Mountaineers Books
1001 SW Klickitat Way, Suite 201
Seattle, WA 98134
800.553.4453
www.mountaineersbooks.org
Manufactured in China on FSC®-certified paper, using soy-based ink.

For more information, visit www.bigrivercolumbia.org.

Copyright © 2024 by Braided River

Introduction, photographs, and captions copyright © 2024 by David Moskowitz
"The Grace of Water" copyright © 2024 by Eileen Delehanty Pearkes
All rights reserved.
First edition, 2024
Excerpt on page 213 is reproduced courtesy of Claudia Castro Luna. To read the entire poem, refer to *One River, A Thousand Voices*, published by Chin Music Press.

No part of this book may be reproduced in any form, or by any electronic, mechanical, or other means, without permission in writing from the publisher.

Braided River and its colophons are registered trademarks.

Executive Director, Braided River: Helen Cherullo
Deputy Director, Braided River: Erika Lundahl
Project Editor: Laura Shauger
Developmental Editor: Linda Gunnarson
Copyeditor: Theresa Winchell
Cover and Book Designer: Amelia von Wolffersdorff
Cartographer: Martha Bostwick
Tribal Advisor: Shelly Boyd
Salmon and trout illustrations on pages 40–41: Joseph Tomelleri

Front cover photo: The Big River flows freely through the Columbia River Gorge toward the Pacific Ocean. *Back cover:* Salmon cooking over a fire during a Chinook Nation salmon honoring ceremony near the mouth of the Columbia River. *Next page:* A crew of paddlers on a rainy day on Upper Arrow Lake in a dugout canoe of the Sinixt people during a canoe journey through their traditional territory

Library of Congress Cataloging-in-Publication Data
Names: Moskowitz, David, 1976- photographer, writer of introduction. | Pearkes, Eileen Delehanty, 1961- author.
Title: Big river : resilience and renewal in the Columbia Basin / Photography and introduction David Moskowitz ; narrative by Eileen Delehanty Pearkes.
Description: First edtion. | Seattle, WA : Braided River, 2024. | Includes bibliographical references. | Summary: "Illuminates the ecological, hydrological, geological, and cultural beauty and activity of the Columbia River watershed, featuring rich, comprehensive images of the land, river, and people, with a focus on the importance of the renegotiation of the river treaty"— Provided by publisher.
Identifiers: LCCN 2023034501 | ISBN 9781680516609 (hardcover)
Subjects: LCSH: Columbia River Watershed. | Stream ecology—Columbia River Watershed. | Nature—Effect of human beings on—Columbia River Watershed.
Classification: LCC QH104.5.C64 M67 2024 | DDC 333.73/15309711—dc23/eng/20230817
LC record available at https://lccn.loc.gov/2023034501
ISBN 978-1-68051-660-9

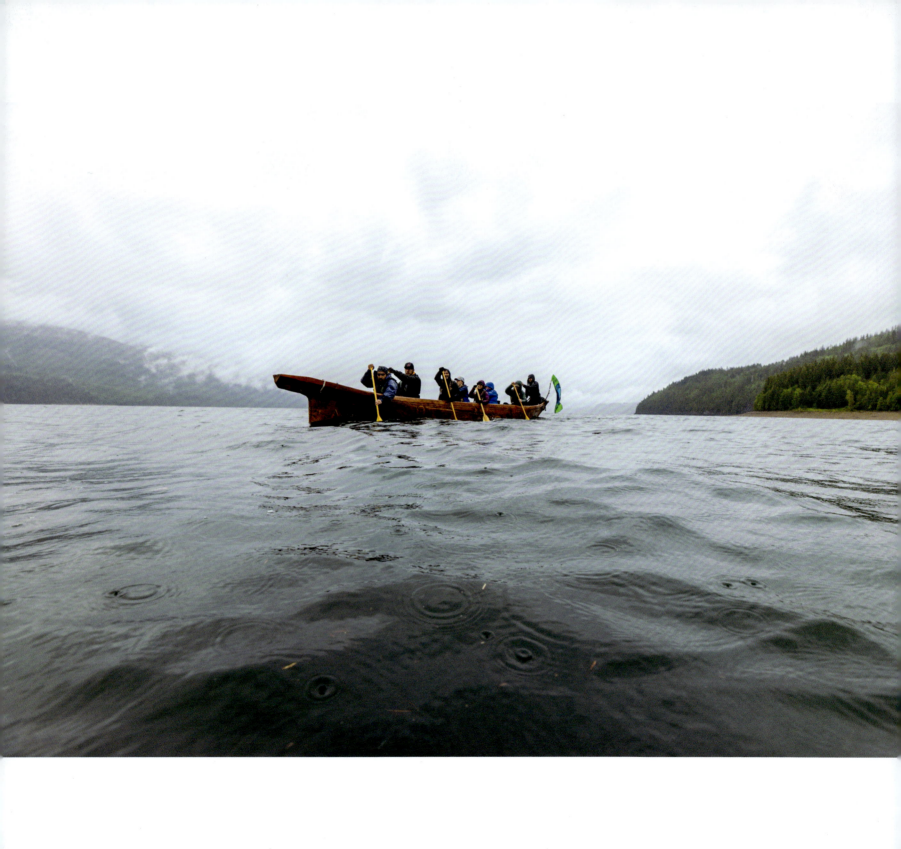